EXQUISITE PURSUITS

TO THE MEMORY OF
HARRY G. C. PACKARD

AND IN HONOR OF
PROFESSOR SHŪJIRŌ SHIMADA
AND THE HARRY G. C. PACKARD COLLECTION
CHARITABLE TRUST

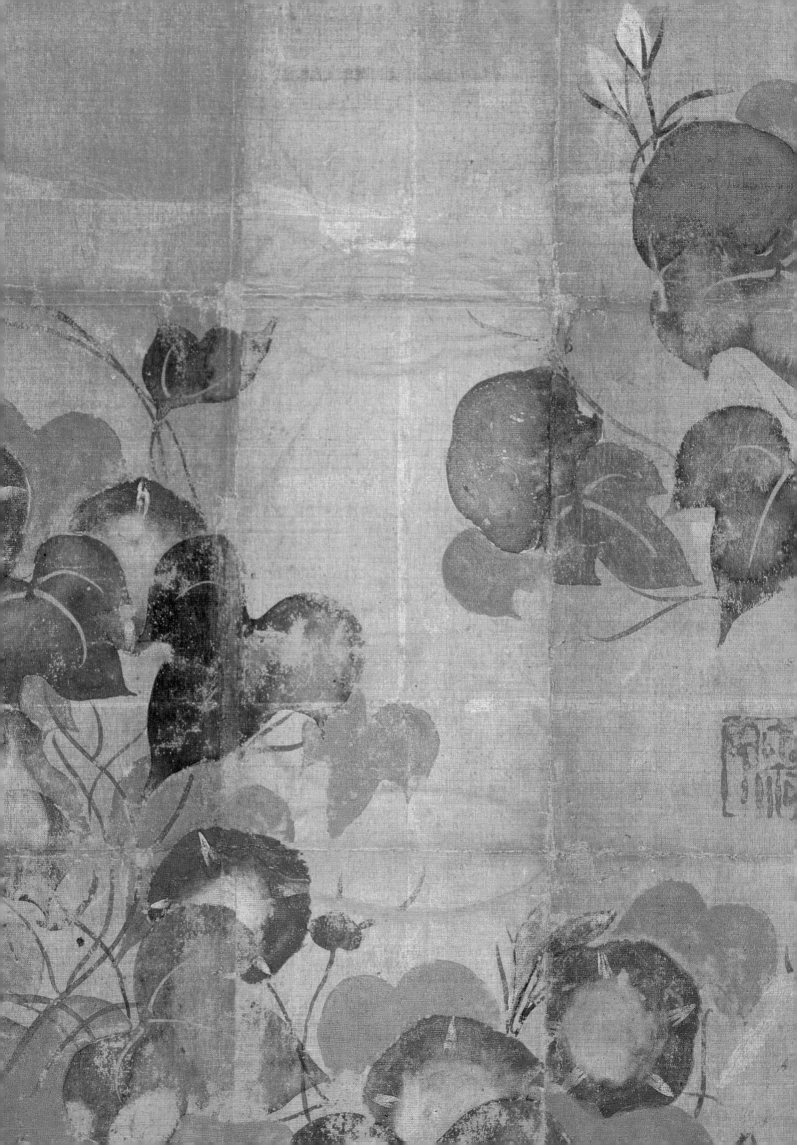

EXQUISITE PURSUITS

JAPANESE ART IN THE
HARRY G. C. PACKARD
COLLECTION

YOKO WOODSON
& RICHARD L. MELLOTT

PHOTOGRAPHY BY
KAZUHIRO TSURUTA

ASIAN ART MUSEUM
OF SAN FRANCISCO
1994

IN ASSOCIATION WITH
UNIVERSITY OF WASHINGTON PRESS
SEATTLE ✌ LONDON

Published by the Asian Art Museum of San Francisco
Distributed by the University of Washington Press,
Seattle and London

Produced by Marquand Books, Inc., Seattle
Production supervision for AAM by Richard L. Mellott
Edited by Lorna Price
Designed by Ed Marquand
Printed and bound in Hong Kong by C&C Offset Printing Co.,
Ltd.

Note to reader: In this volume, paired screens have been placed
on adjacent pages. Read all screen paintings from right to left.

Cover: left scroll of *Monkeys Playing on Oak Branches* (No. 18)
Back cover: *Gōzanze Myōō* (No. 3)
Page 1: Portrait photo by Takao Inoue, reprinted from
Geijutsu Shincho, July 1987
Frontispiece: detail, Ogata Kōrin, *Morning Glories* (No. 21)
Page 6: detail, "The Sacred Tree," *The Tale of Genji* (No. 19)
Page 26: detail, *Eleven-headed Kannon* (No. 2)
Page 70: detail, Abe no Suehide, *Bugaku Dancers Scroll* (No. 15)

Library of Congress Cataloguing-in-Publication Data

Woodson, Yoko.
 Exquisite pursuits : Japanese art in the Harry G. C. Packard
collection / Yoko Woodson & Richard L. Mellott ; photogra-
phy by Kazuhiro Tsuruta.
 p. cm.
 Includes bibliographical references and index.
 ISBN 0-295-97351-X. — ISBN 0-295-97352-8 (pbk.)
 1. Art, Japanese—Catalogs. 2. Packard, Harry G. C. (Harry
Gloyd Cole), 1914–1991—Art collections—Catalogs. 3. Art—
Private collections—California—San Francisco—Catalogs.
4. Art—California—San Francisco—Catalogs. 5. Asian Art
Museum of San Francisco—Catalogs. I. Mellott, Richard L.
II. Title.
N7352.W66 1994
709'.52'07479461—dc20 93-50096
 CIP

CONTENTS

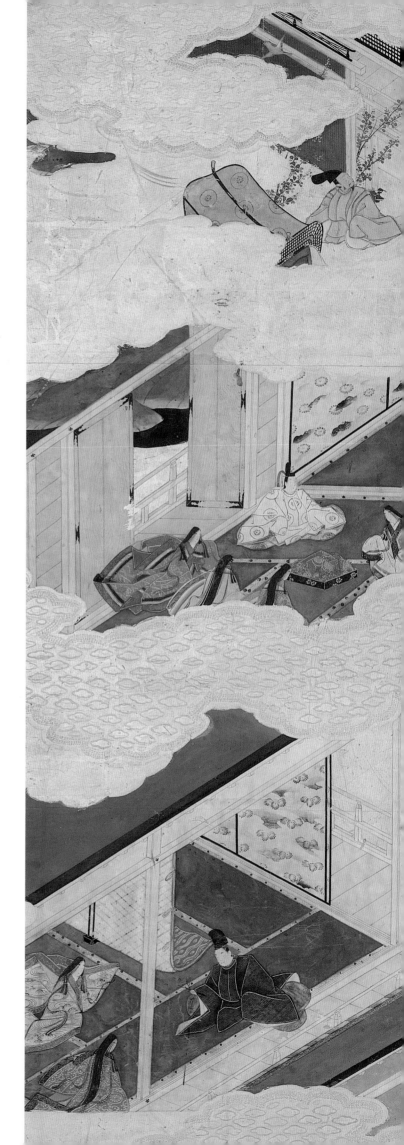

The following institutions and individuals have
supported this catalogue and exhibition:

THE HARRY G.C. PACKARD COLLECTION
CHARITABLE TRUST FOR
FAR EASTERN ART STUDIES

NATIONAL ENDOWMENT FOR THE ARTS

THE COMMEMORATIVE ASSOCIATION
FOR THE JAPAN WORLD EXPOSITION
(1970)

MR. AND MRS. MASAYA OKUMURA

SHAKLEE CORPORATION

CALIFORNIA ARTS COUNCIL

METLIFE——WESTERN TERRITORY

MRS. SUE V. BRANSTEN

ANONYMOUS DONORS

THE PACKARD ACQUISITION

Harry Packard was to dealing what Avery Brundage was to collecting. In the course of Harry Gloyd Cole Packard's forty-year history of aggressive pursuit of Japanese art he accomplished what few dealers even attempt. Educated as a civil engineer and a member of the American Occupation in Japan, Packard made himself into an art historian of formidable reputation, acquired one of the largest collections of Japanese art ever assembled by an American, learned Japanese to sufficient extent that he could lecture on art history in the language, fathered eight children, sold to the Metropolitan Museum its then-largest single acquisition, provoked friend and foe alike with an obsessive determination to capture objects of great quality, established a substantial foundation for the promotion of Asian art studies, and, finally, through his personal generosity, became a patron of major museums. And he was a tennis player of tournament caliber.

I first met Harry in London at an Asian art gallery. He was installing some of his objects. Somehow he had heard my name and associated me with objects for the tea ceremony, for he handed me a bowl by Nonomura Ninsei, a Kyoto artist of the seventeenth century, and asked what I thought of it. This beautiful object—a black bowl with the painting of a dragon in a rondel—is an excellent example of Ninsei's best work, but it was not purchased at the time. Years later, and much to my own pleasure, the Asian Art Museum had the opportunity of buying the tea bowl from Harry. The successful presentation of this before our Acquisitions Committee was made by Richard Mellott, the museum's curator of education.

Richard Mellott, himself an expert in tea ceremony objects and a grounded student of ceramics, was one of Harry Packard's closest friends. It is through this long-time association that the Asian Art Museum was able to acquire the subjects of this catalogue, the last of the great Packard collections.

Richard approached Packard in 1987. His idea, drawing upon the affection Harry evinced for Brundage, and upon the facts that many of the Asian Art Museum's treasures came from the same dealer and that Harry had a life-long association with California, was to obtain for us the hidden resources in Japanese art his friend still retained.

The twenty-seven works of art catalogued here constitute the entire Packard collection. They span the twelfth through nineteenth centuries and include the mediums of painting and sculpture, with the addition of one object in bronze. By the strictest aesthetic standard, these are superbly representative of Japanese art. Some are unique in importance—the *Bugaku Dancers* scroll (No. 15) is the earliest dated work of its kind; the *Zaō Gongen* (No. 14) is the only known sculpture of its kind fixed with pieces of glass; the dated portrait of Hideyoshi (No. 17) is enormously important; the Kōetsu-Sōtatsu calligraphy scroll (No. 20) is complete and stunning on colored papers; the Kōrin silk incense wrapper painted with morning glories (No. 21) would be the envy of any collector and is the only one with Kōrin's seal affixed; the Edo monkey and oak hanging scrolls (No. 18) were, perhaps, originally *fusuma* from Matsumoto Castle; and the Buddhist and Shinto works would stand proudly in any great museum collection.

The art we have acquired is mainly the choice of Harry Packard, but I would be remiss were I not to reveal something Harry told me in a Kyoto conversation in 1988. He said that he had "collaborated" in the selection of the objects with the late Kurata Bunsaku, the highly respected art historian, Nara National Museum director, and officer of the Agency for Cultural Affairs, Tokyo, and with Professor Shūjirō Shimada, eminent art historian and former professor at Princeton University. Harry did not say if any of the art was selected by one person, but, rather, the implication was that the three scholars had agreed on the overall quality of the selections.

The Asian Art Museum Packard collection is nowhere near the size of the one that he sold to The Metropolitan Museum. That astonishing sale was, as with the case of the more recent sale to the Asian, a half-gift, half-purchase, but it involved a vast array of Japanese art. The total number of works of art sold to the Metropolitan varies (ca. 400–700) according to the source and the method of numbering the entries; for instance, does one count each half of a pair of screens as separate works of art, or is the whole listed as one? This monumental acquisition lifted the Metropolitan into the front ranks of museums collecting Japanese art. Reports in newspapers at the time provoked controversies about the

price and about certain of the attributions, but these complaints have long since died before the obvious quality of what Packard offered the Met and before the rising market for Asian art in general. Today, I suspect, no one could assemble anything like the Metropolitan's Packard collection at twice the price.

Harry Packard had sold numerous works of art to Avery Brundage; thirty-nine are identified elsewhere in the catalogue, and there are probably many more, but for which no reliable documentation has been found. We know, as well, Harry visited San Francisco regularly, selling art to Alice Kent, Marjorie Seller, and others. Some of these works of art, too, are now in the collections of the Asian Art Museum.

On one memorable occasion Harry and I discussed only modern and contemporary art, for his aesthetic reach was catholic, extending well beyond the area with which he is most associated. He asked what art I had, and, hoping to stump him, I singled out a then-little known photographer, Sugimoto Hiroshi. "Oh, I've got some of his; do you have any of the movie theaters?" Harry said. Few people knew of the full extent of his collecting interests, and it should be noted here that Harry Packard did assemble a strong collection of California painting.

When we decided to purchase the Japanese collection, I met with our curators, and decided that we should involve some independent authorities to examine the art, either to deny or confirm the museum's findings. I called in a well-known university professor, a prominent senior curator of a large museum, and one of Japan's leading art dealers, each a specialist in Japanese art, and they were given free and independent access to the material. Their conclusions were nearly identical and paralleled those of our curators, Yoshiko Kakudo, Yoko Woodson, and Richard Mellott. I am pleased here to acknowledge that one of the participants in the examinations process is now the Asian Art Museum's own Emily Sano.

One object that came under particularly careful scrutiny was the sutra container of the twelfth century. The patina for this object has been described as "ravishing," and, at the same time, "too good to be true." On first sight the patina *is* "glamorous." It is brilliant and has the appearance of being poured or applied, but

intensive research in our conservation laboratory and also in that of the Los Angeles County Museum subsequently proved to our satisfaction that Harry Packard was right in his attribution of the case to the Heian period.

Museums are known first and best for collections, and we are proud to present the Packard collection in this publication and in exhibition for the first time. An acquisition of this importance is a complex process. In this the museum has been greatly aided by Richard Mellott, Yoshiko Kakudo, and Yoko Woodson. Dr. Woodson is the author of the title essay and all the catalogue entries, and has done extensive research on the collection. Richard Mellott has written the essay on Harry Packard and his long association with the Asian Art Museum. We are grateful to each, and to Marjorie Seller, who chairs our Acquisitions Committee and was an early and enthusiastic supporter of the project, together with her committee members, members of the Asian Art Commission, and the trustees of the Foundation.

Finally, may I extend the thanks of all of us at the Asian Art Museum to the family of Harry Packard and to the officers of the Harry G. C. Packard Collection Charitable Trust for Far Eastern Art Studies for the excellent help, support, and cooperation given in this project.

Rand Castile
Director
The Asian Art Museum of San Francisco

INTRODUCTION

HARRY PACKARD AND THE ASIAN ART MUSEUM

Harry G. C. Packard (1914–91), the American collector and dealer in the fine arts of Asia, is renowned for the gift and sale, in 1975, of his large and important collection to The Metropolitan Museum of Art in New York. Packard's four-decades-long relationship with Avery Brundage (1887–1975) and with the Asian Art Museum of San Francisco, however, is less well known. It seems appropriate to explore here the interaction of two eminent collectors possessed of superb connoisseurship and negotiating skills. Packard's writings, his correspondence with Brundage in the archives and records of the AAM, offer a uniquely revealing glimpse of their friendship.[1]

In 1950, Edwin Grabhorn, the distinguished publisher and co-founder of Grabhorn Press, met Harry Packard in San Francisco to look at some 250 Japanese woodblock prints, which Packard had collected in Japan.[2] Packard had purchased the prints during the late 1940s while stationed in Tokyo at General Douglas MacArthur's Occupation headquarters. The Japanese, in the throes of postwar reconstruction, had little interest in prints, and Packard had been able to buy them inexpensively.

Mr. Grabhorn, a collector of Japanese prints, had published several famous volumes on them.[3] He and Packard found they shared a common enthusiasm for the "floating world" of ukiyo-e prints, and struck up a friendship that was to last their entire lives.

Packard did not want to sell his prints, but intended rather to travel in the United States to study and compare them with prints in private and public collections. Grabhorn gave Packard an introduction to Avery Brundage, whom he knew as a friend and as a serious collector of the arts of Asia.

On January 28, 1950, Brundage wrote to Shinzō Shirae, his agent in Japan: "Harry G. Packard showed up with a few good pieces," and asked Shirae whether he knew anything about Packard.[4] Shirae responded on February 5: "I think I met him only once or twice at the Yamanaka shop many years ago. I don't know, however, anything about him."

In one of the essays in the series "Nihon bijutsu shūshūki" (A Memoir on Collecting Japanese Art), Packard recalls this first meeting with Brundage.[5] Brundage was apparently surprised to see Packard arrive at his Chicago office in the La Salle Hotel carrying a large crate containing the 250 prints. After viewing the prints, Brundage offered to buy them on the spot, an extremely impulsive gesture for the normally cautious collector. Packard declined the offer and explained his intent. Brundage joked that since the crate looked as if it were about to fall apart, he would be happy to safeguard the prints in his own art storage facilities; again, Packard declined.

Brundage then took Packard upstairs to his apartment, where a selection of his growing art collection was on display. Packard writes that he was very impressed, and that as a result of this visit, he began to think of the arts of Asia in broader terms. Specifically, he began to consider expanding his knowledge into older traditions of Japanese art. This meeting also marked the beginning of a twenty-some year relationship between Packard and Brundage.

Perhaps Packard's meeting not only Brundage but also all the other collectors, dealers, and curators whom he encountered—in Boston, New York, Washington, Philadelphia, St. Louis, Kansas City, and San Francisco —convinced him to study seriously the arts of Japan. Shortly after he returned to San Francisco in 1951, Packard decided, at age forty, to enter graduate school at the University of California, Berkeley.[6] He majored in art history and took courses in Far Eastern art for two-and-one-half years with Professor Otto Maenchen-Helfen (1894–1969). Packard relates that he was frustrated because there were then no Asian art objects at the university or in Bay Area museums to study—only books, slides, and photographs.[7]

After receiving his M.A. in 1953 at Berkeley, Packard decided to return to Japan to pursue the study of Japanese art in more depth and to see works of art first-hand. In 1954 he entered the graduate program of Waseda University, Tokyo, majoring in Japanese art and taking courses ranging from the Jōmon period (ca. 12,000–250 B.C.) to the Edo period (1615–1868). After two years at Waseda, starting in the summer of 1956 he spent six months traveling all across India, visiting temples, museums, and collections. He returned to Waseda in spring 1957, but that fall, he sustained a severe head injury while visiting Kyoto. Following several months of hospitalization and a prolonged period of recuperation, Packard decided to give up his studies.

Packard then turned more and more toward the antique trade as a way of life. He suggests in his book that this choice came about through an introduction to old Imari ceramics by several of his dealer and collector friends.[8] Of course, all during his time at Waseda, Packard had regularly visited antique shops and collectors, acquiring many works of art, his "study collection," which he kept in a locked room in his house in Kamakura.[9]

By late 1958 or early 1959 Packard embarked on what became his principal activity for the next twenty years—assembling a group of art objects from all over Japan and traveling in the United States and Europe to sell them. The curators, collectors, dealers, and others he had met on his first trip in 1950, as well as all his contacts in the intervening years, found a place in his itinerary. From about 1959 to 1970 Packard made regular visits to Brundage, who had continued to acquire objects wherever he traveled in the world. The Brundage archives record no purchases from Packard between 1950 and 1959; however, it is clear that the two maintained contact and that Brundage probably bought objects from Packard during this time.

Their correspondence provides the best way to understand the interaction between Packard and Brundage over these years, both personally and in the realm of connoisseurship. The earliest letter in the Brundage archives is dated December 27, 1961. Packard writes:

Dear Mr. Brundage,

Thank you for your purchases last spring.[10]

I am writing today because I have what I consider to be a very important Ashikaga period ink painting. . . .

Title: Li-Po Viewing Waterfall

Artist: Sōami (d. 1525)

In sumi and light color on paper

Seal: Ting-shaped seal in vermilion ink reading "kangaku"

Publications: (a) Plate 79, "Suiboku Painting of the Muromachi Period," by Takaaki Matsushita, Ōtsuka Kōgeisha, 1960. (b) "Ashikaga Ink Painting," exhibit catalogue of the Bridgestone (Ishibashi) Museum, Tokyo, 1961.

Comments: Mr. Matsushita is, as you know, chief of the Arts and Crafts Section of the National Commission for the Protection of Cultural Properties. He is also an excellent and strict authority on Muromachi ink painting

and painting of the Sōtatsu-Kōrin School. This book has identified a number of new artists and paintings of high quality and is quite a contribution to the subject of Japanese ink painting.

Unfortunately, the English translator has botched and interchanged the translations of Plate 78 and Plate 79. This will be clear if you refer to the photocopy of Page 21 which contains the English translation for Plates 78 and 79.

Price: $10,000.00 CIF, U.S.

It is rare that one can offer for sale outside of Japan an ink painting of such high reputation and quality, published in a recent and highly authoritative work.

The price is in line with the importance of the painting. I wish it could be less but high quality Ashikaga ink paintings often run much higher. I am not very well off money-wise. If you decide to buy this painting, I'd like to be paid if possible in two equal installments, at the end of January and February. Delivery can be made by airmail in two or three days if you so instruct. You are welcome to study or consult whomever you wish within the above time limits as long as the decision is made by the end of January.

Enclosed you will find three photos. . . . Please return the photos if you are uninterested.

Sincerely,

Harry Packard

P.S. Sōami is of course an important name in Japanese ink painting.

Typical of almost all Packard's letters of offer is his careful description of the work, summary of the most up-to-date research and publication on it, any available comments about it by the preeminent authority in the field, and justification for the price. Packard was very careful in his research about all the objects he sold; he tried to maintain a professional presentation and was proud of his hard-earned reputation.

Brundage responds on January 5, 1962:

Dear Harry Packard:

You may send the Sōami painting described in your letter of December 27, which has just arrived. It seems to be a pleasing painting and I hope it is worth the price you have quoted. As you know, it is not cheap. I will give you a decision before the end of the month.

Sincerely,

Avery Brundage

Brundage is typically curt, a man of few words, and offers absolutely no premature commitment. He lodges a complaint about the price from the outset, as was to be his practice with almost everything he bought.

Packard replies on January 24, 1962:

Dear Mr. Brundage,

Thank you for your letter of January 5th. I will send you the Sōami by airmail in four or five days. I would appreciate a quick decision. As to the price, it is almost impossible to acquire a really big-name Ashikaga painting in Japan for much less than $10,000. And Sōami, as you know, is a major figure in Japanese ink painting history. Also, this is a major work.

I know it takes courage to put out this kind of money for a Japanese painting, and I hope you can do it. Perhaps it will help if you will look back on the items you have bought from me in the past. I don't think you have had cause to regret any one of them.

At this time, I would like to offer you another item . . . a bronze pilgrim bottle with crouching lion on the lid.

On February 17, 1962 Brundage rejects the bronze:

Dear Harry:

Thank you for sending the photographs of the late Chou bronze which are being returned herewith. It is interesting but not worth that price.

What has happened to the Sōami painting?

This letter crossed in the mail with a careful explanation that Packard had written on February 15, 1962:

Dear Mr. Brundage,

The Sōami was put in air parcel post yesterday addressed to you in Chicago. A few days before that I sent you a copy of Takaaki Matsushita's book Suiboku Painting of the Muromachi Period.

May I ask that you be very careful in handling the Sōami. One reason for the delay . . . is that I had a Kyoto kakemono mounter remove two or three wrinkles in the painting. This was done very gently to preserve the freshness of the patina on the surface of the paper. Carelessness in rolling or unrolling may cause the reappearance of these wrinkles.

For a Muromachi period ink painting, this Sōami is in excellent condition. As far as I know, it has no repainting. The mold marks on the paper are known in

Japan as "daimyo shimi" or feudal lord mold. This mold is present on almost all fine Japanese paintings of good pedigree. It is said to derive from being stored in feudal godowns. And it is a consequence of the wet Japanese climate.

Japanese consider a certain amount of this mold to be desirable in old paintings, as adding to the "flavor" of the painting.

There are also small defects or abrasions on the white or unpainted areas of the paper. Several such small defects have been repaired. These are not important nor do they constitute a drawback to the painting. They are almost inevitable.

By excellent condition, I mean that the ink tones are magnificent, that there is no significant re-painting and no major abrasions.

Next, I am including in this letter another exhibit folder in which the Sōami appears as No. 37. This exhibit was held at the Kurume Center of the Bridgestone (Ishibashi) Museum and the contents of the exhibit were selected by Shinichi Tani. The exhibit included 25 Registered Art Objects and was regarded as an important exhibit.

The selection by Tani includes three paintings of the Sōami group. Cat. No. 35 is the famous painting of the fusuma of the Daisenin Temple. This landscape, an Important Cultural Property, is listed by Tani as "den-Shinsō hitsu" or attributed to the brush of Shinsō (Sōami). No. 36 is also listed as an attribution.

However, No. 37 in the above exhibit (the painting I am offering you) is catalogued by Tani as "Shinsō hitsu" or by the brush of Shinsō (Sōami). Thus, No. 37 is the only painting of the three catalogued by Tani as definitely by the brush of Sōami.

If possible, I would appreciate an early decision on this painting. Please write me your reactions at your earliest convenience.

This letter reveals Packard's extreme concern for the condition of anything he sold. He would often have paintings remounted or repaired, giving all the documentation, and he often had new boxes made to house old ones. He felt an obligation to explain these conditions and circumstances to all his clients.

The second part of the letter, alluding to Shinichi Tani and his views on this painting, indicates that Pack-

ard was still continuing to research the work, a pursuit that often reached nearly obsessive proportions.

Brundage replies on February 22, 1962:

Dear Packard:

Your painting has just arrived . . . but I am leaving for Europe tomorrow and I don't like to make such an important decision without studying the painting carefully. I was under the impression that it was larger, although you did not give the dimensions.

Since my things are now going to a museum, size has some importance. If you don't mind waiting until next month, I'll give you a decision at that time. Otherwise, I have left instructions to have it returned to you in my absence.

Is the figure you quoted the net price or is there a collector's or museum discount?

You never gave me a bill with the description of the objects I bought from you last year. I'd like to have all the information you have on them.

Brundage, requesting more time, is clearly unhappy with both the scale and the price. He asks outright for a discount, establishing a pattern that persisted throughout his dealings with Packard. Note, too, that once Packard had begun to provide scholarly information about objects, Brundage asked for it if it wasn't forthcoming.

Packard writes on March 10, 1962:

Dear Mr. Brundage,

In regard to your inquiry about a collector's discount, I would have asked the Freer $15,000 for this painting. Still, I will reduce the price to you by another $500.

In regard to the size, Ashikaga painting is intended for use in a tea ceremony room tokonoma. I believe the Sōami is larger than the average Ashikaga painting. The picture surface is larger than many National Treasures and Important Cultural Properties.

I cannot go into a long series of comparison of size with large Ashikaga paintings here. Most large ink paintings (I believe Harry Nail showed you a couple two years ago) are fragments of shoji or fusuma or wall paintings from temples, and the artist is seldom clearly known. Most are without seals or with later seals. From the Western standpoint, this painting I am offering you is fully as large as gems of early Western paintings. I believe it is larger than Raphael's Alba Madonna.

I offered you this painting because I felt it to be an absolutely top-ranking museum painting that will stand any scrutiny by Japanese or other scholars. I hope you will buy it as such.

Packard makes a slight concession on the price, as he knows he must, to keep Brundage interested. But he defends the size of the painting, explaining the reason for the small format, in an attempt to help Brundage understand that size, in both Western and Japanese contexts, isn't an adequate criterion in assessing value.

Twelve days later, on March 22, 1962, Brundage replies:

Dear Mr. Packard:

On my return from my European trip a few days ago, I found your letter of March 10. While I liked your painting and still do, by a strange coincidence I found in my travels another Sōami which I like much better and which is less than half the price of yours. Had I not found this one I might have bought yours, although I still think it is too expensive. Do you wish me to return it to you or do you want to submit it elsewhere?

Brundage was always looking for better and cheaper objects and felt no hesitation to turn down anything, for any reason, but particularly if he thought it was overpriced.[11]

On March 30, 1962, Packard writes:

Dear Mr. Brundage,

Scholars in Japan have led me to believe that the Sōami I offered you is the only unquestioned one in existence. However, if you have found another undoubted Sōami at a cheaper price I am helpless in the matter, because my purchase price doesn't enable me to compete pricewise. I'm sorry I seem to be always offering you things at prices that appear to be higher than those of other people. . . .

I plan to be in America on a selling trip in the near future, probably arriving around the 15th in April. I will probably be in San Francisco for 3–4 days and in Los Angeles for 3–4 days.

If things go well, I will probably return to Japan after a ten-day visit without visiting the East coast. . . . Would it be possible to see you? . . . I would be willing to visit you in Chicago if necessary.

I will have with me twenty or thirty very high quality Korean and Japanese ceramics, as well as Japanese paintings.

Obviously Packard doubts the authenticity of any other Sōami painting Brundage may have found and doesn't hesitate to say so. Undaunted by Brundage's rejection, he makes a point of wanting to meet to offer Brundage a selection of new objects.

On April 7, 1962, Brundage, still grumbling about the price of the rejected Sōami, but always intrigued by the promise of new works, replies:

Dear Mr. Packard:

Your Sōami painting will be sent to your daughter as you requested. I like it, but I think it is priced too high, particularly since I found the other one, which I like even better, at less than half your figure. . . .

I expect to be in California again about the end of this month, so if you postpone your trip a couple of weeks, I can see you there.

Finally, nearly eight months after Packard first offered him the Sōami, Brundage capitulates and decides to buy it. He writes on August 1, 1962:

Dear Packard:

Jan Fontein has been here and has now returned to Amsterdam. I saw him here in California and asked him to stop off in Chicago to look at the objects you left there on approval. He did so, but I do not yet have his report. When I get back to Chicago I'll decide which, if any, I shall keep.

He likes your Sōami painting and I have decided to take it even though I still think the price is too high. . . .

If you run across anything of importance let me know. When I return to Chicago I'll advise you about the objects there.

Brundage relied heavily on Asian art scholars such as Fontein, René-Yvon d'Argencé, and others, but in the end he made an independent decision. Other letters over the next decade reveal that this kind of protracted negotiation over objects was not unusual between the two men.

According to records in the Asian Art Museum, Brundage bought a total of thirty-nine objects from Packard between 1962 and 1967 (see Appendix).

From at least as early as 1949, Packard had begun to assemble his private collection of Japanese art, beginning with the original 250 *ukiyo-e* prints. By 1967, Brundage was fully aware that Packard owned an important private collection. On July 17, 1967, in a new role, he launched a courtly but somewhat oblique inquiry:

Dear Mr. Packard:

In our last long-distance telephone conversation, I told you that an expanded program of national if not international importance was being studied in California. It may be that there might be a place for you. You have told me about your collection but I have heard no details. If you do not object, I would like to know what you have in your collection. Something of advantage to you might well develop.

In a two-and-one-half-page letter dated October 10, 1967, Packard replies:

Dear Mr. Brundage:

. . . I am now working on a photo catalog of the entire collection in preparation for a showing of the collection at Los Angeles in October 1968. When this catalog is complete, I will send it to you for your perusal. . . .

The basic collection catalog consists of 14 volumes and about 500 items or groups of items. . . .

Packard then describes his entire collection, according to country, types, and number of objects. He gives a current estimate of its market value and notes that the collection, as a whole, is highly published. He continues:

Next to your collection, I feel that my collection is one of the important groups of Oriental objects still not irrevocably located. Some of the objects of the collection remaining in Japan will require delicate negotiations to remove.

The forming of this collection was an expression for me of an ambition that I have not yet been able to adequately realize in other ways . . . i.e., to pursue a career as an art scholar and to have a part in the building of an American museum of Oriental art of uniform, impeccable quality, if possible in the Western part of the U.S., which would provide guidance services and make source materials available to future generations of Oriental art scholars.

I am not interested in selling the objects at any price; I formed [the collection] with the intention of donating it under certain conditions. . . .

Packard then sets out five conditions under which his collection might be placed in the U.S.[12] He closes with a carefully worded commitment:

As I promised during our phone conversation some time ago, I will not sign a contract to donate these objects to any institution without conversing with you about the matter.

Brundage, with equally exquisite reserve, responds on October 21, 1967:

Dear Mr. Packard:

Thank you for your letter of October 10, relating to your collection, which I have read with interest. As I told you in our long-distance telephone conversation, the situation in California is still fluid. I hope to reach a settlement soon, but as you know, museums move very slowly, and the project we are working on has many complications.

Nine months later conditions had evolved sufficiently for Packard to write to Brundage, on July 6, 1968, outlining the conditions under which he might offer his collection to San Francisco if the Brundage collection were to remain there.[13] On July 14, 1968, Brundage, admitting complications, counsels solidarity:

Pursuant to our agreement, in view of our close collaboration during the last twenty years, I agree to keep you advised of my negotiations with the museums in California.

As you know, I am not happy with the situation in San Francisco as it stands, and I have been talking with representatives of Los Angeles and other cities.

I am sure it will be to our mutual advantage to continue to work together, and if you will keep me advised and not come to any agreement without notifying me, I will do the same.

In five months' time, the situation is much clearer, and far more optimistic. Brundage writes on December 16, 1968:

For your information, my negotiations with the City of San Francisco are reaching a conclusion, and I think we will have a final agreement shortly. I promised to let you know, and I think that you should talk with Mr. George

F. Jewett, Jr., who is the Chairman of the Committee appointed by Mayor Alioto of San Francisco to develop a great center of Oriental culture in the Bay Area. . . .

Almost a year later, these promising negotiations terminated when Packard, in a long letter to Brundage, of November 18, 1969, withdrew the offer of his collection to San Francisco. This reversal came after a large Japanese sculpture Packard had offered to the museum was called into question by the museum staff. Packard and Brundage remained on cordial terms, however, continuing to exchange letters and visits, but there are no records of Packard offering Brundage any more art objects. Brundage died in 1975.

Packard entered negotiations with Los Angeles regarding his collection; when they broke off after 1970, he approached The Metropolitan Museum of Art in New York City. In 1975 Packard's personal collection, then approximately 700 objects, went to the Metropolitan as partial gift and partial sale. The cash portion was used to establish the Harry G. C. Packard Collection Charitable Trust for Far Eastern Art Studies, to further the study of Japanese and other Asian art.[14]

The final chapter of Packard's involvement with the Asian Art Museum of San Francisco came with the acquisition in 1991 of the twenty-seven objects in this catalogue. While studying in Japan between 1976 and 1984, I became friends with Harry Packard, who had spoken to me several times of his fond memories of Brundage and the great treasures Brundage had given the city. I had become aware that he owned yet another, smaller, collection of choice objects. But only after I took my present position at the Asian Art Museum in San Francisco in January 1985 did I begin to wonder whether Packard might be tempted to offer his last collection to the AAM.

On a visit to Japan in early October 1987, I approached Packard with this idea. After some long thought, he finally said he would seriously consider it and gave me a list of the objects and some photographs. When I returned to the United States, I showed the photos to Yoshiko Kakudo, Curator of Japanese Art, Yoko Woodson, Associate Curator of Japanese Art, and to Rand Castile, Director. All were eager to pursue ac-

quiring this collection. On December 20, 1987, Packard sent us a letter of intent. In it he explained that the twenty-seven objects were the property of the Packard Trust, which he had formed after the Metropolitan sale:

These objects were purchased by the Packard Trust mostly in 1979, with the advice of Dr. Shūjirō Shimada (then Director of the Trust's grant dispensing agency, the Metropolitan Center) and by other museum or university scholars, chosen for expertise in their specialist fields.

Disposal of the objects would require, on our side, approval of Dr. Shimada, still art advisor to the Packard Trust, and majority approval of a six-member Trust Protectors Committee, in addition to approval of the Trustee.

Packard continues with a current estimate of the value of the art and a specific plan to pursue the evaluation of the works and their presentation to the museum. He concludes with a condition:

P.S. It is hoped that this group of objects would be known as the Dr. Shūjirō Shimada Memorial Collection.[15]

During the weekend of March 25–27, 1988, at the annual meeting of the Packard Trust Protectors Committee in La Jolla, California, I gave Packard and the committee members a copy of a letter from Mr. Castile:

March 21, 1988
Dear Harry:
We are pleased with your kind offer of the important collection of Japanese art. I am delighted you and your Trust see the Asian Art Museum as the appropriate site for what has been assembled.
Here is what I see as the course of things over the next months. . . .

Castile then presents a sequence of development that includes study of the collection at the museum by the staff, a report by the staff and outside experts to the Asian Art Museum Commission, a vote in favor of acquisition, fund raising, and finally a public announcement:

The process will, I suspect, take about two or three years. As all the funds must be raised—probably from one individual source—you might expect a single payment,

though this could be modified by a donor's wish to pay over time. . . .
Please let me know your reaction to these notes. I want to make sure we are always in agreement.

The Packard Trust Protectors Committee approved the plan and the tentative time-frame of acquisition, with the hope that a clearer schedule could soon be worked out; the committee also voted to have all the objects sent to the museum. I was asked by the committee to hand-carry two paintings (Kōrin and Buson) from Japan later in 1988, because of their delicate condition.

By fall 1988, the entire collection was at the museum. For the next fifteen months, the curators and conservators continued their intense study of each object. Three outside experts (a prominent dealer in Japanese art, a senior curator of Japanese art from a major museum, and a senior academic scholar in the arts of Japan) were also invited to evaluate the collection's authenticity, artistic quality, condition, and value. They unanimously concluded that these works would be a fine addition to any serious collection of Japanese art, that they were by-and-large as represented, in good condition, and definitely worth more than twice the asking price.

A letter from Packard to Castile dated August 30, 1989 set out the specific conditions of the sale, which included a reference to Dr. Shūjirō Shimada and the Trust in naming the collection; final payment was due not later than August 31, 1991.

On Tuesday, November 28, 1989, at a special meeting of the Acquisitions and Loan Committee, the objects from the Packard collection were put on view. After a complete presentation by the staff, the committee voted enthusiastically and unanimously to acquire the collection subject to funding. The Asian Art Museum Commission voted to approve the recommendation of the committee on December 5, 1989, pending funding.

A year later, on December 6, 1990, Castile was able to write to David Packard, acting Chairman of the Packard Trust, that funding was in place and that all conditions of sale would be met.[16]

David Packard responded in a letter of January 9, 1991:

Everyone is extremely happy with the fund raising success you've had. Dad had wanted the objects to remain in San Francisco and he is most pleased. We look forward to completing the project in 1991.

Payment for the collection was completed on August 31, 1991, just two months prior to Packard's death on October 31. Although very ill, he told me he was delighted that his last collection had found a place beside many of the objects that once belonged to his old friend Avery Brundage. I'm sure he was also pleased that because of their joint efforts, students of Far Eastern art on the West Coast now had the opportunity to study Asian art objects of the highest quality. With the publication of this catalogue and the public exhibition of the Packard collection, this long history of two prominent collectors comes to an auspicious close. The many masterpieces that make up this great collection are their legacy and their contribution to San Francisco's unique cultural and artistic heritage.

Richard L. Mellott
Curator of Education
The Asian Art Museum of San Francisco

Notes

1. Born in Salt Lake City, Utah, Packard moved with his family during the 1930s to Seattle, where he entered the University of Washington. He majored in civil engineering, completing his degree in 1939. He moved with his family again to Oakland, California, where he managed a notions store owned by his mother. Packard volunteered in 1942 for service in the U.S. Navy and received a commission. By fall 1942 he had volunteered to study Japanese at a Marine Corps language school in Colorado Springs. This intensive course lasted one year; at the end of it, Packard was fairly fluent in written and spoken Japanese. As a Marine, Packard was sent to the Pacific theater of the war, where he worked as a translator and interrogator. He returned briefly to the United States at the war's end in 1945, but returned to Japan in 1946 where for the next four years he worked in MacArthur's headquarters. He returned to California in 1950.

In 1966 Packard published "Nihon bijutsu no mōten" (Blind Spots of Japanese Art) in *Geijutsu Shinchō* (March 1966). Ten years later he published a series of essays, "Nihon bijutsu shūshūki"(A Memoir on Collecting Japanese Art), in the same publication, between January and December 1976. Prof. Gōzō Sasaki of Waseda University recently edited and published these essays in one volume, *Nihon bijutsu shūshūki* (Tokyo: Shinchōsha, 1993).

Kenneth Baker recently published "Harry Packard's Japanese Treasures," *Architectural Digest* 49:8(Aug. 1992): 55–62. Joe Brotherton's article

"Packardo-San" appeared in *Orientations* 23:2(Feb. 1992): 76–77; Yoko Woodson is the author of "Nanga Paintings from the Harry G. C. Packard Collection in the Asian Art Museum of San Francisco," *Orientations* 24:4 (April 1993): 50–57.

2. Packard, ed. Sasaki, *Nihon bijutsu shūshūki*, 33.

3. The four books were all published in San Francisco at the Grabhorn Press: Edwin E. Grabhorn, *A Brief History of Japanese Color Prints and Their Designers* (1938); Judson D. Metzgar, *Adventures in Japanese Prints* (1943); Edwin E. Grabhorn, *Figure Prints of Old Japan: A Pictorial Pageant of Actors and Courtesans of the Eighteenth Century Reproduced from the Prints in the Collection of Marjorie & Edwin Grabhorn, with an introduction by Harold P. Stern* (1959); and Edwin E. Grabhorn, *Ukiyo-e: "The Floating World"* (1962).

4. Avery Brundage Personal Archives. The identities of all those with whom Brundage dealt are contained in his personal art-collecting archives, now housed at the Asian Art Museum of San Francisco. All quoted correspondence prior to 1985 is from these archives. Quoted correspondence and references after 1985 are from letters in the archives of the Asian Art Museum of San Francisco.

5. Packard, ed. Sasaki, *Nihon bijutsu shūshūki*, 34–36.

6. Ibid., 35.

7. Ibid.

8. Ibid., 50.

9. Personal conversation with Packard's daughter Katherine, July 18, 1993.

10. The objects Brundage refers to are a group of six pieces of ceramics that entered the AAM collection in 1960: five Chinese Imperial porcelains and one large Japanese jar. Packard's offering was no doubt a deliberate appeal to Brundage's fondness for Chinese ceramics.

11. The Packard Sōami is the only work by this artist in the AAM collection. The whereabouts of the painting Brundage found in Europe is not known; the archives contain no further records of it.

12. The institution receiving the collection agreed to promise to complete the sequences of art in the collection by acquisitions that would fill in the gaps; to name the collection after Packard; to actively improve its Oriental department; to establish in Japan a research program and library for use by students and scholars; and to employ Packard, giving him special responsibilities for acquisitions.

13. Packard's conditions included maintaining in perpetuity the collection's identity as the Packard collection; establishing in Tokyo a research center for students of Oriental art; providing sufficient funds for continuing acquisitions; and employing Packard as acquisitions curator.

14. The Metropolitan Center for Far Eastern Art Studies, the Packard Trust's grant-dispensing agency since 1977, has supported research of scholars and institutions throughout the world.

15. Packard first met Prof. Shūjirō Shimada in 1953 at Kyoto University. They became lifelong friends; Packard always considered Shimada his most important teacher in Japan. With Packard's approval, the credit line for the collection was revised to read: Gift and Purchase from the Harry G. C. Packard Collection Charitable Trust in honor of Dr. Shūjirō Shimada; The Avery Brundage Collection.

16. Funding came from a portion of the insurance money the museum collected for several objects damaged or destroyed during the October 17, 1989, earthquake. The Acquisition and Loan Committee voted to use these funds for the Packard collection.

EXQUISITE PURSUITS

JAPANESE RELIGIOUS AND SECULAR ART

IN THE HARRY G. C. PACKARD COLLECTION

The Asian Art Museum's Packard collection covers a span of time from the late twelfth to the nineteenth century. It consists of a group of twenty-seven objects about equally divided into religious (fourteen) and secular (thirteen) works of art, representing an extremely selective choice. The great artistic merit embodied in each work makes this small collection outstanding and very valuable. Neither historically comprehensive nor united by theme, media, or period, it expresses the interests and passion of Harry G. C. Packard, a collector and connoisseur of unique ability.

Harry Packard typically acquired individual works of art to study and enjoy. His wide-ranging interests in Japanese art eventually led to his becoming established as a renowned collector and dealer. Packard's assets in connoisseurship were an exceptionally keen eye for the exquisite, and a tireless persistence in pursuing the objects he wished to acquire. Some of the works he collected possess unquestionable artistic merit and are highly acclaimed in both the West and in Japan. Others are extremely rare objects, sole examples, or the best of their kind. Packard may also be credited with bringing to light some previously unknown works. Although his dedication and persistence sometimes created tensions, Packard proved a faithful, respectful friend to his scholar-colleagues, who assisted him generously with their expert knowledge of Japanese art.

The earlier, religious works in the Packard collection contain profound Buddhist and Shinto meaning; they reflect change and the forces of assimilation. The later, secular works draw their expression from their formal character or literary associations. To enhance an understanding of the Packard collection works of art, it will prove helpful to place them in the context of the historical circumstances of their origins.

RELIGIOUS ART

The many diverse countries of Asia, which extend from the continent to the Pacific islands, experienced unity under Buddhism and its culture. Characteristically adaptive, Buddhism accommodated the religious tradition and culture of each country it reached—Hinduism in India, Taoism in China, *bon* in Tibet, and Shinto in Japan. Japanese Buddhism and its culture is thus a variant of a pan-Asian tradition. When Japan's ancient

Shintoism and Buddhism interacted, each maintained its independent identity, creating a number of peculiar hybrid creeds; some still exist. Japanese art history inevitably reflects these religious conditions.

SHINTO

Shinto (the Way of God) curiously did not originally have a name for itself. The term was coined in response to the newly introduced Butsudō (the Way of Buddha) and appeared for the first time in a written source in A.D. 720.[1]

Vague and difficult to define, Shinto is based on a belief in *kami*, a polytheistic concept. Possessing neither a specific founder, scriptures, nor dogma, Shinto belief emerged in the culture of the prehistoric Yayoi period (ca. 250–200 B.C.) in the mountainous environment of Japan. The belief holds that every human being, place, and natural form (such as rocks, mountains, trees) possesses a quality that may be termed *kami*. One may feel the existence of *kami* in the awe or sense of supernatural power inherent in mist-covered mountains, ancient towering trees, or crashing waterfalls. *Kami*, conceived as positive deities, offer no judgment on people and their conduct, but respond benevolently to believers' sincere prayers. *Kami* would grant a person's most earnest wish, say, long life and prosperity in this world. With such positive beliefs, the Japanese did not yearn to escape the hardship and miseries of this world by looking forward to fulfillment in the next. The "this-worldly" outlook of Shinto is attributed to the unthreatening natural environment that provided people with relative safety and abundant food.

TUTELARY KAMI (UJIGAMI)

Among many *kami*, the most important are tutelary deities (*ujigami*), who were believed to protect clans. For example, Amaterasu Ōmikami (the Sun Goddess) is the *ujigami* of the Yamato clan, the ancestor of the present imperial lineage, and by extension, the protective deity of the nation and its people. The foremost shrine in Japan, the Ise Shrine, was dedicated to this *kami*. Similarly, the powerful Fujiwara family of the imperial court in the Heian period is associated with several Kasuga gods to whom the renowned Kasuga Shrine in Nara is dedicated.

Shinto rites include prayers to the *kami,* ceremonies, festivals, and ascetic discipline. In ancient times, ceremonies took place outdoors in natural settings of special serenity. Temporary buildings built at such a site to protect participants from bad weather were eventually conceived as permanent structures, or shrines. The establishment of shrines changed and clarified the concept of *kami;* although still considered to exist throughout nature, they now also resided in shrines, where people came to pray and hold festivals. The earliest, the Sumiyoshi Shrine, was built at the end of the sixth century and was followed by the Ise and Izumo shrines of the seventh century.[2]

INTRODUCTION OF BUDDHISM

Buddhism developed in the sixth century B.C. from the teaching of Siddhartha Gautama, a prince of a small kingdom in northern India, the present-day Nepal. In contrast to Shintoism's affirmation of life in this world, Buddhism regards human existence as painful. According to Gautama, suffering results from causes inherent in human nature; if these causes are extinguished, suffering will also cease. For example, some sufferings stem from illusions caused by blind desire—attachment to things, persons, or the world. A person can attain enlightenment by extinguishing such desires through spiritual discipline and meditation.

Buddhism eventually branched into two main forms. Around the third century B.C. the Hinayana (Lesser Vehicle) form, stressing spiritual enlightenment by individuals through meditation, was followed by conservatives. Between the first and third century A.D. the Mahayana (Greater Vehicle) form emerged among common people, who possessed fewer economic resources, and much less leisure to meditate, than the conservative upper classes. Mahayanists emphasized faith in Sakyamuni (Shaka), the historical Buddha, as well as in innumerable evolving Buddhas and bodhisattvas, Buddhas-to-be. The two forms of Buddhism spread throughout Asia via the trade routes. The Hinayana form took the southern route from Sri Lanka (formerly Ceylon), to Indonesia, Burma, and Thailand. The Mahayana form, or Northern Buddhism, took a route northward from Gandhara to Central Asia, China, Korea, and thence to Japan.

In A.D. 552, a thousand years after Gautama's death, the king of the Paekche kingdom of Korea sent a mission to Japan with gifts of an image of Buddha, several banners and umbrellas for rituals, and a number of volumes of sutras. The Japanese were dazzled by the shining golden image of Buddha and other fine objects, but powerful clans at the imperial court held a divided opinion of the new belief. While the Soga family supported it, the Mononobe and Nakatomi clans insisted on not disturbing Japan's *kami.* This conflict became a political struggle in which the Soga family prevailed. Buddhism was then freely accepted, initiating a golden age of Buddhism in Japan. The belief in Buddhism, now held in common with other Asian countries, provided the isolated Japanese islands with ample opportunities to reach out to the advanced material and intellectual cultures of the Asian continent, above all that of China.

SECTS

In the early period Japanese Mahayanism developed into six doctrinal schools. In addition, the Pure Land sect was implanted early in the sixth century but flourished only later. This sect centered around Amida Buddha (Amitaba), the most compassionate manifestation of the deity, who resides in the Western Paradise of the Pure Land. The belief that Amida would help those who had faith in him to attain salvation if they merely called his name powerfully appealed to the ruling class of Kyoto, who built elaborate halls to enshrine statues of Amida. After the eleventh century, several charismatic founders and reformers made the sect vastly popular among the commoners.

Faith in Amida as a savior created a special theme, the Amida *raigō* (Descent of Amida), which became a motif in religious art. In painting form Amida, surrounded by a group of bodhisattvas, descends to take a dying person's soul to his paradise. The two Packard Amida sculptures are examples of votive statues of Amida produced in the Kamakura period (Nos. 5, 6). The identity of Amida is at once revealed by the hand gesture *raigō-in* (gesture of descent). Along with belief in Amida's paradise, a contrasting popular concept of hell also developed. The Packard's *Enma* (No. 9) depicts the king of the world of the dead, who judges them by their deeds during life. Both feared and loved, Enma

was considered a benevolent being who guided people to right behavior.

New sects were also continually introduced from China. By the thirteenth century, all the major sects of Japanese Buddhism (which are still practiced today) had emerged. The most important were two esoteric sects, Tendai and Shingon, in the ninth century, and the Zen sect, in the thirteenth century. Some of the ancient sects merged into the Pure Land sect or into esoteric and Zen sects, and some died out.

In the seventh and eighth centuries during the Asuka and Nara periods, temple-building projects were carried out by the government and by aristocratic sponsors. A monastery where monks lived and studied often adjoined the temple. Temple interiors—main hall, lecture halls, and dining rooms—were lavishly furnished with sculptures and paintings. The demand for artworks was so great that the government operated its own Buddhist art workshops. The Bussho (Studio of Buddhism) provided sculptures, and the Eshi no Tsukasa (Painters' Office) furnished paintings for these government-supported temples. Painters produced works to decorate large temples as well as secular paintings. In the ninth century, however, the official workshop was reduced in scale, and painting workshops for local temples were operated privately. Some of the painters of the government workshop merged into the Edokoro (Court Painting Academy) of the Imperial Household.

Paintings and sculptures in the eighth century (Nara period) were executed in the idealized style that had originated in Gupta India and was later modified in China. In Japan, this idealized style was fully accepted by the government and aristocratic patrons; it established the classic canon for later periods. Images of Buddha and the bodhisattvas were conceived in beautiful human bodies; their supernatural power and limitless compassion were expressed in serene and unworldly facial expressions. Although this idealized style altered from time to time as Buddhist ideals changed, this classic canon continued to provide models into the nineteenth century.

By the seventh and eighth centuries, several sculptural media were used: bronze, wood, clay, and dry lacquer. After the ninth century, the Japanese especially favored wood, their indigenous material. The Packard

Phoenix (No. 4) illustrates the essence of Japanese wooden sculpture, simple and elegant. Made in a multiple-block technique perfected in the twelfth century, the bird is rounded, graceful, and complete in the simplest of forms. Wood was also a desirable material for religious and theatrical masks. With lacquer-finished thin walls, such masks were light and comfortable for the wearer. The *ōmai* mask (No. 8) was used for a religious procession in a temple or shrine.

The earliest extant sculptures were bronze, which continued to be a favored material; iron was employed much later, in the thirteenth century. As early as the eighth century a gigantic bronze image of Buddha was cast for Tōdaiji in Nara; as late as the thirteenth century, another colossal image of Buddha was cast in Kamakura. But because of expense and technical difficulty, bronze and other metal images were commonly small. The Packard standing *Amida* (No. 5), and seated *Shō-Kannon* (No. 7), both in bronze, and the standing *Amida* (No. 6) in iron are all of the Kamakura period, the glorious age and last period of creative Buddhist sculpture.

ESOTERIC BUDDHISM AND AMALGAMATION OF BUDDHISM AND SHINTOISM

From the tenth century on, the religious current in Japan was dominated by esoteric Buddhism, which involved elaborate ritual and came to exert profound influence on religious art. Introduced in the eighth century, esoteric Buddhism gained strength through the work of two remarkable priests: Saichō (767–822) of the Tendai sect, and Kūkai (774–835) of the Shingon sect.

After study in China, Saichō returned to Japan where, on Mount Hiei, he had built a hut for meditation even before his sojourn in China. He eventually built there an enormous Tendai religious center with 3000 temples. The Tendai doctrine (named for China's Mount Tiandai, site of numerous monasteries) is based on the Lotus Sutra. It considers that Sakyamuni, the historical Buddha, is a manifestation of the Buddha-nature possessed by all existence, and thus every person has the potential to be Buddha.

Kūkai, a priest, poet, and calligrapher who also studied in China, established a religious center at Mount Kōya in Kii province (now Wakayama prefecture). The Shingon (True Word) sect worshiped the

Mahavairocana (Dainichi) Buddha. In order to express its intricate religious ideas, esoteric Buddhism remarkably increased the number of deities and employed elaborate rituals using special implements. The deities' relative positions in the huge pantheon were shown in mandala, diagramlike paintings. Already imbued with Hindu symbolic forms, esoteric Buddhism also created fantastic deity forms, with multiple faces with different expressions, and numerous arms, each holding a symbolic attribute (thunderbolt, sword, arrow, lasso). It also created fierce deities, like Fudō (The Immovable), who guarded Buddhism by destroying evil with physical power and the magical energy of his attributes.

Monju, the Bodhisattva of Supreme Wisdom, already existing in eighth-century Japan,[3] was reintroduced in esoteric Buddhism as a deity with great power to grant comfort. The Packard *Monju,* with five knots of hair, symbolizes health and veneration (No. 1). The *Eleven-headed Kannon* (Ekadasamukha Avalokitesvara) (No. 2) has the ability and willingness to help all sufferers, symbolized in his multiple heads. His benevolence is expressed in the serene, beautiful face and feminine body adorned with jewelry. A large painting of *Gōzanze Myōō* (Trailokyavijaya) (No. 3), one of the Five Kings of Light, appears with multiple heads and arms that illustrate his potent ability to ward off evil.

Esoteric Buddhism stimulated assimilation of Shinto and Buddhism, creating hybrid creeds and a theory called *honji-suijaku.* It holds that *kami* are incarnations or manifestations (*suijaku*) of Buddhist deities (*honji*). Thus Buddhist deities are paired with *kami* of a particular shrine. Major Shinto shrines actively applied this theory to propagate their shrines, creating many Shinto mandala paintings that were similar to Buddhist mandala. The Packard *Kasuga Honjibutsu Mandala* (No. 12) illustrates the relationship of five Kasuga *kami* (*suijaku*) with their Buddhist *honji.* Another painting illustrating the *honji-suijaku* theory is *Appearance of Kasuga Myōjin* (No. 11). It depicts the story of the shrine's founding by Takemikazuchi no Mikoto, legendary ancestor of the Fujiwara family, who was identified as one of the five gods. The theory can also be expressed in a sculptural form; the Packard wooden *kakebotoke* with Shō-Kannon represents a Shinto god of a certain shrine in its Buddhist *honji* manifestation (No. 13). The iden-

tity of the Shinto god is not known because the pairing of Shinto and Buddhist deities is not fixed and may differ from shrine to shrine.

Amalgamation of Shinto and Buddhism created another hybrid creed, Shugendō, a cult devoted to ascetic practice and worship of mountains. The Packard *Zaō Gongen* (No. 14) is the tutelary *kami* of Mount Kimpu in the Yoshino Mountains near Nara, and a manifestation of the Buddhist deities Miroku (Buddha of the Future), Shaka, Amida, and the guardian of Shugendō.

SECULAR CULTURE AND ITS ARTS

Japanese religious art thrived into the twentieth century, as did Buddhism and Shintoism. It ceased, however, to be the major current, eventually yielding to secular art. This shift is attributed to the gradual secularization, over hundreds of years, of Japanese society. The two art tendencies overlapped and coexisted in equal importance until secular art shifted to the prominent position. The first sign of secularization appeared in the late eleventh to twelfth century, when Japanese society experienced its first major social and political upheaval through the wars of two rival military families, the Minamoto (also known as the Genji) and the Taira (also known as the Heike). Eventually prevailing, the Minamoto brought about the end of imperial rule and established the *bakufu* (military government) in Kamakura, in northeastern Japan.

The pessimism and hysteria of the disturbed Japanese society is reflected in the view that Japan was entering the end of Buddha's Law (*mappō*). The declining aristocrats created numerous sutra mounds, in which copies of sutras were buried to preserve Buddha's Law until the appearance of Miroku. They placed copies of sutras in containers like the Packard sutra case (No. 10) and buried them in remote mountains.

The aristocrats' prayers did not prevent the ascendancy of the military class, whose government prevailed under two more clans in the following 700 years: the Ashikaga of the Muromachi period and the Tokugawa of the Edo period. With their spartan spirit and military activities, these warriors viewed the world and themselves very differently from the aloof aristocrats. Although esoteric Buddhism was at its peak of prosperity,

its complex rituals were too removed from the realities of most people's lives, especially those of the warriors, who faced death daily. Its claim that intricate rituals were the only way to attain enlightenment was seriously questioned.

At the same time, the rise of the Zen (Chinese: Chan) sect in the thirteenth century had profound effects on Japanese secularization as well as on Buddhism itself. Zen had been founded in China by the Indian monk Bodhidharma (d. ca. 532), whose ideas assimilated indigenous Taoist thought. Formally introduced to Japan in the thirteenth century, Zen offered the Japanese an alternative to esoteric Buddhism. Zen teaching emphasizes self-reliance, in contrast to the belief in a passive salvation by faith held by other sects. It holds that individuals are able to assume responsibility for their own fates. Moreover, the Zen sect had many secular aspects. Zen monks also practiced calligraphy, painted, wrote poems, and performed the tea ceremony. These pursuits, secular as well as social, influenced various art forms from ink painting, landscape gardening, and the tea ceremony to Noh drama.

When the Ashikaga shogunate weakened, another period of war persisted for a hundred years (the Sengoku period, 1467–1568). Many temples in Kyoto were burned. In those difficult times, Buddhism lost its influential position in Japan's spiritual as well as cultural life. From the seventeenth century onward, the new Tokugawa shogunate meticulously organized and controlled all facets of Japanese society and cultural life. The Buddhist establishment fell under the shogunate's constant and minute scrutiny, from organization to income. When the shogunate adopted Confucianism as the national creed, Buddhism declined even more. The quality of Buddhist art likewise declined; although great quantities of Buddhist paintings and sculpture were produced into the nineteenth century, they were executed in the established canon and lacked notable innovation and originality. Artistic talent and energy were concentrated in secular art, which was sponsored by upper-class warriors, and later also by rich merchants and farmers.

YAMATO-E AND NARRATIVE SCROLLS

Along with the introduction of Buddhism and its art, Chinese secular art was also transmitted to Japan to sinosize imperial and aristocratic life. The art treasures in the Shōsōin, the Imperial Storehouse in the precinct of Tōdaiji, offer evidence of the highly sinophile art and culture of Japan in the eighth century; Chinese goods were imported, and Japanese works of art were produced in the style of Chinese prototypes.

Yamato-e, the colorful painting in native style and themes, developed in the middle of the Heian period. Japan had broken off diplomatic relations with China after the fall of the Tang dynasty (906), but continued to digest and assimilate earlier Chinese styles and techniques. One resulting and remarkable development in art is the narrative scroll, *emaki.* As Japanese literature developed popular themes in the narrative genre, painting adopted them. The earliest extant scroll, *The Tale of Genji* (first half of the 12th century), depicts popular scenes from the famous eleventh-century novel written by Murasaki Shikibu, a lady-in-waiting in the imperial court. The scroll unfolds scenes of aristocratic heroes and heroines engaged in romantic activities imbued with subtle melancholy. Another famous scroll, *The Tale of Heiji,* now divided and kept in the Tokyo National Museum, the Iwasaki family collection, and the Museum of Fine Arts, Boston, illustrates a military narrative with historical background, the interaction of warriors of the Minamoto and Taira clans.

The Japanese were captivated by narrative scrolls. From the late Heian to the Kamakura period (12th–14th century), a large number of *emaki* were produced, most in *yamato-e* style. As the Packard *Bugaku Dancers* scroll (No. 15) of 1408 unrolls from right to left, one dancer to the next, it reveals their colorful costumes and dynamic poses. Sometimes calligraphic works are written in the handscroll format. *Sixteen Poems from the Shin Kokin Wakashū* (New Collection of Ancient and Modern Poems), a group of late sixteenth-century classic love poems, are inscribed (No. 20) in scroll form by Hon'ami Kōetsu (1558–1637) in his fluid style on beautifully decorated papers by Tawaraya Sōtatsu (d. ca. 1640).

INK PAINTING

A revolutionary aesthetic change in secular art occurred with the discovery of the great expressive potential of ink monochrome. Ink painting, as developed and prac-

ticed by Chinese and Japanese Zen monks starting in the thirteenth century, employed a great range and quality of ink tones, lines, and brushstroke effects. First appreciated in Zen monasteries, ink-monochrome painting soon spread beyond these religious precincts. By abandoning a palette of immediate appeal and association, ink-monochrome works induce a profound contemplation in viewers. In an abstract manner, ink monochrome captures the essence of the complex phenomena of nature, man, and animals.

The abstract quality of ink monochrome is pushed to its limits in the technique known as *haboku* (splashed ink), a method used in landscape painting. Executed in a few brushstrokes and at great speed, *haboku* landscape aims at capturing the essence of nature. Based on the balance between a premeditated plan of composition and the accidental effects of execution, *haboku* is a painter's most difficult idiom. Executed by the disciplined Zen monk Soga Sōjō (fl. 1490–1512), the Packard *haboku* landscape is a rare example of its successful application (No. 16).

Secularization of Zen paintings was accelerated by painters of the Ami and Kano schools, who were not related to Zen sects. The successive members of the Ami school served the Ashikaga shogunate as advisers and curators for art objects imported from China, and the Kano school painters were the official painters for the same shogunate. The Kano school style combined the strong, dynamic quality of ink lines and the beauty of color. Gradually lustrous gold was added in the background. Kano school painters laid the foundation for spectacular screen paintings in the short and turbulent Momoyama period.

LARGE SCREEN PAINTING

Although the unification of Japan was carried forward by Oda Nobunaga (1534–82), Toyotomi Hideyoshi (1537–98) whose portrait is represented in the Packard collection (No. 17), and Tokugawa Ieyasu (1542–1616), the country remained restless until 1615, when Ieyasu established a new *bakufu* in Edo. Yet, this short, transitional phase was an important period of superb artistic accomplishment. A surplus of money from foreign trade, the spirit of ambition and enterprise shared by all sectors of society, the ascendance of the merchant class,

and above all the eagerness of powerful lords to display their authority through art objects all contributed to establishing secular art as the dominant current in Japanese culture.

Warlords built tall, fortified castles that also served as uncomfortable residences—rigid, uncompromising structures, with small windows and difficult access to the outdoors. Their owners decorated the interiors with folding screens and sliding doors (*fusuma*) painted with auspicious themes—strong trees, fierce, hawklike birds, and powerful leonine animals, all executed in a powerful style, often on a gold background.

These large paintings also served to impress rivals by a display of dazzling works of art as well as enlivening the dim interior spaces. The Packard *Monkeys Playing on Oak Branches* exemplifies a painting for a style of grandiose sliding door (No. 18). Although now they are mounted as a pair of hanging scrolls, the paintings' unusually large size, their theme of monkeys as the guardians of the horse, and traces on each indicating the removal of a round *hikite* (door-sliding aperture) support the speculation that they were originally mounted as *fusuma* in a large castle.

LATER SECULAR PAINTING

During its 250 years, the Tokugawa shogunate controlled nearly 300 regional lords who were, however, permitted to govern their own domains autonomously. This era of strong centralized power also marked Japan's almost total isolation from the rest of the world. Apprehensive of Christian missionary activities, the shogunate adopted a policy of national seclusion in 1639, prohibiting almost all except small contingents of Chinese and Dutch traders from entering Japan, and strictly forbidding Japanese to leave. This seclusion, whatever its negative aspects, helped create a period of peace and stability Japan had not experienced since the end of the Heian period in the twelfth century. The population, agriculture, and small industry production all increased. Merchants and well-to-do farmers prospered, accumulated fortunes, and educated themselves and their children. Under the Tokugawa shogunate, they were able to enjoy art as consumers and also as patrons. Production and distribution of secular art in the form of painting, calligraphy, ceramics, architecture, and landscape gar-

dens reached their highest level. The complex painting situation in this period, with many schools and individualists, various styles, and many themes, reflects these dynamic social conditions.

Two old schools supplied paintings to the court and to the samurai class. The Tosa school, which had begun to serve the imperial court in the Muromachi period, retained an artistic monopoly in the Court Painting Academy of the imperial household. Its painters, working in the traditional *yamato-e* style, produced works on classical themes alluding to literature and painted in beautiful colors. The Kano school, which established a strong tie with the samurai class in the late Muromachi period, continued to serve it. Both schools prospered, retaining their prestige and their patronage monopolies. But their adherence to tradition prevented them from exploring new ideas or making innovations; they soon stagnated.

Competent painters who had trained in the Tosa and Kano schools but were not fortunate enough to obtain employment in the Court Painting Academy, or in shogunal or other local lords' painting offices, made livings as artisan-painters catering to merchants in large towns. Less restricted by their clients, these town-painters (*machi eshi*) could be more innovative in interpreting traditions. The Packard collection's unusual pair of screens, *The Tale of Genji and an Aviary*, shows such an innovative composition (No. 19). On the right-hand screen, scenes of the famous tale appear as vignettes isolated by gold clouds, in a traditional manner. On the left screen, a large aviary scene is illustrated in a unified composition. The innovative spirit revealed in the work is interesting and strikingly fresh.

New schools, the Rimpa, Nanga, and Maruyama, supplied paintings to the rising commoner classes. Rimpa (lit. Rin school), later named for the brilliant eighteenth-century painter Kōrin, was a loosely formed school of painters in Kyoto. Founded in the late sixteenth to early seventeenth century by Hon'ami Kōetsu and Tawaraya Sōtatsu, the Rimpa school was based on the *yamato-e* tradition but added a new and bold design sensibility. Rimpa school paintings are characterized by grace, charm, striking compositions, and superb execution. Small as it is, *Morning Glories* by Ogata Kōrin (1658–1716) in the Packard collection shows all the character-

istics of the eighteenth-century Rimpa school (No. 21). Watanabe Shikō (1683–1755) played an important role in transmitting the school's style to the painters in the second half of the eighteenth century (No. 22).

Two entirely new schools, the Nanga and Maruyama, were both inspired by foreign styles. The Nanga school (lit. southern painting) derived its name and stylistic sources from the Chinese Southern school of painting, practiced by the Chinese literati since the Tang dynasty. Until the early eighteenth century, Japanese painters, even those who had gone to China, were unaware of this important tradition. Although forbidden to leave the country, Japanese Nanga painters, most of whom were literati, nonetheless acquired through imported books a surprising level of knowledge about China. Japanese scholars and poets identified themselves as literati and viewed their Chinese counterparts as their models. They began to teach themselves theories and techniques of Chinese literati painting through reading books and studying painting manuals (*gafu*). They painted in the Southern school style, which had been affirmed by late Ming scholar painter Dong Qichang as the "right lineage."

The Japanese Nanga school attained its highest expression in the work of two great artists, Ike no Taiga (1723–76), and Yosa Buson (1716–83), who achieved a literati painting style unique to Japan. Buson's *West Lake in Spring* (No. 23) goes far beyond imitation of a Chinese style. Its sensitive brushwork and lyricism and highly organized composition make it an exemplary work of the Japanese Nanga painter.

Denied foreign travel, bookish Japanese literati longed to visit Chinese sites famous for their beauty and literary associations; the famous places in China became ideal, even utopian, to them. The *Yueyang Tower* screen by Aoki Shukuya (d. 1802) (No. 24) depicts such a place. It is an adaptation of a tiny album-leaf painting by a second-class Suzhou painter to the format of a large-scale Japanese screen.

Most Nanga painters were well educated in Confucianism and were competent poets. With their uncompromising personalities and free spirits, Nanga painters often declined to serve the shogun and local lords, making their livings producing paintings and works of calligraphy for educated merchants and

farmers. The Packard screens by Noro Kaiseki (1747–1828) and Okada Hankō (1782–1846) are Japanese Nanga paintings with literary associations in China, produced for intellectual patrons with whom they shared artistic ideals (Nos. 25, 26). Sometimes these patrons simply needed beautiful, functional works to decorate their homes. The *Screen of Flowers and Birds* by Yamamoto Baiitsu (1783–1856) is a pleasant screen with auspicious themes favored by Nanga patrons (No. 27).

While Nanga painting was maturing in Kyoto, an entirely new painting based on Western graphic art appeared in the same city. Western influence was sparely filtered through the Dutch traders and their commercial products. Some Japanese grasped the principles of Western pictorial art, such as perspective and shading, through illustrations in imported books. Maruyama Ōkyo (1733–95) combined these new stylistic elements with Chinese and Japanese traditions to create an original painting style. Light-hearted, more realistic, and easy to understand, Ōkyo's painting was pervasively popular among newly rich merchants and farmers. Ōkyo eventually formed the Maruyama school.

With the opening to foreign countries in 1867, and the restoration of imperial rule by the Meiji emperor, Japan underwent drastic changes that destroyed the economic and social foundation which had produced and supported art. The system of educating artists in the traditional atelier and apprentice system gave way to modern art schools. Students now could travel to foreign countries and could see original art works in their primary locations. They enthusiastically studied realistic Western oil painting. The nation's painting was categorized into two major schools, Western and Japanese, into which all the past Japanese traditions were synthesized. Sculptors, for the first time free from the need to produce religious art, were able to make works purely for appreciation. Yet the wealth of past accomplishments continued to profoundly affect artists in all categories, whether or not they were consciously aware of it.

The masterworks in the Packard collection exemplify works that contributed to the solid tradition from which Japanese artists of the late nineteenth to the twentieth century launched confidently on an entirely new kind of artistic production.

Yoko Woodson
Associate Curator of Japanese Art
The Asian Art Museum of San Francisco

Notes

1. *Nihongi,* quoted in *Kōdansha Encyclopedia of Japan,* v. 7 (Tokyo: Kōdansha, 1983).

2. Hiroshi Mizuo, *Nihon bijutsushi: Yō to bi no zōkei* (Tokyo: Chikuma Shobō, 1982), 178.

3. The earliest Japanese Monju (dated 711) is in clay and is located in Hōryuji. See Ryūken Sawa and Takashi Hamada, eds., *Bosatsu, Myōō,* Mikkyō bijutsu taikan, v. 3 (Tokyo: Asahi Shinbunsha, 1984), 212.

THE PACKARD COLLECTION

CHRONOLOGY

JŌMON PERIOD	CA. 12,000–250 B.C.
YAYOI PERIOD	CA. 250 B.C.–A.D. 250
KOFUN PERIOD	250–552
ASUKA PERIOD	552–710
NARA PERIOD	710–794
HEIAN PERIOD	794–1185
KAMAKURA PERIOD	1185–1333
NAMBOKUCHŌ PERIOD	1333–1392
MUROMACHI PERIOD	1392–1573
MOMOYAMA PERIOD	1573–1615
EDO PERIOD	1615–1868
MEIJI PERIOD	1868–1912
TAISHŌ PERIOD	1912–1926
SHŌWA PERIOD	1926–1989

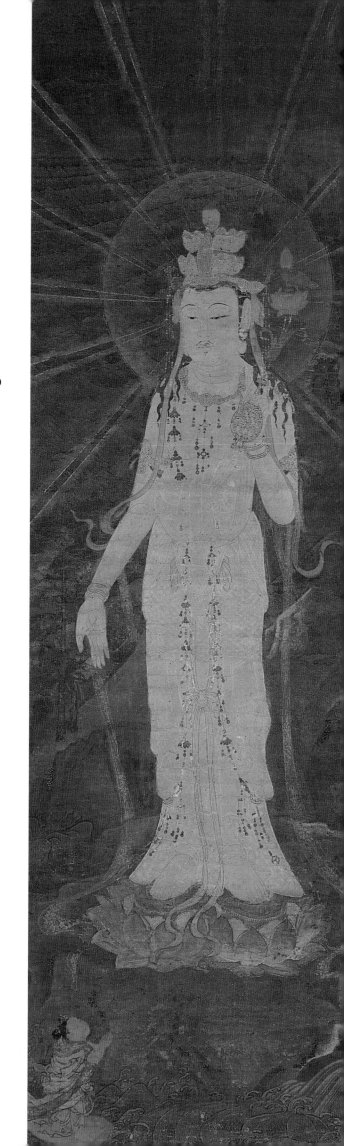

RELIGIOUS ART

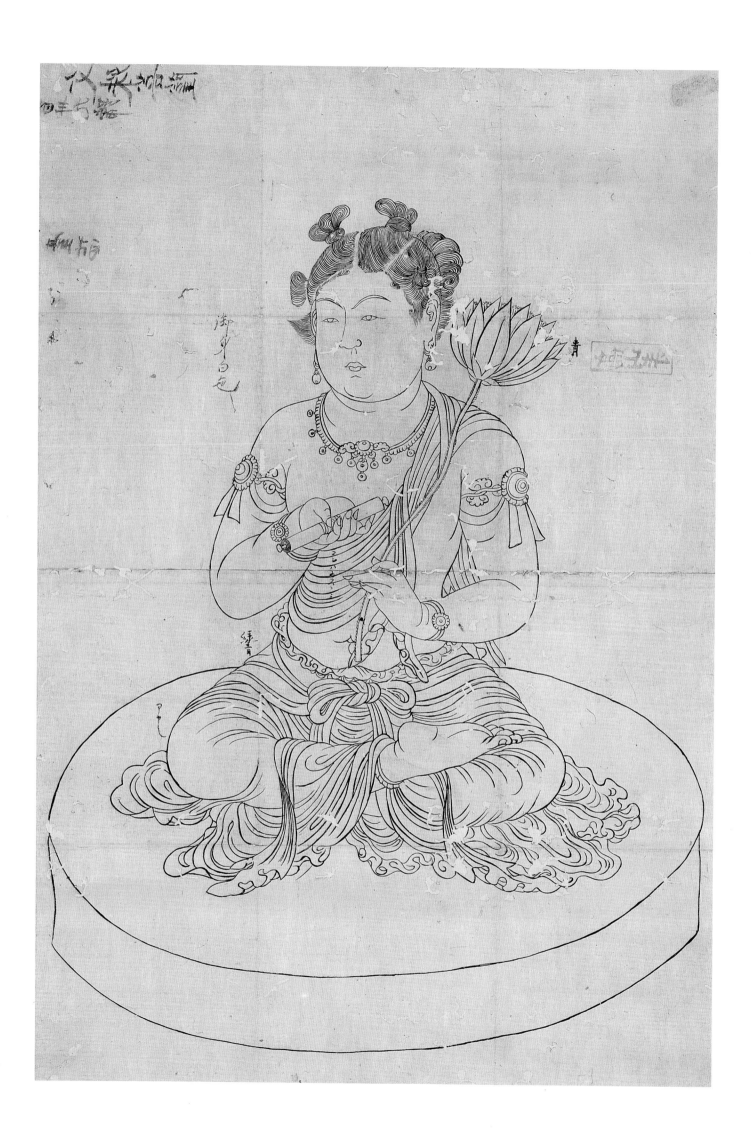

1. MONJU (MANJUSRI)

Iconographic sketch
Hanging scroll, ink on paper
Heian period, late 12th century
H: 58.5 cm W: 40.5 cm
1991.55

This iconographic sketch (*zuzō*) depicts Monju (Manjusri), the bodhisattva of the wisdom of Mahayana Buddhism, who is also the left attendant of Shaka Buddha. The youthful-looking Monju, seated in the lotus position on a simple, circular dais, holds the scroll of wisdom in his right hand and the stalk of a lotus blossom in his left. He wears elaborate jewelry: earrings, necklace, armbands, and bracelets. The garment covers his lower body in graceful folds, and a scarf, tied at the left chest, crosses his torso from left shoulder to right waist.

Monju is drawn in fluid, thin ink lines. Color instructions are inscribed on both sides of the figure. A character at the lotus edge reads "blue"; on Monju's right, characters read "the holy body in white"; and on the side, characters near the upper and lower parts of the garment read "blue-green" and "red" respectively. On the verso of the paper are a seal, *Kōzanji* (an esoteric temple of the Shingon sect), and the inscriptions "Number 139, Monju Bosatsu," and "Dai 24." They seem to be the inventory record of the temple.[1] Although now mounted as a hanging scroll, the drawing was originally a sheet or scroll section, and was kept in reference storage stacked with other similar drawings.

Zuzō originated in the late Heian period (12th century), when many drawings of the numerous deities of

Seal, *Kōzanji*, on verso of scroll.

esoteric Buddhism proliferated. Each occupied a hierarchic position in the Buddhist pantheon. *Zuzō* production reached its peak in the late twelfth to the first half of the thirteenth century.[2] These drawings served as valuable references, providing an accurate description of each deity complete with iconographic features and emblems, to help student-monks and artists. *Zuzō* production decreased drastically when, in the thirteenth century, esoteric Buddhism was overshadowed by the increasingly popular Zen sect that had been introduced from China in the late twelfth century.

The cult of Monju was popular in China; its major center was the sanctuary atop Mount Wutai (Five-Pedestal Mountain) in Shanxi province. The belief that Monju would grant wisdom, responding immediately to a devotee's sincere prayers, had a powerful appeal. In Japan the cult became even more popular, producing multiple variations of Monju. In esoteric Buddhism, these variations were symbolized by the number of his hair knots: Monju with one knot of hair (Ikkei Monju) represents fortune and wealth; Monju with five knots (Gokei Monju) stands for health and veneration; Monju with six knots (Rokkei Monju) symbolizes absolved sin and subdued passions; Monju with eight knots (Hakkei Monju) represents health and subdued passions. Gokei Monju was the most popular of these variations. The *Kongōchō Manjusri giki* (Kongōchō Iconographic Rules of Monju) of the eighth century describes him: "His body is golden in color. On his head are five knots of hair; his right hand holds the sword of wisdom, and his left hand holds a lotus flower that supports a sutra book."[3] Sometimes, however, Monju holds the scroll of wisdom in his right hand, a change which seems to have derived from a different iconographic source. The twelfth-century *Besson zakki* (Casual Description of Different Deities), for example, describes Monju holding the scroll and a lotus stem.[4] The earliest extant iconographic drawing, *Kōsō zuzō* (Iconographic Drawing of Great Monks), dated 1163, shows a Monju very similar to the Packard one, except for the face, which turns to the left, and the frown of his eyebrows: the five knots of hair, scroll of wisdom, jewelry, and the dais are the same (Fig. 1).[5]

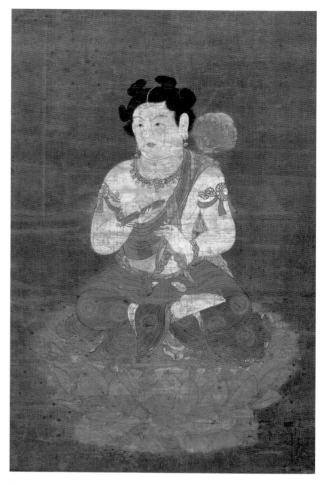

Fig. 1. *Monju* from *Kōsō zuzō;* iconographic drawing, detail; handscroll, ink on paper; Heian period, dated 1163; Nin'naji, Kyoto. Photo: Shibundō, Tokyo.

Still another Monju, a beautiful painting of Gokei Monju in the Museum of Fine Arts, Boston, looks identical to this one, even down to minute details: the five knots, jewelry, and garments. Exceptions are the face and lotus throne (Fig. 2). In the Boston painting, Monju's intelligence and brightness are expressed in his Kamakura-period face with wide-open eyes, which makes him look as if he were searching for eternal truth, and with curved, accentuated eyebrows that reveal his wisdom. The Packard *Monju,* on the other hand, is rounded and gentler, like an infant.

The coloring of the Boston Monju matches the instructions in the Packard *Monju.*[6] The Monju in the *zuzō* scroll of 1163, the Packard *Monju,* and Boston Monju seem to show stylistic progress from the Heian to the Kamakura period, the Packard *Monju* being in the middle. They all derive from the same prototype.

Fig. 2. *Monju;* framed, ink and color on silk; Kamakura period, 13th century; Fenollosa-Weld Collection; courtesy of the Museum of Fine Arts, Boston.

Provenance: Kōzanji

Published: Yoshi Shirahata, "Chigo Monju Bosatsu zuzō," *Kobijutsu* 44 (April 1974): 105.

Notes

1. This "Dai" means Kōzanji Hōkodai and indicates that this *zuzō* was stored at Hōkodai. See Shirahata, "Chigo Monju Bosatsu zuzō," 111–12.

2. Ibid., 112.

3. Quoted in *Bukkyō kaiga,* Zaigai Nihon no shihō, v. 1 (Tokyo: Mainichi Shinbunsha, 1970), 143.

4. Quoted in Shirahata, "Chigo Monju Bosatsu zuzō," 112.

5. The illustration in the *zuzō* scroll is reproduced in Takashi Hamada, *Zuzō,* Nihon no bijutsu, v. 55 (Tokyo: Shibundō, 1970), pl. 7.

6. *Bukkyō kaiga,* pl. 63.

2. ELEVEN-HEADED KANNON (EKADASAMUKHA-AVALOKITESVARA)

Hanging scroll, ink and colors on silk
Late Kamakura period, 14th century
H: 153.5 cm W: 45.0 cm
1991.56

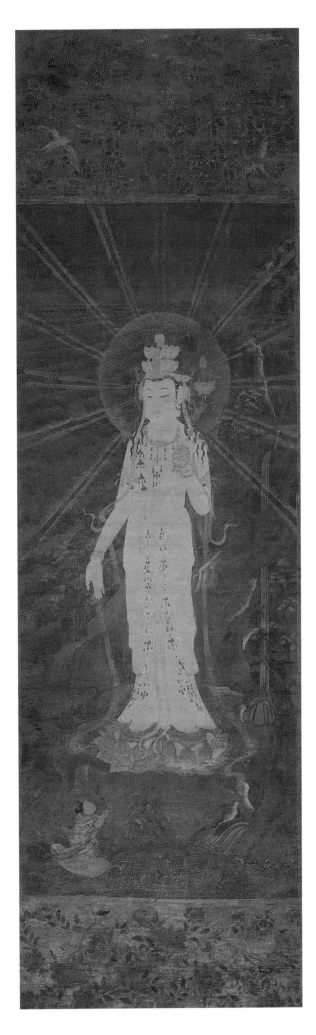

This strikingly serene painting represents in three-quarter view, an Eleven-headed Kannon standing on the lotus throne in Potalaka (Jpn. Fudarakusan). This island-mountain paradise is indicated by ocean waves, rugged mountains, trees, and waterfalls. The kannon's right arm extends slightly forward, forming a *varada* (gift-giving) gesture, an invitation to worshipers, while his left arm, bent to his chest, holds a vase of lotus, one of Avalokitesvara's standard emblems. Behind his head is a halo from which thirteen double-line rays radiate to all directions. Below his right foot is the boy-pilgrim Sudhana (Zenzai Dōji) floating on a lotus-petal boat in a posture of worship as he listens to the kannon preaching. The deity's handsome face and body and the serene landscape give the painting a profound sense of spirituality. The kannon's thin and elegant body, too delicate to hold the heavy crown of eleven heads, is balanced by his arms and the flying scarves around him. The imagery is a superb example of a votive painting of the fourteenth century, created for a cult of the Eleven-headed Kannon.

The ridges with lighter shading around the outside suggest high mountainous areas. Behind the kannon, a high waterfall flows down to the ocean in the foreground. While the palette is limited, the color scheme is well calculated for a decorative but subdued and refined effect. The white body of the kannon shines against the dark colors of the mountains. The lotus petals of the kannon's throne and the mountains are green; Sudhana's lotus-petal boat and the autumn maple leaves are pink. It is an idealized scene of the kind of natural beauty found in many regions in Japan.

The gently curved body, the beautiful face painted with gold-toned white, and the long jewelry that hangs over both thighs to the feet are very much in the style of Buddhist paintings of the Kamakura period. The cliffs shaded in gold help to date the painting specifically to the latter half of this period. In addition to its exquisite painting techniques, the votive painting demonstrates the most delicate and finest craftsmanship in abundantly used *kirikane*. *Kirikane* is a technique employing thinly cut gold foil, which is affixed to the painting's surface for decorative effect. The kannon's garments are adorned with gold foil in varying patterns of nets, flowers, and leaves over the gold-white garment. Even the petals of the lotus throne are lined with *kirikane*.

The Eleven-headed Kannon, a manifestation of the bodhisattva who assists mankind, is the first among six kannon that appeared in the Nara period, and the first esoteric image that developed in Japan.[1] *Jūichimen Kanzeon jinshukyō* (Sutra of Divine Formula of Eleven-headed Kannon), one of the esoteric sutras upon which its worship is based, was translated from Sanskrit into Chinese in the second half of the sixth century. It states that the great bodhisattva makes a spiritual "eleven-headed" vow for the sake of all sentient beings: to relieve them of illness, misfortune, suffering, and worries; to free them of evil intentions; to turn their thoughts toward good karma (deed or deeds)—for a total of eleven deeds of grace.[2] Because of his limitless compassion toward all living beings, the Eleven-headed Kannon came to be the most popular of the six.[3]

Jūichimen jinshu shinkyō giso (Commentaries on the True Words Sutra of the Divine Formula of the Eleven-headed Kannon) describes the iconographical aspects of the eleven heads and their arrangement: The three in the center were shown as being compassionate to the devotee of good karma; the three on the left had angry expressions intended to ward off evil, to save believers; the three on the right had white tusks emerging from their upper jaws, to assist people with pure karma to find the Buddhist way; a single face in the back was shown with a violent laugh, to reform evildoers; and the Buddha face on the top of the head was to preach the dharma to those capable of following the doctrines of Mahayana.[4] In the center of the crown that holds these heads is a small standing Buddha (*kebutsu*). The arrangement described is in a single tier, but often the heads are arranged in three tiers.

Early in the Nara period, sculptures of Eleven-headed Kannon were abundant, and many are extant. But in painting the theme is relatively scarce. With its beauty and permeating spiritual quality, this Packard *Eleven-headed Kannon* is a splendid example of this type of votive painting.

In the twelfth century, during the late Heian period, the cult of the Eleven-headed Kannon was connected to worship of the Potalaka Paradise, and became even more popular. The *Shin Kegonkyō* (695–99; a Chinese re-editing of the *Avatamsaka-sutra*) describes the paradise as

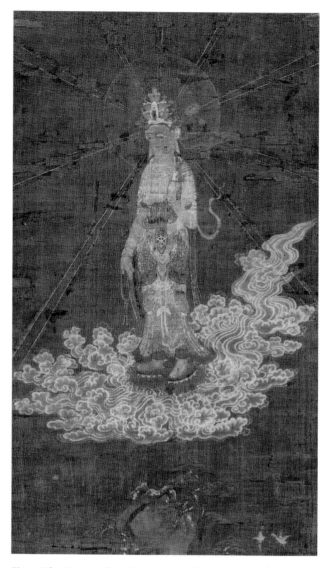

Fig. 3. *The Descent of the Eleven-headed Kannon;* framed, ink and color on silk; Kamakura period, 13th century; Fenollosa-Weld Collection; courtesy of the Museum of Fine Arts, Boston.

a glorious place in the mountains, where the kannon preaches. The sutra instructs: "You go and find him. . . . Walk till you reach the mountain and look for him here and there. You look into the cave on the west cliff, and there you find springs flowing, trees growing abundantly, fragrant flowers covering the ground."[5] This paradise, originally said to be located in the sea south of India, is the paradise of Avalokitesvara, and comparable to the Western Paradise of the Amida Buddha. By the early thirteenth century, however, the cult of Mount Potalaka developed independently of the Eleven-headed Kannon. The priest Jōkei (1155–1213), of Kaijūji Temple, eagerly preached that if anyone was too sinful to ascend, after his death, to Amida's Paradise, he should first try to ascend to the Potalaka Paradise.[6] By the first part of the Kamakura period, in Nara the cult of Potalaka was

paired with one of the popular kannon, such as the Eleven-headed Kannon, Fukū Kenjaku Kannon, and Shō-Kannon.

In the effort to increase their following, priests of major temples, proclaiming their holy nature, identified them as Mount Potalaka.[7] They chose a popular deity for their temple to be the resident Lord of Paradise. People thronged to those temples that paired Mount Potalaka with a popular kannon. Nachi Falls in Kumano and Shidoji in Takamatsu are renowned temples that became powerful as the result of an association with Potalaka. The Packard *Eleven-headed Kannon* was created in this religious and cultural context.

With its gently curved figure and three-quarter posture, though in a slightly different iconographical context, the Packard *Kannon* is comparable to *The Descent of the Eleven-headed Kannon* at the Museum of Fine Arts, Boston and in Tōdaiji,[8] which are both represented in the fashion of Amida Buddha's descent, flying on clouds from the Potalaka Paradise, which is depicted above the kannon.

The silk mountings immediately above and below the Packard painting are seamless, proving that they were part of it from the beginning. The upper mounting is painted with birds flying among flowers; the lower part depicts flowers. The design is superbly executed with the dark colors of flowers outlined in *kirikane*, which sets them off from the dark-green background.

Provenance: Marquis Kaoru Inoue (1835–1915); see Shinjō Mochizuki, "Jūichimen Kannon gazō," *Kobijutsu* 46(1974): 108; "Koga Jūichimen Kannon-zu," *Kokka* 253(1911).

Published: "Koga Jūichimen Kannon-zu"; Mochizuki, "Jūichimen Kannon gazō," 107–108; *Kannon Bosatsu* (Nara: Nara National Museum, 1977), pl. 31 (exhibited and published); *Shinto no bijutsu*, Nihon bijutsu zenshū, v. 11 (Tokyo: Gakushū Kenkyūsha, 1979), pl. 159; *Kannon Bosatsu* (Nara: Nara National Museum, 1981).

Notes

1. Painting on wall no. 12 at the Kondō of Horyūji; see Takashi Hamada, *Mikkyō Kannonzō seiritsu to tenkai*, Mikkyō bijutsu taikan, v. 2 (Tokyo: Asahi Shinbunsha, 1984), 198; see also Ryūken Sawa, *Mikkyō bijutsu ron* (Tokyo: Benridō, 1969).

2. John Rosenfield, *Journey of the Three Jewels; Japanese Buddhist Paintings from Western Collections* (New York: Asia House Gallery in association with John Weatherhill, 1979), 10l.

3. Hamada, *Mikkyō Kannonzō*, 194.

4. The passage is quoted in *Bukkyō daijiten*, v. 2, 2208; translated by Rosenfield, *Journey of the Three Jewels*, 101.

5. *Bukkyō daijiten*, v. 5, 4429.

6. Yutaka Hirata, *Kokka* 919(1968): 11.

7. Yoko Kawaguchi, "Jūichimen kannon raigō zuyō; Nanto ni okeru tenkai to sono haikei," *Bijutsusji kenkyū* 20(1983): 90.

8. *Kannon Bosatsu* (Kyoto: Nara National Museum, Dōhōsha, 1982), 32.

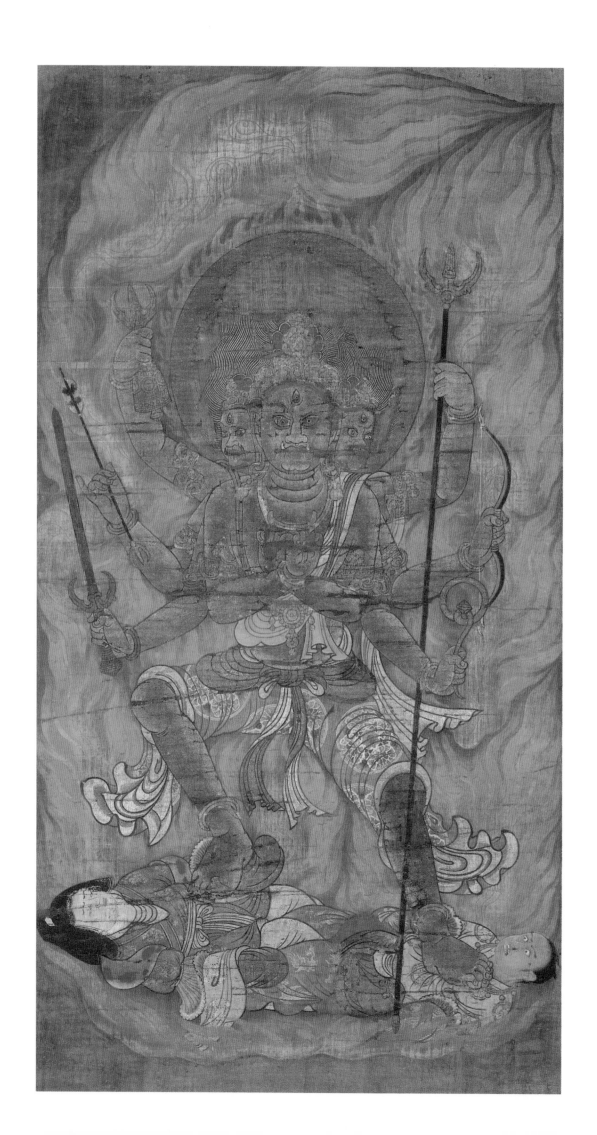

3. GŌZANZE MYŌŌ (TRAILOKYAVIJAYA)

Hanging scroll, ink and colors on silk
Kamakura period, 13th century
H: 107.3 cm W: 57.0 cm
1991.57

Gōzanze Myōō, one of the group of Five Myōō or Five Deva (Great Kings of Light or Great Kings of Wisdom), is a subduer of the Three Worlds (Earth, Air, and Heaven). The ferocious deity stands in an aggressive posture. His left foot treads the head of Daijizaiten (Mahesvara, the Hindu god presiding over the human world of desires), and his right steps on the breast of his consort, Uma. Behind the deity, a great halo of flame trails from the upper right corner of the picture.

Deriving its iconographic model from a Hindu deity, Gōzanze has three additional faces, each with three eyes, and eight arms. The frontal face expresses fury, the right one anger, and the left one disgust. The face at the back expresses heroism, although it is not shown in paintings. With his two front (main) hands, he makes, on his breast, the mudra of anger (niwa-in) by placing the two hands back to back, interlocking the little fingers, and pointing index fingers up, while clenching the others. His three hands at the right (beginning at the top) hold a vajra (thunderbolt), an arrow, and a sword; the hands at the left carry a lasso, a bow, and a snake.

Worshiped as a group, the Five Myōō are powerful deities in esoteric Buddhism. Like guardians in exoteric Buddhism (kenkyō), the Five Myōō are depicted as ferocious beings with violent gestures. However, they are fundamentally different from exoteric guardians in some aspects. While guardians in exoteric Buddhism are simply guardians of Buddha and his law, the Myōō, as Great Kings of Wisdom, embody the teaching of Buddha and actively engage in guiding sufferers through Buddha's wrath against evil. In the hierarchy of esoteric deities, the Five Myōō rank just below Buddha and bodhisattvas.[1]

The Five Myōō also protect national peace and security, each guarding one of the cardinal directions. Fudō Myōō, the Immovable One (Acalanatha) guards the center; Gōzanze Myōō (Trailokyavijaya) guards the east; Daiitoku Myōō (Yamantaka), on the buffalo, has six arms and six legs and guards the west; Kongōyasha Myōō (Vajrayaksa), with distinctive double-tiered eyes, guards the north; and Gundari Myōō (Kundali), identified by coiling snakes that symbolize human vices such as prejudice, guards the south. Fudō is the most important, but Gōzanze's power equals that of Fudō.

Unlike ordinary guardians depicted as mature males with developed muscles, the Five Myōō are usually depicted with childlike bodies, multiple, three-eyed faces, and multiple arms, suggesting their origin in Indian folk-demons. The mystical Hindu feeling is even more heightened by the dark-blue body color, the skulls they wear as ornaments, and the snakes they hold or which twine around their bodies. A wide range of emblems illustrates their multiple missions and abilities. They have threatening facial expressions, biting the lower lips and exposing the two fangs that grow upward from the lower jaw.

When displayed as a group of sculptures on an altar, they are positioned with Fudō Myōō in the center and the other four Myōō at their respective cardinal points. In paintings, a set of five hanging scrolls is displayed in one row, with Fudō in the center and Gōzanze at his left.

Worship of the Five Myōō was introduced in the ninth century, and their veneration became a popular cult in the Heian period.[2] They quickly gained the trust

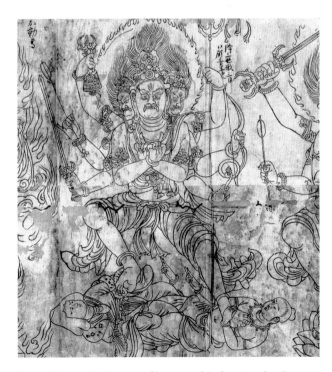

Fig. 4. *Gōzanze Myōō*; copy of iconographic drawing, detail; *Nin'nogyō-hō honzonzō*; handscroll, ink on paper; Kamakura period, dated 1250; Daigoji, Kyoto. Photo: Shibundō, Tokyo.

of the people disillusioned with the Buddhist sects in Nara that flourished, but were nonetheless corrupted by being closely involved in government politics and power struggles among the sects and temples. Japanese society considered that the Five Myōō, with their eccentric mythic feeling and appearance, might replace the deities of Nara Buddhism and save them from suffering and their country from corruption.

Several Gōzanze paintings from the Heian and early Kamakura periods are extant: at Kyōō Gokokuji, dated 1127;[3] at Daigoji, datable in the Heian period;[4] and at Kannonji, Shiga, datable in the Kamakura period.[5] These Gōzanze paintings share certain characteristics. The kings are depicted in three-quarter view and more violent postures, with the main head turned sideways, multiple arms spread wide, and the right foot on Uma, who is trying to rise in resistance. The Packard king is frontal; three pairs of arms, extended to the air but in good balance, are confined in the rectangular frame. The closest comparable example is the Gōzanze in the *zuzō* (iconographical drawing) of the Five Myōō, which was copied in 1250 by Kōgen from the original of the Nin'nogyō Sutra that had been brought to Japan by Kūkai (774–835) from China (Fig. 4).[6] The *Gōzanze* in the Packard collection and in this *zuzō* are identical— the frontality of the main face, which is rounded, the vital but well-balanced posture, prone bodies of Shiva and Uma, and the minute details of the clothes. Clearly the Packard *Gōzanze* was based on this *zuzō* or on some work that had been based on it. Since there is no iconographic or stylistic deviation in the Packard *Gōzanze*, its date around 1250 is warranted.

The painting is quite damaged from exposure to incense smoke over many years, especially around the Myōō's hair and halo. Gōzanze Myōō paintings are rare, especially in the West, making this one an invaluable example.

Provenance unknown.

Unpublished.

Notes

1. Genzō Nakano, *Bosatsu, Myōō*, Mikkyō bijutsu taikan, v. 3 (Tokyo: Asahi Shinbunsha, 1984), 222.

2. Ibid.

3. *Heian Butsuga* (Nara: Nara National Museum, 1986), pl. 57. The Five Myōō were based on the wall painting in the Endō, Nin'naji. This is the oldest example of the Five Myōō.

4. *Jūyō bunkazai*, v. 7, *Kaiga* 1 (Tokyo: Mainichi Shinbunsha, 1973), pl. 193.

5. Ibid., pl. 194.

6. Nakano, *Bosatsu, Myōō*, 227.

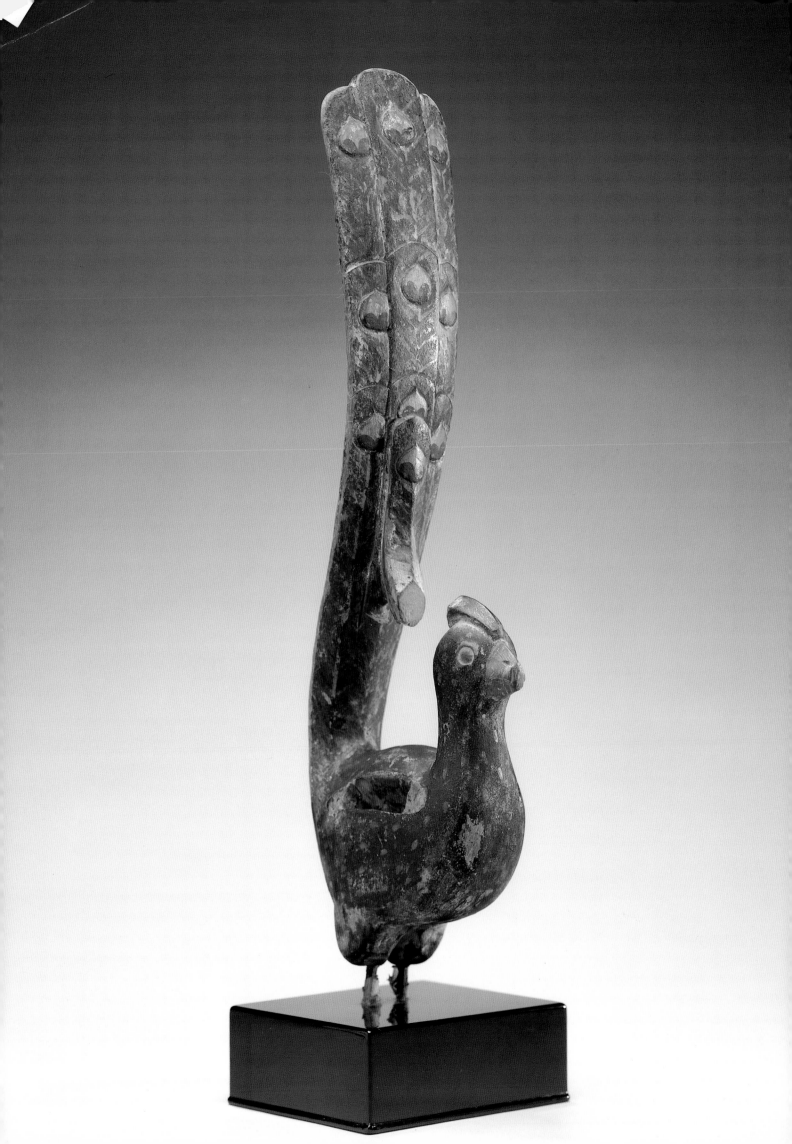

4. PHOENIX

Wood, painted with pigments
Heian period, late 11th–early 12th century
H (figure): 40.5 cm W: 8.0 cm
1991.71

This standing figure of a phoenix is carved of *kaya* (miscanthus) wood and painted in several pigments. The tailfeathers are arranged in three vertical, parallel lines and stand almost perpendicular to the body. A small part of the bird's crest, once connected to the upright tailfeathers, is now missing, leaving a small gap. Two rectangular cutouts, one on each side of the body, once held wings. Metal posts are a recent replacement of the missing feet. The bird is now mounted on a decorated wooden stand.

The painting is well preserved. The entire bird was coated with white clay[1] and painted green and white on the feathers, and orange-red on the beak. The tailfeather pattern is more that of a peacock than a phoenix. The round eyes are carved in a double circle and then painted.

From early periods, fantastic birds and animals—the phoenix and dragon as well as sacred plants, like the lotus—adorned architectural elements of Buddhist structures, such as canopies and the pedestals of statues. The canopy over the Shaka Triad in the seventh-century Golden Hall of Hōryūji is adorned with wooden phoenixes around its base (*fukikoshi*).[2] The Packard bird, it is speculated, may have graced such a structure, most likely a canopy over a platform (*shumidan*) for images. The long tail may have been a design feature resulting from the need for vertical elements to adorn the canopy.[3]

The Japanese have long been master carvers of wood, the native material abundant in all parts of Japan. Ornaments that accompanied Buddhist statues were traditionally carved by the same master sculptors who did the statues themselves. This bird exhibits superlative carving technique, suggesting carving by a major sculptor.

Although this phoenix was meant to be a part of a structure, it is fully rounded and can be appreciated as an independent work. It is comparable to the well-known group of animal sculptures in Kōzanji: a divine horse, a deer, and a puppy, all independent sculptures of wood. The puppy is carved of multiple blocks, coated with white clay, painted, and inlaid with crystal eyes. Its round body is simple and unpretentious, but masterful carving gives it a wonderful animation.[4] Likewise, the simple and unself-conscious carving makes this phoenix especially attractive.

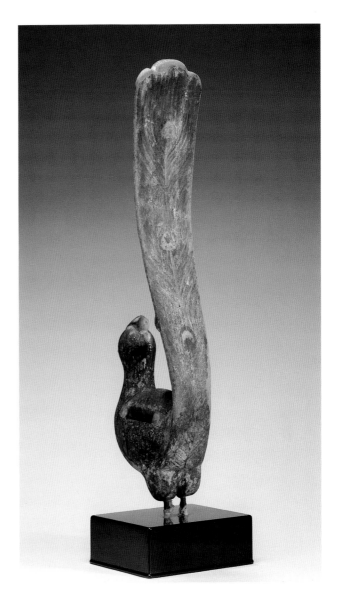

Provenance unknown.

Unpublished.

Notes

1. *Hakudo:* also known as *tōdo* (pottery clay); the main ingredient is calcium silicate, used as a white pigment. For wall painting and wooden sculptures, white clay replaced *gofun* (powdered oyster shell).

2. Nara Rokudaiji Taikan Kankōkai, *Nara rokudaiji*, v. 2 (Tokyo: Iwanami Shoten, 1968), pl. 92.

3. Consultation with Mr. Masashi Mitsumori, the chief curator of Nara National Museum.

4. Takeshi Kuno, "Mokuzō koinu zō," *Kobijutsu* 97(1991); Kyōtarō Nishikawa, "Kōzanji no dōbutsu chōkoku," *Kokka* 1089(1985).

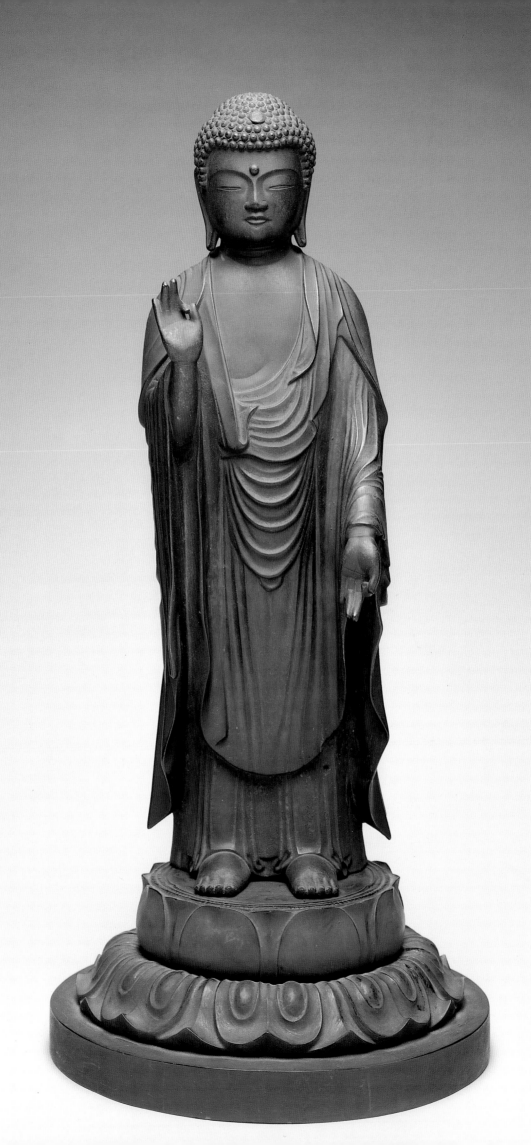

5 . STANDING AMIDA
(AMITABHA-BUDDHA, AMITAYUS-BUDDHA)

Bronze with traces of gilt
Kamakura period, early 14th century
H: 49.0 cm W: 16.5 cm
1991.74

The figure represents Amida Buddha, Lord of the Western Paradise (the Pure Land of a previous existence). Wearing a monk's robe over both shoulders, he stands with right hand raised, palm outward, and left hand pendent. Together the hands form the hand-gesture *ani-in* (consolation mudra), with thumb touching the end of the inflected index finger. In combination, the gestures of the two hands are called *raigō-in* (mudra of descent), which signifies the descent of Amida to earth to greet souls of the devotees as they depart for the Pure Land paradise. Amida sculptures with *raigō-in* emerged during the late Heian period, becoming even more prominent in the Kamakura period.

The term *amida* combines the meanings of the names Amitabha (Buddha of Infinite Light) and Amitayus (Buddha of Infinite Life). Thus Amida Buddha is believed to embody the boundless light of salvation and to possess everlasting life himself as well as the ability to offer it to everybody who believes in him. He is believed to preside in the Pure Land in the Western Region. Focusing on the compassionate aspect of the Amida Buddha, the faith developed and became known as the Pure Land teaching. The Pure Land sutras, which describe the sights of Amida's paradise and the ways of attaining rebirth into it, were believed to have been established during the Kushan dynasty (ca. 1st century B.C.–4th century A.D.) in India. The sutras and the Amida cult, transmitted from India through Tibet and China, were established in Japan by the middle of the seventh century. It became one of the most popular sects in Japan, as shown by a wall painting in the Golden Hall of Hōryūji (ca. 711), illustrating Amida in the Western Paradise.[1] The sect is still vital in the twentieth century.

During the 1300 years of its development, the teaching of the Amida sect altered its religious attitudes to meet the needs of the people. The arts of the sect also changed in symbols, forms, and expressions. The reformed cult taught that to be saved by Amida, all one needed was faith in him. The teaching of this compassionate Amida powerfully appealed to the commoners, who were too busy with the demands of daily life to spend long hours in ritual observance or in study of sutras. The early Amida resided in his paradise, meditated, and preached, but the later Amida in the twelfth century was a deity of action; he would immediately

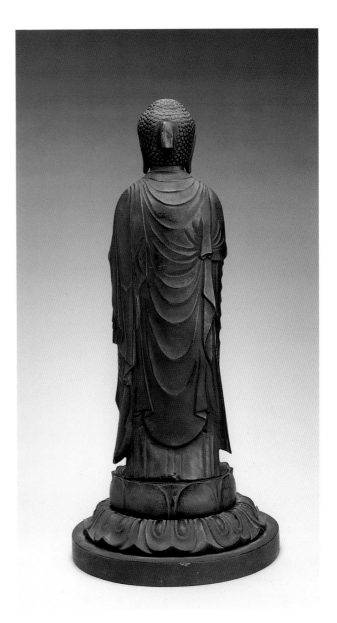

respond to pleas of sufferers. Paintings and sculptures of the time inevitably reflected this aspect of Amida, producing the characteristic *raigō* theme.

In paintings, Amida is depicted as he descends to earth surrounded by a group of bodhisattvas on flying clouds. In this form, the mudra of Amida changed from *jō-in* (meditation mudra) with hands held in front of the navel with the fingers of both hands together, to the *raigō-in*, each with the thumb and the first finger joined to form a circle. In sculptural form, Amida is attended

Fig. 5. *Standing Amida;* bronze; late Kamakura period, dated 1314; Kinonezawa Buraku, Chiba. Photo: Nara National Museum.

by the Kannon Bosatsu (Avalokitesvara) and Seishi Bosatsu (Mahasthamaprapta). Often, however, Amida is represented alone and with the *raigō-in* gesture, which is sufficient for worshipers to identify him.

Statues of Amida with earlier mudra, such as the *seppō-in* (preaching mudra), a sign of the turning Wheel of Buddhist Law with both hands before the chest, each with the thumb joined to another finger, and *jō-in* (*dhyana;* meditation mudra) were still produced, but the *raigō-in* Amida became increasingly popular, especially as a votive image, as the cult taught that immediate salvation could be attained by merely calling Amida's name.

Gilt bronze statuary was first in vogue in the seventh and eighth centuries, but was replaced by wood during the religious reforms of the ninth century, when many temples were built on mountainsides to avoid close contact with certain corrupt Buddhist sects that

were closely involved in politics. The improved sculpture construction technique of assembling figures in multiple blocks of wood further increased popularity of this material, because it made possible mass production, larger statues, and prevented the cracks that occurred in large single pieces of wood. Bronze statuary was revived, however, in the renaissance of Nara sculpture at the beginning of the thirteenth century in the Kamakura period. A substantial number of bronze images of high quality survive from this period. The Packard *Amida* is cast in one piece, including hands and feet. It demonstrates superlative craftsmanship in the crisp folds of the garment and clear-cut rendition of the facial features. In the back of the head a projection with a hole appears to have once held a circular halo.

This Amida's wide, rounded face with the borders of the hair slightly curving down in the center, the flat *usnisa* (bump of wisdom) on his head, square shoulders, sleeves hanging heavily at the sides, and the folds of the monk's robe (*kesa*) on the left shoulder are all characteristic of the late Kamakura period. The Amida figure is closely comparable in style, proportion, and details to an Amida figure of Kinonezawa Buraku, Chiba, dated 1314 (Fig. 5).[2] This slightly smaller statue was also made on a wooden model with similar split molds. The arrangements of its robe in front and back are nearly identical to the Packard *Amida,* which may date from around the same time.

Provenance unknown.

Published: *Amidabutsu chōzō* (Nara: Nara National Museum, 1974), pl. 115; *Heian Kamakura no kondōbutsu* (Nara: Nara National Museum, 1976), pl. 75.

Notes

1. *Hōryūji*, Genshoku Nihon no bijutsu, v. 2 (Tokyo: Shōgakukan, 1966), pl. 19.

2. *Heian Kamakura no kondōbutsu*, fig. 74.

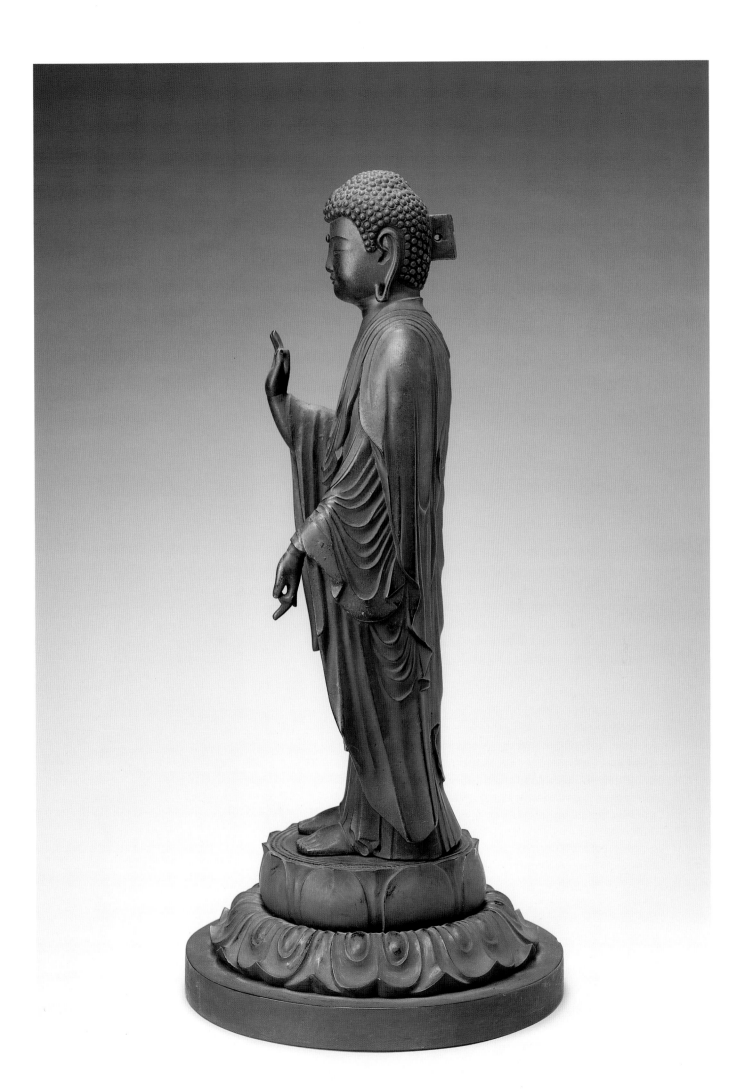

6. STANDING AMIDA (AMITABHA-BUDDHA, AMITAYUS-BUDDHA)

Cast iron
Kamakura period, 13th century
H: 30.5 cm W: 11.3 cm
1991.76

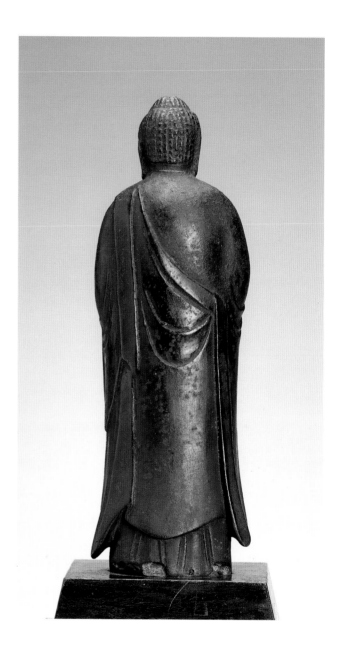

This standing Amida is a rare example of cast-iron statuary in Japan, where wood and bronze figures are far more abundant.[1] The Amida stands facing frontally, with his head inclined slightly forward. His hands are held in the *raigō-in* mudra, the sign of his descent to the earth to welcome the departed souls of the faithful to the Pure Land. His face is serene, with half-closed eyes. He wears a thin, clinging robe over rounded shoulders. The folds of the robe, the facial features, and the curls of the hair are soft and smooth, as if they were worn down from years of being rubbed. It is also possible that the figure was once burned in a fire.

The *raigō-in* mudra, most commonly held by Amida, emerged in the late Heian period and became even more popular in the Kamakura period when the Amida cult had penetrated deeper than ever into people's religious life. This mudra is believed to be a composite of two signs, the *abhaya mudra* (absence of fear) of the right hand, and the *vara mudra* (fulfilling the vow) of the downward-pointing left hand. The popularity of the Amida cult was enhanced by the revival of the Pure Land sect by two priests, Honen (1133–1212), founder of the Jōdo sect, and Shinran (1173–1262), founder of Jōdo Shin sect, as well as by others who preached that rebirth in the Pure Land could be attained through the mere act of calling the name of Amida (*nenbutsu*).[2]

Iron casting was a difficult technique; the material requires a high melting-point, and the cast surface is rough and hard, making difficult the finishing, polishing, and chiseling of the fine details. Despite these disadvantages, cast-iron statues, popular in the Song dynasty, also began to be produced in Japan in the twelfth to the thirteenth centuries and were favored throughout the medieval period. One may ask why iron was used when bronze, an easier material to work with, was available, and bronze-casting techniques had been well established since the seventh century. It is speculated that the newly rising samurai class recognized symbolic qualities of iron in its strength and its enduring nature in fire. This theory may be substantiated by the fact that most iron statues are found in the northeast (Kantō) region, the center of samurai activities in the Kamakura period.[3] The rough or rustic appearance of iron statues might have appealed to the simple but heroic samurai spirit.

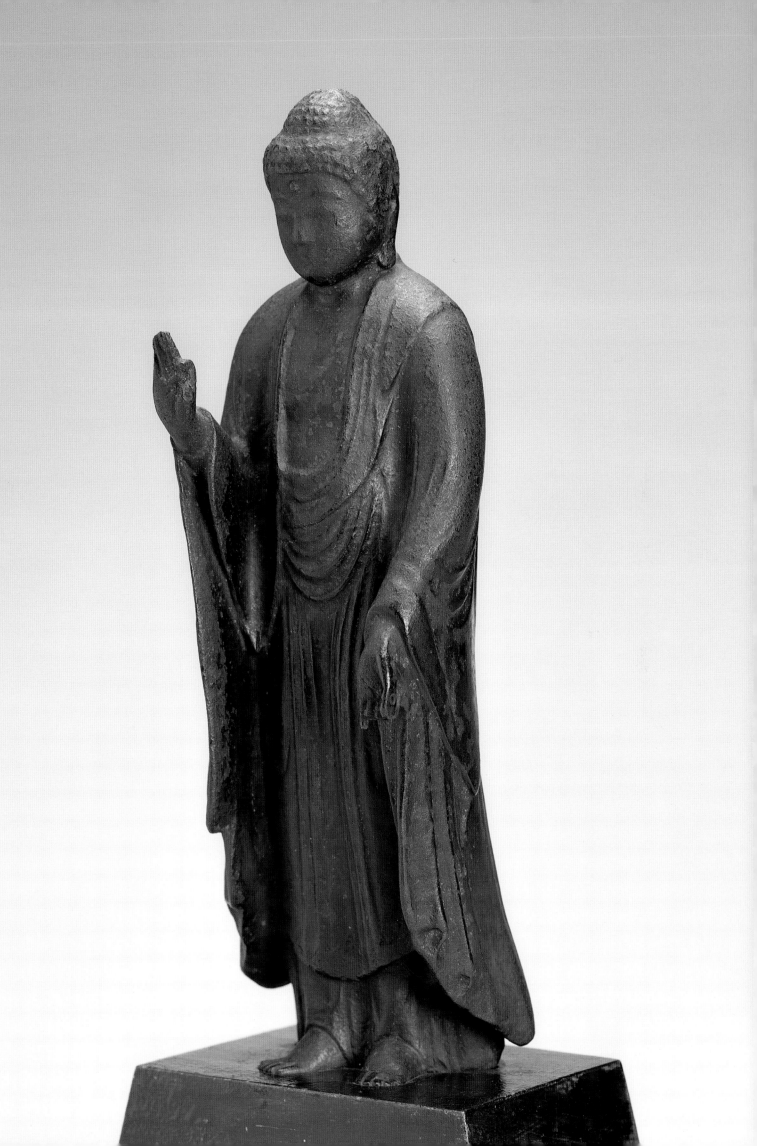

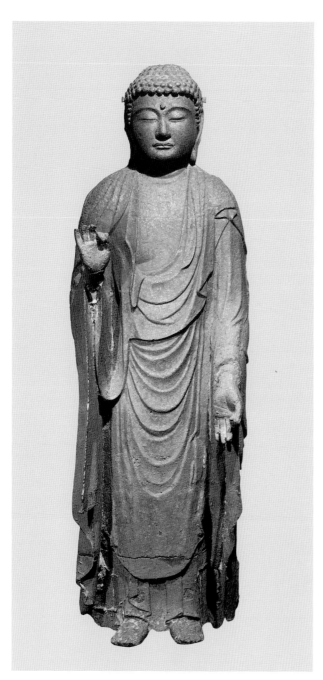

This statue was cast by a technique similar to that used for bronze casting, which developed in the twelfth century and after. It is an improved lost-wax method like that used in earlier periods. A clay or wood model is made, over which a clay mold is formed. This outer mold is then cut into front and rear halves and removed from the model. The two halves are then rejoined, and an inner core is fixed in the mold's void by means of pins, to establish the wall thickness of the casting. The front and rear halves for this Amida were probably made on a wood model. The figure's thin wall is evidence of technical improvement over earlier works.

This Amida is very closely comparable to the Amida statue of the Amida-dō, Suifumura, Ibaraki prefecture, dated 1264 (Fig. 6).[4] A date in the 1260s or 1270s for the Packard *Amida* statue seems warranted.

Provenance unknown.

Published: *Amidabutsu chōzō* (Nara: Nara National Museum, 1974), pl. 117; Akio Saitō, *Tetsubutsu*, Nihon no bijutsu, no. 252 (Tokyo: Shibundō, 1987), pl. 90.

Notes

1. Kyōtarō Nishikawa and Emily Sano, *The Great Age of Japanese Buddhist Sculpture, A.D. 600–1300* (Fort Worth, Texas: Kimbell Art Museum, 1982), 114.

2. Consultation with Mr. Masashi Mitsumori, the chief curator of Nara National Museum.

3. Saitō, *Tetsubutsu*, 68, 80.

4. Ibid., pl. 9.

Fig. 6. *Standing Amida;* iron; Kamakura period, dated 1264; Amida-dō, Suifumura, Chiba. Photo: Shibundō, Tokyo.

7. SEATED SHŌ-KANNON

Bronze
Kamakura period, late 13th century
H: 50.8 cm W: 38.0 cm
1991.77

Shō-Kannon (Avalokitesvara), one of the six manifes-
tations of kannon (saviors of those who suffer in this
world), is believed to save hungry ghosts. Shō-Kannon
is the kannon's regular form, as distinguished from one
of his other manifestations, such as the Eleven-headed
Kannon and the Thousand-armed Kannon.

The Packard *Shō-Kannon* is represented in a lotus
position, the formal posture of Buddhist deities, with
legs folded so that the right foot rests, sole upward,
against the left thigh, and the left foot rests similarly
against the right thigh.

His garment covers both shoulders and the entire
lower body except for the feet. The scarf drapes from
the left shoulder to the right waist and hip, while the
skirt forms a beautiful fold pattern over the legs. Follow-
ing the Song dynasty Chinese prototype, the straight
hair is parted in the center and arranged in a high knot.
The right hand is raised in front of the chest with the
palm outward in the consolation gesture, *ani-in;* the
index finger and the thumb touch to form a circle, the
hand gesture most frequently seen in Amida Buddha.
The left hand originally held a lotus, Shō-Kannon's
usual emblem, which is now missing. His contempla-
tive look with half-closed, downcast eyes gives the deity
a deep spirituality. The lower part of the throne below
the lotus is missing.

The first Buddhist statues that the ancient Japa-
nese ever saw were of bronze. In 552, a Korean king of
Paekche sent a mission to propagate the religion with
elaborate gifts, which included a "shining golden statue."
The enthusiastic pursuit of bronze image making brought
about the golden age of Buddhist statues in the seventh
and eighth centuries. The developed technique made it
possible to cast the famous gigantic image of Buddha at
Tōdaiji.[1]

The Packard *Shō-Kannon* shows a superlative tech-
nique: the face and body are well rounded, and the
garment folds are raised in a crisp pattern. The bodhi-
sattva's body consists of several separately cast pieces:
the head, both arms, hands, and the lower body. The
lotus pedestal, also cast separately, bore inscriptions
extensively covering all but a few petals. Unfortunately
they have been intentionally scraped off; they could
have provided the date of execution, the name of the
temple, and the donors. Several remaining Chinese

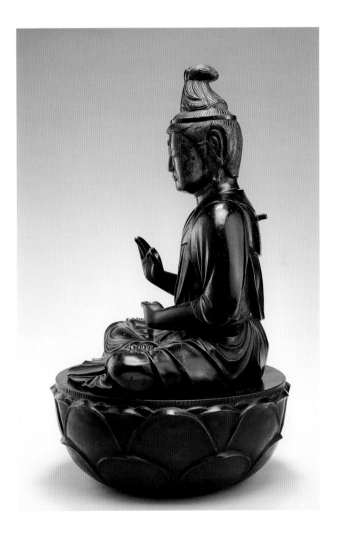

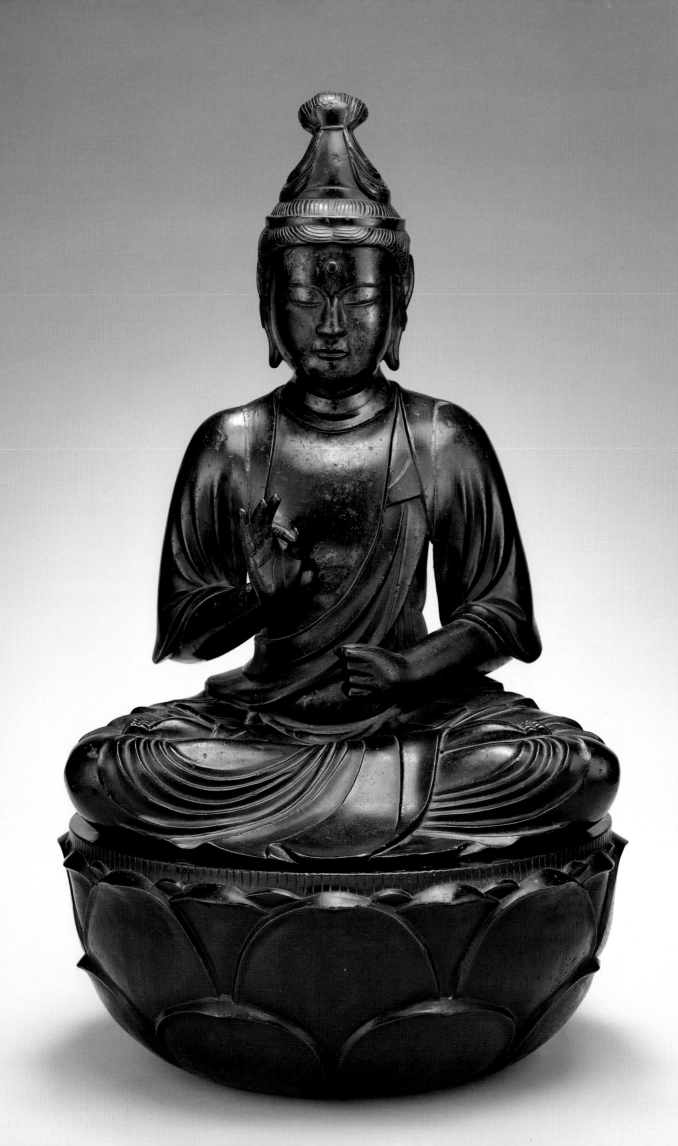

states. The Saichi Shō-Kannon is preserved perfectly, with an ornate mandorla, body and head nimbuses, inscriptions, and the lotus throne with its lower part intact.

The Packard bodhisattva is somewhat simpler in detail, but the basic style is similar to that of the Saichi Shō-Kannon in the natural modeling of the body, the thin, clinging garments, and the serene facial expression. A date around the 1270s for the Packard *Shō-Kannon* is warranted.

Provenance unknown.

Published: *Heian Kamakura no kondōbutsu* (Nara: Nara National Museum, 1976), pl. 80.

Notes

1. The Buddha had been extensively restored and does not retain its original beauty, but the scale alone shows the advanced technique of bronze casting in the eighth century. See Seiroku Noma, *The Arts of Japan,* v. 1 (Tokyo: Kodansha, 1966), pl. 64.

2. William Sturgis Bigelow Collection, 11.11447, the Museum of Fine Arts, Boston; see *Chōkoku,* Zaigai Nihon no shihō, v. 8 (Tokyo: Mainichi Shinbunsha, 1980), pl. 49.

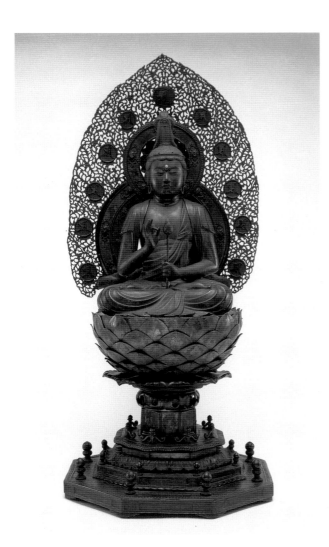

Fig. 7. *Shō-Kannon;* Saichi; bronze; Kamakura period, dated 1269; William Sturgis Bigelow Collection; courtesy of the Museum of Fine Arts, Boston.

characters are legible as *shin'nyo* (devoted woman) and *shinshi* (devoted man), common titles for deceased men and women in the Pure Land sect; the statue might have been donated by a large group of devotees of a temple of this sect.

A close cognate for this bodhisattva is the Shō-Kannon at the Museum of Fine Arts, Boston (Fig. 7).[2] It was made by the sculptor Saichi for the Matsuo-dera (now called Kongōrinji), Hatagawa, Shiga prefecture. An inscription dates it to 1269. The height of the Packard and Saichi statues is 50.8 cm and 46 cm respectively; they are of medium size for Kamakura period bronze

8. ŌMAI MASK (RELIGIOUS MASK)

Wood
Muromachi period, 15th–16th century
H: 22.2 cm W: 18.0 cm
1991.72

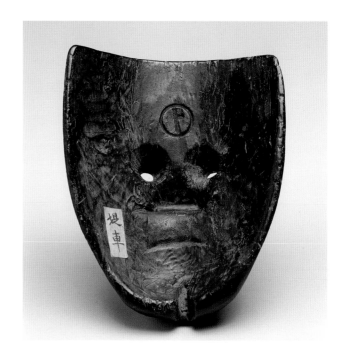

The identification of this long-nosed being of fierce demeanor is rather difficult to determine, but he is considered an *ōmai*[1] or a king of the *tengu* (long-nosed goblin), a popular Japanese mythological character who appeared at the head of *gyōdō*, a type of religious procession. Comparable to the *chidō* (road-keeper) in *gigaku* (masked court dance), who leads a pageant of actors, the *ōmai* also leads the procession.

The *ōmai* mask is carved from a single block of Japanese cypress (*hinoki*). The mask has thin walls and is very light in weight. A pair of thick eyebrows flies upward and spreads to the temples above wide-open, bulging eyes. The nostrils of the prominent nose flare between high cheekbones. Thin, compressed, down-turned lips make the expression tense and fierce. At the upper edge of the forehead is a horizontal border marking the attachment point of a cloth to cover the wearer's head. Small holes around the chin indicate that a beard made of strands of textile was once implanted.

On the back of the mask at the left side, an inscription of two characters, framed in a rectangular area, reads *teisha*. On the back of the forehead is another mark branded with the single *katakana* syllable *to* in a circle. These marks may identify either the woodcarver's workshop or the store name of the owner of the work. The mask was originally lacquer-coated and painted, but this surface is no longer intact.

Gyōdō, a Buddhist religious ceremony begun in the eighth century and held once a year, involves a procession in which masked figures carry a major holy image that otherwise remained concealed throughout the year in its temple or shrine. Originally a Buddhist ceremony, *gyōdō* observance was adopted by Shinto shrines. In the twentieth century it is still performed in both temples and shrines; the faithful, wearing masks of Amida Buddha, bodhisattvas, and other deities parade around the precincts of the temple or shrine.

Japanese culture, theater, and art history are enriched by many types of masks used for dances, dramas, and rituals. Masks began to be used as early as the seventh century. They are categorized according to use in five major types: *gigaku* masks, *bugaku* masks, *gyōdō* masks, and Noh and Kyōgen masks.

Gigaku masks, the oldest of the mask types, originated in the prototypes of China and other places on the Asiatic continent in the seventh century, arriving in Japan along with Buddhist culture. In *gigaku*, a silent dance-drama of comical nature, which was performed outdoors accompanied by music, masked characters appeared in sequences that led the audience to bursts of laughter. The wooden masks, large and heavy, covered the wearer's entire head. The deeply carved facial features and their expressions were exaggerated. *Gigaku* drama flourished for two centuries until it was surpassed by the newly arrived *bugaku* (dance-music), which was more complex in form and content. Performed with or without masks, *bugaku* exhibits more refined dances accompanied by more complex music, played by a large and varied orchestra. The masks often display fantastic forms in a variety of characters. They often had movable jaws, eyes, and noses.

Both *gigaku* and *bugaku* were exclusively performed in the imperial court and in prestigious temples and shrines. Although *gigaku* was extinguished in the seventeenth century, *bugaku* is still performed in the imperial court and at the Kasuga Shrine, displaying the grandiose ceremony of the ancient dance.

Gyōdō involves a procession of Amida and the guardians known as the Eight Bushū, the Twenty-eight Bushū, and the Twelve Deva Kings, all led by an *ōmai*. Unlike *gigaku* masks, *bugaku* and *gyōdō* masks were held on the face only with strings fastened around the ears. The lack of a back-piece required that the masks be light in order to stay in position on the face. The mask's size became smaller, and its wooden walls became thin. The eyes are open to allow the wearers to see, but the mouths in most cases are closed. In general the *gyōdō* masks display solemnity and little animation.

Although crude in carving and restrained in expression, *gyōdō* masks contributed to the popularization of masked plays, and were instrumental to the emergence

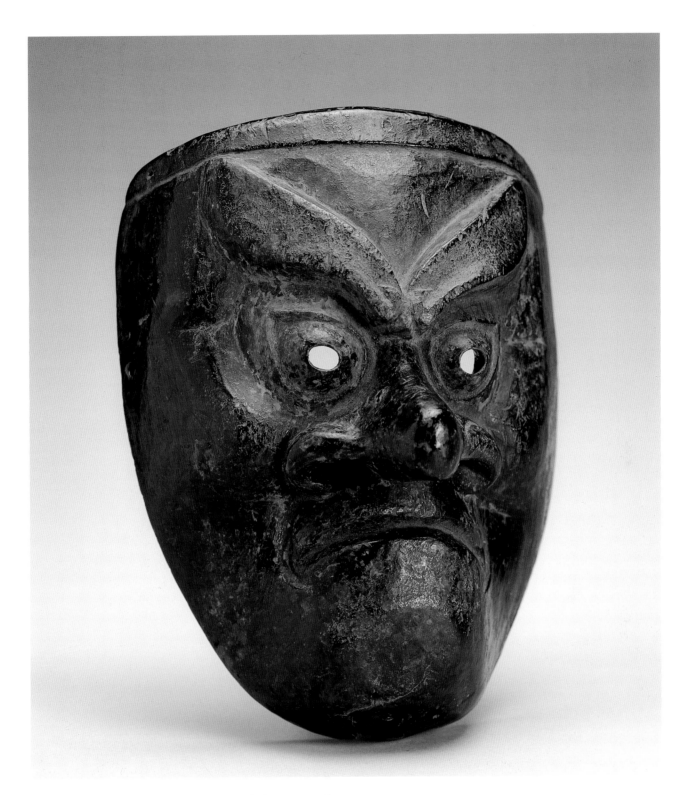

and development of solemn, masked Noh drama. *Gyōdō* rituals were performed in shrines and temples in large cities as well as remote areas; the masks were kept in the provincial temples and shrines. The simplicity and ingenuous charm of the Packard mask reveal that it was produced in the folk tradition.

Gyōdō as well as *bugaku* masks were carved by sculptors as a sideline. On the other hand, Noh and Kyōgen masks were produced by specialist mask carvers (*men'uchi*) who also understood deeply the art of Noh and the drama itself.

Provenance unknown.

Published: Saburōsuke Tanabe, *Gyōdōmen to shishigashira*, Nihon no bijutsu, no. 185 (Tokyo: Shibundō, 1981), pl. 117.

Notes

1. Tanabe, *Gyōdōmen to shishigashira*, pl. 117.

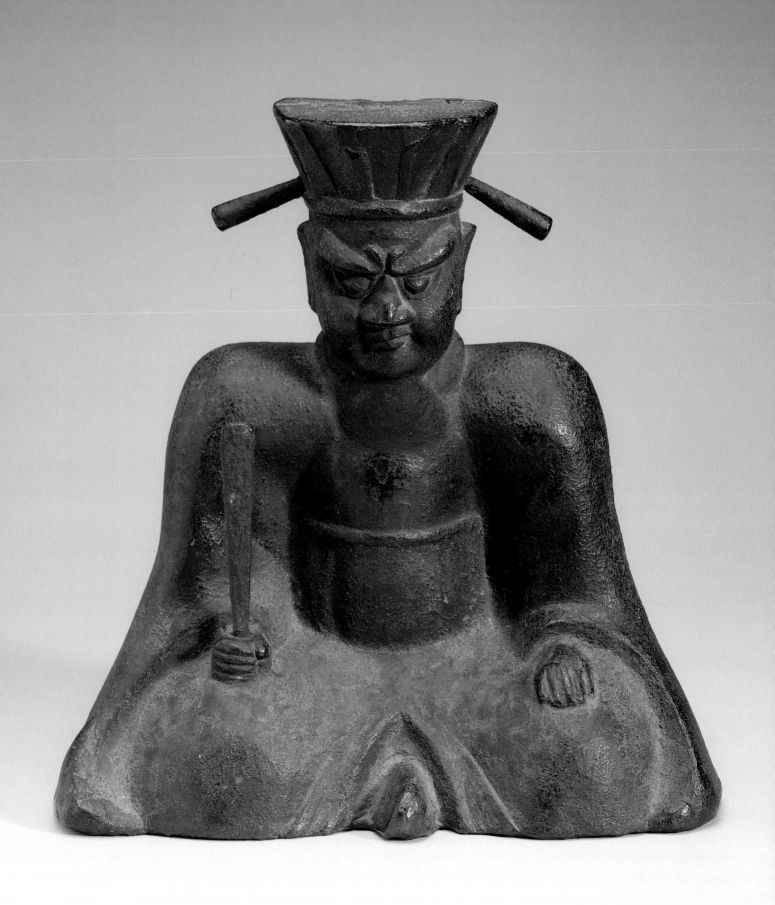

9. KING OF HELL (ENMA)

Bronze
Kamakura period, 14th century
H: 22.1 cm W: 21.7 cm
1991.75

This bronze statue represents Enma, one of the Ten Kings of Hell. The king is shown in deep concentration, gaze directed downward. His brows are deeply furrowed, his shoulders squared. His right hand rests on his thigh; the left one holds a scepter, which denotes his temporal power. His toes point directly ahead. He is wearing a simple Chinese official's coat with a high, straight waistband and a stiff collar, which overlaps in front behind his beard. He wears a flattened crown with projections at each side, a style for an official's hat since at least the Tang period in China. All other Kings of Hell are usually shown wearing a similar Chinese official's costume.

The Packard *Enma*'s body is cast in one piece, from paired clay molds of the front and back; atop the hat is a hole where an iron bar was inserted to position the outer and inner molds. The scepter is a separate piece of iron. Traces of lacquer coating remain on the surface.

The afterlife was an eternal mystery for people in many cultures. Many people believed that an ideal life in heaven was a way to escape from the pains and hardships of this world. They also imagined with great apprehension the terrible life in hell that might await them. Based on the Chinese adaptation of Yama, the dreaded king of Indian mythology, in the late Tang to Five Dynasties period (9th to 10th century), the medieval Japanese created a cult of the Six Realms of the Afterlife (Rokudō), based on the belief that all living beings were destined to be reborn into one of these realms according to their acts during their life on earth. These realms, in ascending order, are Hell (*jigoku*), and then the regions of hungry ghosts (*gaki*), of animals (*chikushō*), of fighting spirits (*ashura*), of humans (*jin*), and of Heaven (*ten*).

According to Rokudō belief, a period of intermediate existence spanning three years occurs after death, when the deceased passes through mountains, crosses a river, and faces judgment by the Ten Kings of Hell, who eventually assign the soul to a realm for the next life. The first judgment was held on the seventh day after death, and six more were held at seven-day intervals, followed by three others—on the hundredth day, in one year, and in the third year after death, for a total of ten trials by the Ten Kings.[1] The judgment of Enma, leader of the Ten Kings of Hell and the most feared by the dead, comes on the thirty-fifth day (fifth week).

Accompanied by four attendants, Enma sees in a magical mirror, like a modern video recording, the actions of the dead person during his life on earth, and checks these acts with scrolls held by Enma's registrar. It is a shocking experience for the sinner, because his sinful conduct recorded there was sometimes unintentional or unconscious. The defendant goes through the judgments until the tenth king gives the decision. Only then will the dead know into which realm he will be reborn. The moral implication is that so long as humans conducted their mortal lives in accordance with moral teachings, they would have nothing to fear in the afterlife.

Worship of the Ten Kings of Hell became popular in the Kamakura period. Depicted in paintings and sculptures, the kings, especially Enma, were held in awe, but at the same time they were regarded as compassionate beings because they guided people toward moral conduct. Worship of the Ten Kings spread to rural regions and penetrated deeply into the lives of the common people. Small Enma halls, for example, were built on roadsides in villages, or in a corner of the temple precinct where the people visited daily. Worship of Enma is still alive in Japan. Numerous sculptures and paintings of Enma and the other kings attest how deeply the belief in the Ten Kings was integrated into the spiritual lives of the common people.

Although Enma statues are abundant, bronze ones are extremely rare. The only other known example is the one dated 1325 at Rin'nōji, which has a large head disproportionate to its narrow body.[2] The Packard *Enma*, in comparison, exhibits a superior casting technique. Although the massive body is simplified and lacks much detail, the proportions are natural, and the facial features are well defined. It probably predates the Rin'nōji Enma.

Provenance unknown.

Published: *Heian Kamakura no kondōbutsu* (Nara: Nara National Museum, 1979), pl. 97.

Notes

1. *Enma tōjō* (Kawasaki: Kawasaki Shimin Museum, 1989), 104.

2. *Heian Kamakura no kondōbutsu*, pl. 96-2.

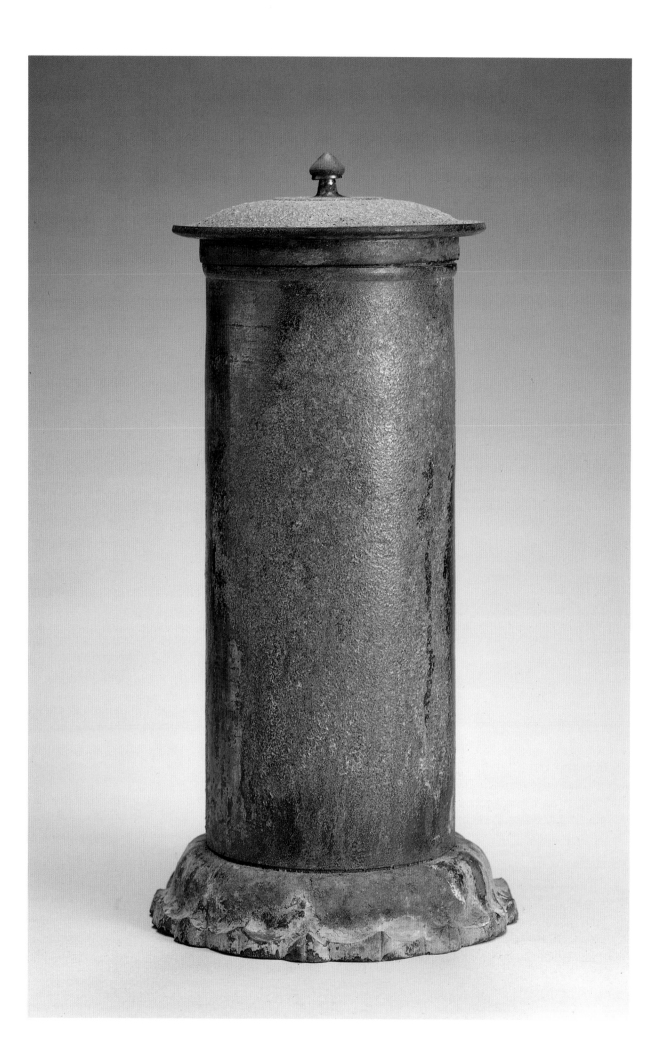

10. SUTRA CONTAINER

Bronze
Heian period, 12th century
H: 33.3 cm Diam: 17.2 cm
1991.78

This bronze container was designed to hold Buddhist sutras. It has a flat lid with a jewel-shaped knob that recalls the sacred jewel of Buddhism. The raised lotus leaf base symbolizes purity and Buddhism. The overall patina varies from deep black to light green, depending on the metal's state of corrosion. It appears that the case was constructed from four separate pieces of metal: lid, knob, cylindrical body, and base.

Sutra containers like this one provide extraordinary materials that attest to a period of religious preoccupation during the late Heian period. Various religious sects, but mainly the Pure Land sect, the most influential doctrine at the time, spread the pessimistic view that Japan was entering *mappō*, the end of Buddha's Law, a dark age the world would enter 2000 years after the death of Buddha. Social instability and rivalry among major temples only enhanced people's hysteria at this prospect. By preserving sutras, it was thought that Buddha's teachings could be saved until the time when Maitreya (Jpn: Miroku, Buddha of the Future) appeared thousands of years later to revive Buddhist law. Thus people made copies of sutras and placed them in bronze cases, which were in turn placed in protective cases or jars, often of ceramic, and then buried them at remote sites in the mountains. Hundreds of scroll burials (*kyōzuka*) took place during the eleventh and twelfth centuries.

The earliest recorded sutra mound is that of 1007 at Mount Kimpu, a mountain in the Yoshino area near Nara, which contained the sutras copied by Fujiwara no Michinaga (966–1028), regent of government and patriarch of the powerful Fujiwara family.[1] By the last half of the eleventh century, the custom had spread to Kyushu in the southwest and Kantō in the northeast. Many of these mounds remain undisturbed to the present day. About 2000 mounds have been excavated, and their sutra cases, sutras, and other ritual items have been collected.[2] By the middle of the thirteenth century, the custom of burying sutras had ceased.

Sutra cases have various shapes: cylinders, boxes, pagodas. Most are cylindrical and have lids. In general, sutra cases of the eleventh century are tall and elegant, with a narrow, cylindrical body, while cases of the twelfth century are more sturdy, typically shorter, and wider in diameter. In addition, the flattened, overhanging lid with a simple jewel-shaped knob occurs more often on later cases. The Packard sutra case is datable to the twelfth century.

Provenance unknown.
Unpublished.

Notes

1. For Michinaga's diary, see *The Midō Kampaku ki*, quoted by Hideo Okumura, "Kyōzuka ihō." In *Shinto no bijutsu*, Nihon bijutsu zenshū, v. 11 (Tokyo: Gakushū Kenkyūsha, 1979), 163.

2. Hideo Okumura, "Kyōzuka ihō," 158.

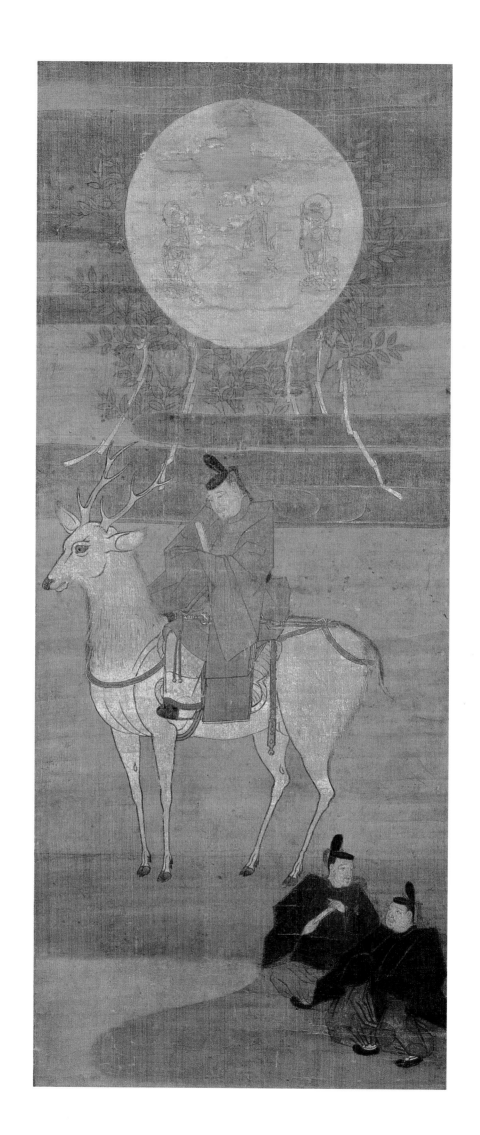

11. APPEARANCE OF KASUGA MYŌJIN (DEPARTURE FROM KASHIMA)

Hanging scroll, ink and colors on silk
Late Kamakura–Muromachi period, 14th century
H: 92.8 cm W: 39.3 cm
1991.58

The *Departure from Kashima* is one of three themes depicted in Kasuga Shrine paintings. It depicts Take-mikazuchi no Mikoto, legendary ancestor of the Fujiwara clan, leaving the Kashima Shrine in 768 for Mount Mikasa near Nara to found the Kasuga Shrine. The old man, in courtly attire and mounted on a white stag, holds a ceremonial staff (*shaku*). Below at the right stand two of his descendants, Nakatomi no Tokikaze and Nakatomi no Hideyuki, who were said to have accompanied him. Numerous symbols further connect the Kasuga Shrine and the Fujiwara family: a legendary and sacred tree (*sakaki*) behind the old man; the five strips of white paper containing prayers (*gohei*) in its branches and symbolizing the five major sanctuaries in the shrine; and a sacred mirror containing five Kasuga gods in Buddhist forms (*honji*). These *honji* deities are the Eleven-headed Kannon, who represents Himegami, the consort of Ame no Koyane no Mikoto; Jizō Bosatsu (Ksitigarbha), representing Ame no Koyane no Mikoto; Yakushi (Buddha of healing), representing Futsunushi no Mikoto; Shaka (historical Buddha), representing Takemikazuchi no Mikoto; and Monju Bosatsu, representing Wakamiya, symbol of various agricultural deities.

Toward the end of the Heian period, the theory of Shinto-Buddhist unification (*honji-suijaku*) stimulated the emergence of a large number of Shinto votive paintings for worship of tutelary deities of major shrines in Japan. The Kasuga Shrine was established in the eighth century, in the cultural and political center of Nara, by the Fujiwara, the most powerful aristocratic family in the imperial court. In an effort to popularize the Kasuga cult, the shrine adopted the *honji-suijaku* theory and produced a variety of votive paintings. Most were highly schematized and thus are known as mandala.

Three major types of votive paintings are found at the Kasuga Shrine. The *Kasuga Shrine Mandala* reveals topographical features of the shrine's precincts, with its five major sanctuaries depicted in bird's-eye view. In the *Kasuga Deer Mandala*, the shrine is symbolically represented by the four elements affiliated with Shintoism and the Fujiwara family—the white stag, sacred mirror, *gohei*, and *sakaki* branches. The third painting type is *The Departure from Kashima*. The first two types are common, with many extant examples; the third, however, is quite rare.

This painting and other Kasuga mandala were executed at Nanto Edokoro (the official bureau of painting in Nara, located at Kōfukuji) by Buddhist painters. Because Shinto votive paintings emerged with no tradition behind them, the painters were compelled to rely on the refined, colorful *yamato-e* style, familiar among aristocrats. The three tutelary deities are dressed in formal courtly attire. The costume of the major deity is bright orange, now slightly faded, with black and silver–checked trousers. The blue sky is partly covered by spreading clouds, a typical *yamato-e* feature.

The three types of votive paintings were widely used in ancestor worship by the Fujiwara and the parishioners of the Kasuga Shrine, most of whom were courtiers. They built shrines at their residences and held daily services. This custom was gradually simplified to the use of paintings hung within their residences, increasing the demand for votive paintings. As the Kasuga cult became influential in the Kamakura period, parishioners of the shrine organized associations of devotees called Kasuga-kō to hold mass services on the twenty-first of each month. Kasuga-kō services were held even more earnestly in the Muromachi period.[1] Worship of the Kasuga gods penetrated the populace of commoners in the provinces; when the shrine's priests traveled to local regions on business, for example, they took the mandala to propagate the cult, which resulted in a demand for even more votive paintings.[2] From literary sources, *kō* organizations are speculated to have emerged in the end of the Kamakura period. They reached the peak of their popularity in the Muromachi period; most of the extant works are from this period.[3]

In iconography and style, the Packard painting is comparable to two famous *Departure* works: one in the Kasuga Shrine collection dated 1383,[4] and one in the Seattle Art Museum, datable around 1428, based on the inscription on its box (Fig. 8).[5] The mandala of 1383 represents the subject in more detail. For example, at the top, Mount Mikasa is indicated beneath the sun, and the *sakaki*-tree branches spread wider to cover the god's back. The Packard mandala shows a tendency for simplification; it lacks Mount Mikasa,[6] and the *sakaki*

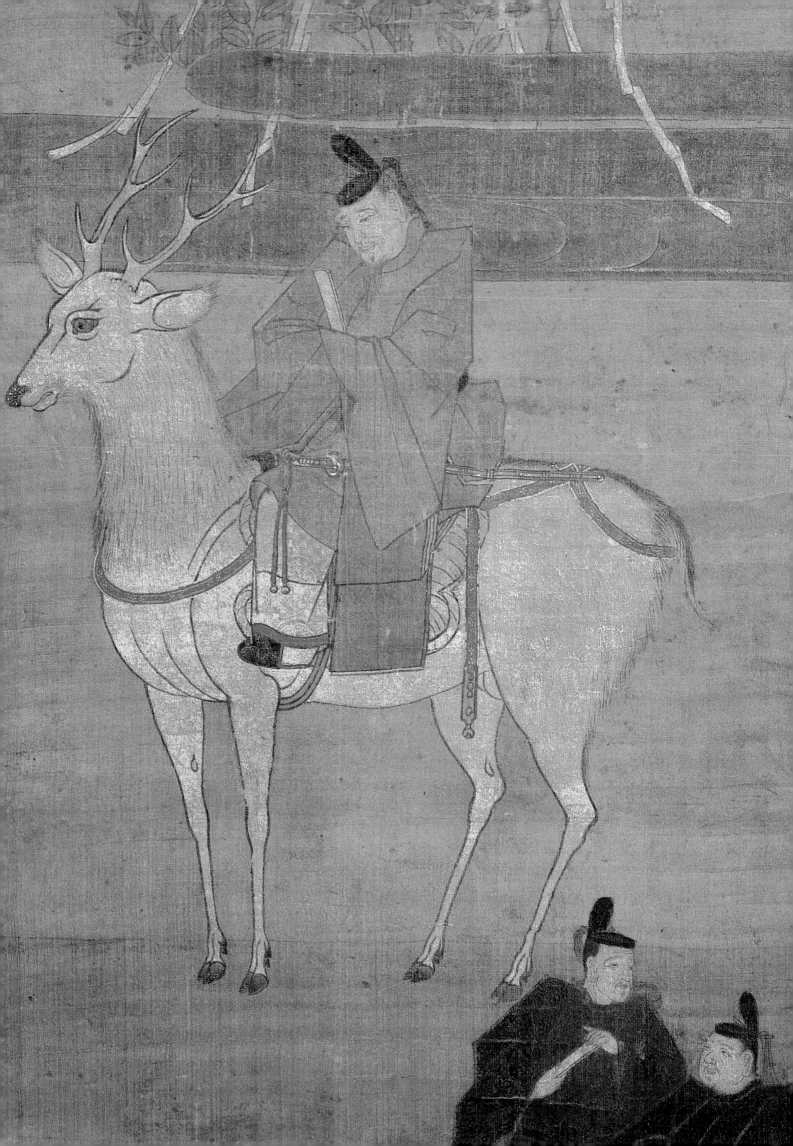

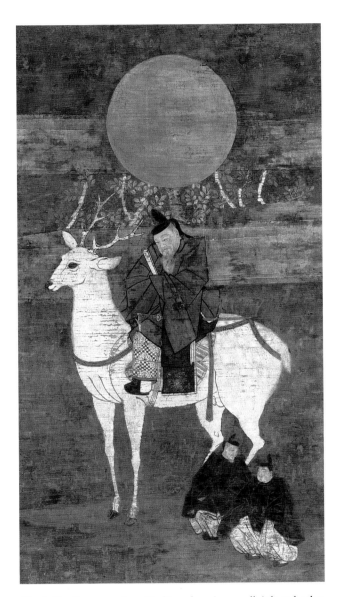

Fig. 8. *The Departure from Kashima;* hanging scroll, ink and color on silk; Muromachi period, ca. 1428; Seattle Art Museum (92.8); Gift of the Heirs of D. E. Frederick: Janny Padelford, Donald F. Padelford, Diana P. Binkley, Carol P. Luxford, Fay P. Michener.

branches are partly covered by clouds. A tendency to reduce iconographical details is even more pronounced in the Seattle Art Museum *Departure;* both the mountain and the five Shinto *honji* are absent from the mirror.[7] One of the standing descendants lacks a staff, and there are six *gohei* instead of five. These simplifications and confusions may indicate that production copying of the prototype was beginning to occur. It seems that the Packard *Departure,* which tends toward simplification but still retains accurate details, may be placed between the Kasuga and Seattle paintings, after 1383 and before 1428.

Provenance: Formerly in the Noda family, whose members successively served the Kasuga Shrine as priests. See *Kamigami no bijutsu* (Kyoto: Kyoto National Museum, 1974), description of pl. 6.

Published: Shigenari Mochizuki, *Nihon Bukkyō bijutsu hihō* (Tokyo: Sansaisha, 1973), pl. 40; *Kamigami no bijutsu,* pl. 6; *Shinto no bijutsu,* Nihon bijutsu zenshū, v. 11 (Tokyo: Gakushū Kenkyūsha, 1979), pl. 134.

Notes

1. Fukutarō Nagashima, "Kasuga mandala no hassei to sono rufu," *Bijutsu kenkyū* 133(1944): 249.

2. Ibid., 249–52.

3. Ibid.

4. Terukazu Akiyama, *Bukkyō kaiga,* Zaigai Nihon no shihō, v. 1 (Tokyo: Mainichi Shinbunsha, 1979–81), 161.

5. Ibid.; and see *A Thousand Cranes* (Seattle: Seattle Art Museum, 1987), fig. 36.

6. It may be that the upper part of the painting was damaged and removed.

7. Akiyama, *Bukkyō kaiga,* pl. 100.

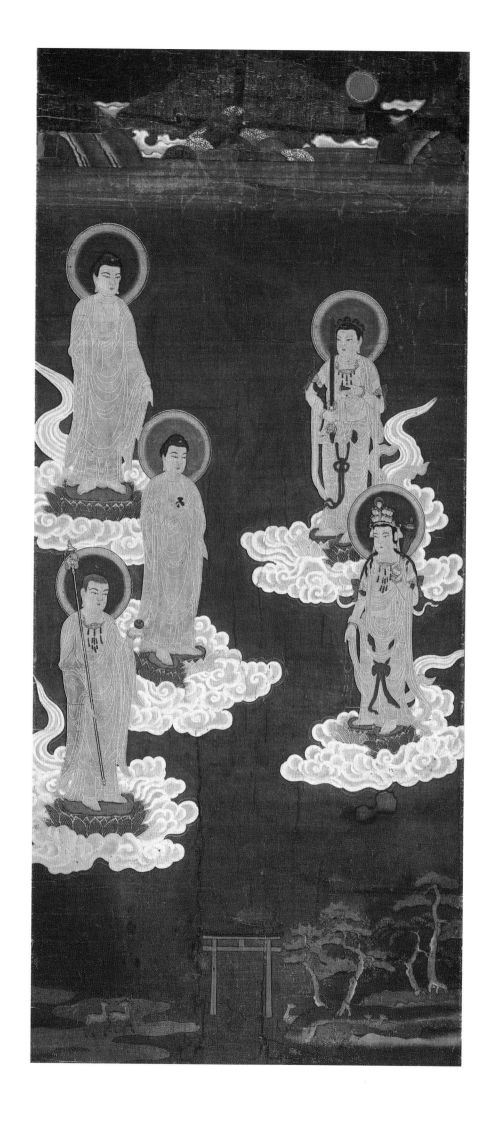

12. KASUGA HONJIBUTSU MANDALA (FIVE BUDDHIST AVATARS OF THE KASUGA GODS DESCENDING OVER THE KASUGA SHRINE)

Hanging scroll, ink and colors on silk
Muromachi period, 15th century
H: 85.2 cm W: 37.3 cm
1991.59

Against the dark-blue night sky, the five Kasuga gods in Buddhist deity forms (*honji*) are descending, each on a trailing cloud, to the precincts of the Kasuga Shrine, which is suggested by the *torii* gate, deer, and pine trees in the lower sector, and Mount Mikasa under a full moon in the top portion of the picture.

The painting is one of the several categories of votive paintings that show the five major gods of the Kasuga Shrine. It represents the relationship between the Buddhist and Shinto deities of the Kasuga Shrine as formulated by the *honji-suijaku* theory.

The Kasuga Shrine, one of the most famous in Japan, was established in Nara in the eighth century by the Fujiwara family. Its four Shinto deities, said to have originated in northeastern Japan, the native place of the family, were moved to Nara and installed in the four sanctuaries of the Kasuga Shrine, where they were worshiped as *ujigami*, tutelary deities of the family. During the Heian period when, stimulated by esoteric Buddhism, the theory of *honji-suijaku* emerged, the main deities of both the Kasuga Shrine and Kōfukuji (the nearby Buddhist temple, also built by the Fujiwara), were paired and enshrined in five sanctuaries. The five Kasuga gods, their *honji*, and their locations are:[1]

Sanctuary	Suijaku	Honji
1	Takemikazuchi no Mikoto	Shaka (Sakyamuni)
2	Futsunushi no Mikoto	Yakushi, Buddha of Healing (Bhaisajyaguru)
3	Ame no Koyane no Mikoto	Jizō Bosatsu, helper of deceased children (Ksitigarbha)
4	Himegami (Consort of Ame no Koyane)	Eleven-headed Kannon (Ekadasamukha)
5	Wakamiya	Monju (Manjusri)

Based on literary sources, the earliest pictorial representation of the Kasuga gods and their Buddhist original forms dates from 1184.[2] Most extant paintings of

this kind date later, however, in the thirteenth to the fourteenth century (the Kamakura and Muromachi periods). The Packard painting exemplifies the later work. By this time the Fujiwara family had long lost its political power, overshadowed by the newly arisen samurai class who assumed power at the establishment of the Kamakura *bakufu* (military government). The Kasuga Shrine ceased to be an exclusive Fujiwara tutelary shrine, becoming instead a popular shrine that was supported by the commoners.

Honji-suijaku theory and its depictions of Shinto shrines and their gods in Buddhist deity forms are the result of Shinto's serious effort to propagate itself through assimilation with popular Buddhism. This effort was a major cause for the production of vast numbers of Shinto mandala paintings of various categories. In many of these mandala, deities are stiffly arranged in rows. The more appealing and innovative depiction of the avatars of the Shinto gods descending to the shrine derived from the descent of Amida Buddha, a Pure Land sect theme popular since the Heian period. Like Amida, the five avatars descend on trailing clouds, and the Shinto gods appear in pure Buddhist forms. A few clues, however, identify this painting as a Shinto work. In the Buddhist version of Amida's descent, only one major deity, Amida Buddha, appears in the center surrounded by many adoring bodhisattvas

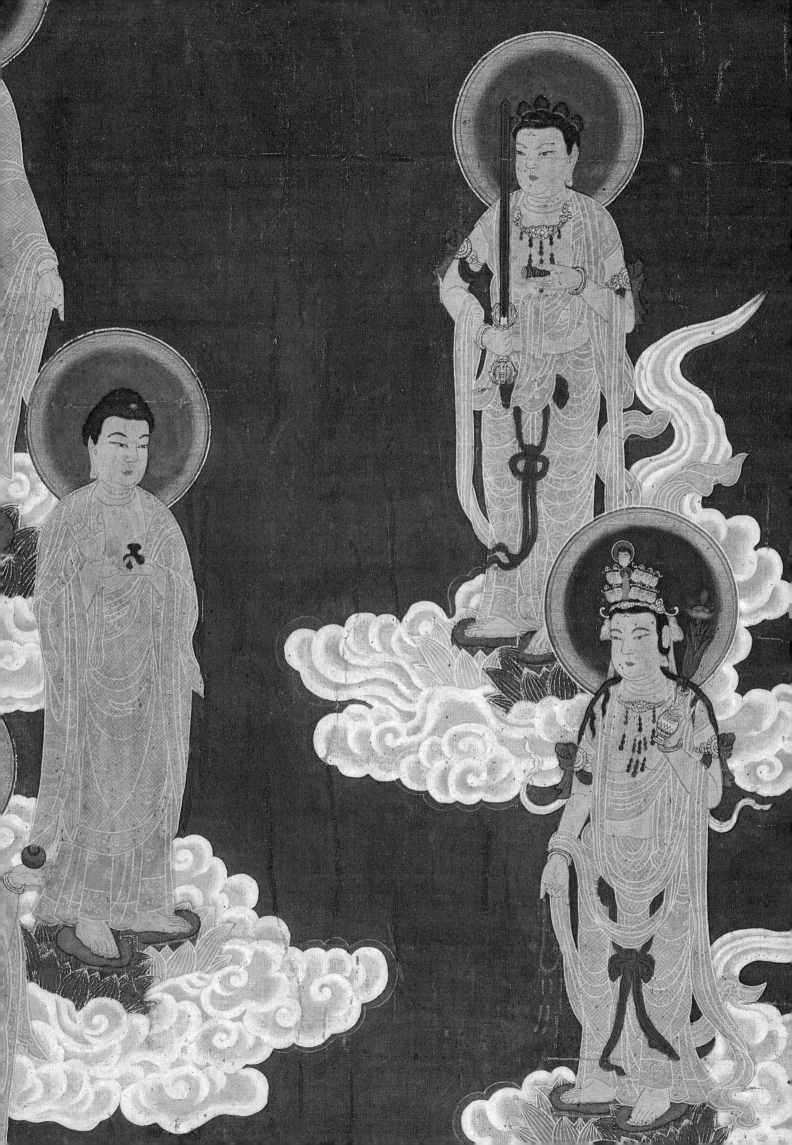

playing musical instruments and holding banners. In this Shinto mandala, the five deities are depicted as being equally important; they are all the same size and have different postures. In addition the topographical features—the mountain under the full moon at the upper sector, and the *torii* gate, deer, and pines in the lower one—all are suggestive of the shrine in the Nara area. Of the numerous votive paintings of the Kasuga Shrine, this painting of Buddhist avatars (*honji*) in the act of descending is a unique variation.

The painting is depicted in contrasting styles: the Buddhist avatars are in the religious style of the time, while above them the mountains and the shrine precinct are in traditional Japanese *yamato-e* style. The deities' garments also demonstrate an excellent technique of *kirikane,* in which several decorative patterns are cut in gold foil and affixed to the silk.

Provenance unknown.

Published: *Kamigami no bijutsu* (Kyoto: Kyoto National Museum, 1974), pl. 18.

Notes

1. Nobukazu Ōhigashi, "History of Kasuga Shrine," in *Bugaku: Treasures from the Kasuga Shrine* (Boston: Museum of Fine Arts, Boston, 1984), first page.

2. John Rosenfield and Shūjirō Shimada, *Traditions of Japanese Art: Selections from the Kimiko and John Powers Collection* (Cambridge: Fogg Art Museum, Harvard University, 1970), 142.

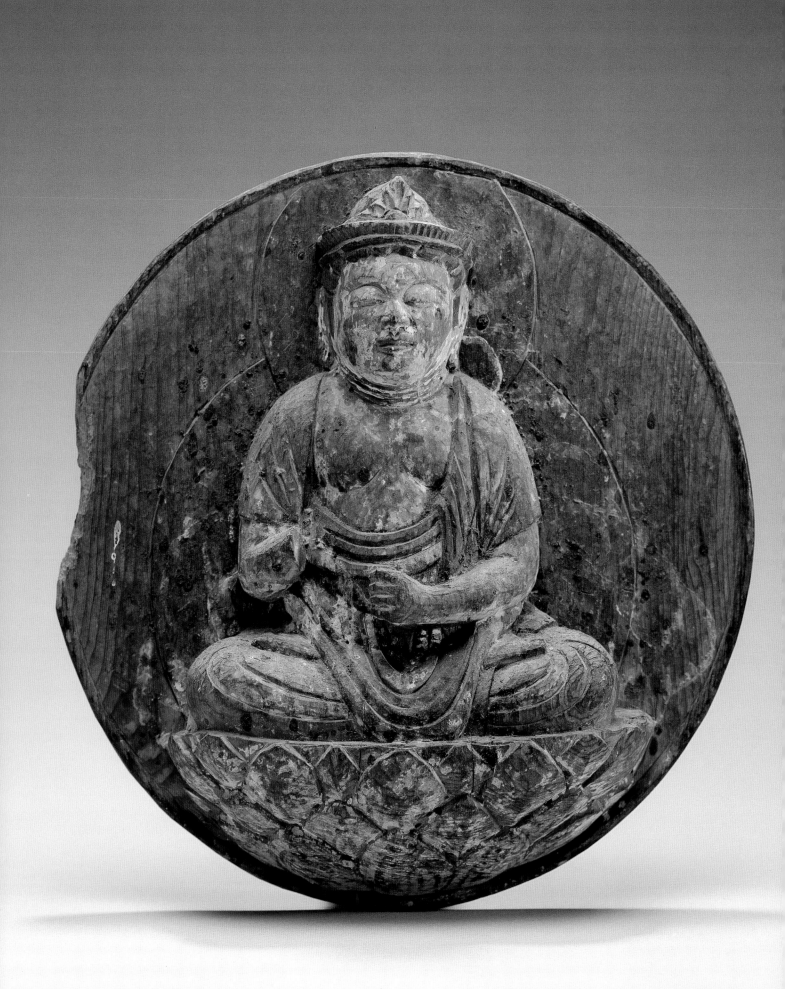

13. VOTIVE PLAQUE WITH FIGURE OF SHŌ-KANNON (KAKEBOTOKE)

Wood with colors
Heian period, late 11th–early 12th century
Diam: 24.0 cm
1991.70

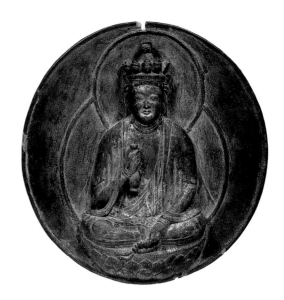

Fig. 9. *Eleven-headed Kannon (kakebotoke)*; wood; Kamakura period, dated 1228; Shōrinji, Yamagata. Photo: Shibundō, Tokyo.

The deity of this votive plaque is seated cross-legged on a lotus pedestal. Although part of the right forearm is now missing, it is very likely that the absent hand formed the gesture of consolation (*ani-in mudra*) in which the index finger and thumb are joined to make a circle. The left hand, held below the waist with fingers forming a hole, must have once held a lotus stem, the attribute of Shō-Kannon. The plaque, the kannon, and the lotus pedestal are carved from a single piece of Japanese cypress. The halo of double circles is indicated by a shallow, grooved line; the plaque's rim is finished in a round edge. Although the carving is rather crude, with angular chisel marks unsmoothed, it successfully renders the deity in volume; the face and body are soft and rounded.

Traces of pigments indicate that the entire plaque was once coated with white clay (*hakudo*), and the deity then must therefore have been painted in several colors as the *tan* (reddish-brown) color of the base of the crown still remains. The kannon's body and lotus petals were then delineated in black ink.

Although this wooden votive plaque appears to be a simple Buddhist work, it bears both Shinto and Buddhist iconography. This *kakebotoke* (hanging Buddhist image) plaque represents Shō-Kannon (Avalokitesvara), who is actually represented as the Buddhist form (*honji*) of a Shinto tutelary deity (*suijaku*). The uniquely Japanese mixing of Buddhist and Shinto iconographies emerged in the late Heian period as the result of the theory that native Shinto gods were considered manifestations (*suijaku*) of Buddhist deities (*honji*). First appearing in the late Nara period, the theory led to the emergence of different forms in Shinto art, which had previously been quite simple, lacking personified images of its gods. Matching of the Buddhist images and Shinto gods is arbitrary and changes in different tutelary shrines and regions. Since the original site of this plaque is not known, the Shinto equivalent of Shō-Kannon is difficult to identify.

Shō-Kannon is the usual and basic form of kannon, from whom five variations are manifested. Kannon save the sufferers in this world; Shō-Kannon is believed to save chiefly hungry ghosts.

Personification of Shinto gods first appeared in bronze mirrors, which in early times served as the abstract embodiment of a Shinto god or gods (*kami*) in a shrine. They were incised with a figure of a Buddhist-Shinto deity. Called *mishōtai* (true embodiment [of Shinto gods]), the mirror served as the emblem or repository of the divine spirit. The incised mirrors developed further to become more elaborate *kakebotoke*, and had separately cast relief images affixed to them. *Kakebotoke* were often commissioned by devotees and were dedicated to their shrines as a form of prayer.

Kakebotoke were suspended both inside and outside Shinto shrines, and later also in Buddhist temples. This *kakebotoke*, with traces of insect damage, was likely hung outdoors under the eaves of a shrine. Wooden *kakebotoke* were rather common in remote mountainous regions, where wood was easily accessible. The earliest wooden *kakebotoke*, dated 1228, at Shōrinji in Yamagata, in the northeastern part of Japan, has an Eleven-headed Kannon (Fig. 9).[1] The plaque of Japanese cypress is carved in the thirteenth-century Kamakura style, with sharp, detailed facial features and realistic drapery folds. In the Packard *kakebotoke*, with its childlike gentleness, softness, and roundness, the deity is clearly rendered in the earlier style of the Heian period. Unsophisticated and charming, the plaque also suggests that it was produced in the folk tradition of a local region. It is one of the earliest extant wooden *kakebotoke*. It further attests that the elegant style in Kyoto and Nara had already spread to the remote regions.

Provenance unknown.

Published: *Shinto no bijutsu,* Nihon bijutsu zenshū, v. 11 (Tokyo: Gakushū Kenkyūsha, 1979), pl. 134.

Notes

1. Tōru Naniwada, *Kyōzō to kakebotoke,* Nihon no bijutsu, no. 284 (Tokyo: Shibundō, 1990), pl. 10.

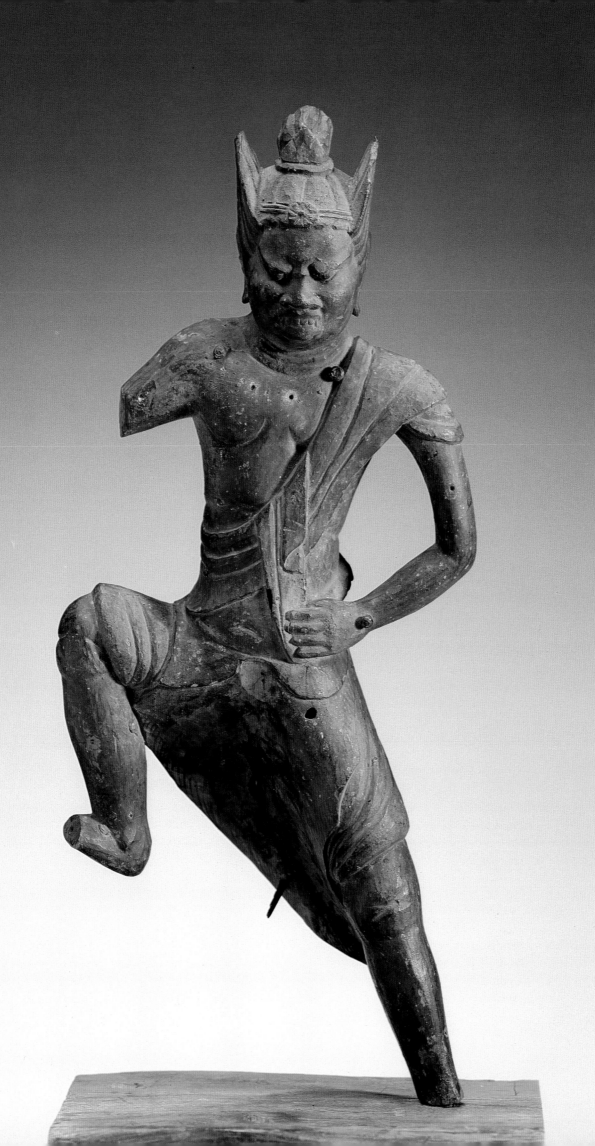

14. ZAŌ GONGEN

Wood, colors, and inlaid glass
Heian period, 12th century
H: 31.5 cm
1991.73

Zaō Gongen, also called Kongō Zaō, is the Shinto tute-
lary deity of Mount Kimpu in the Yoshino district,
south of Nara. Carved of a single block of *kaya* wood,
Zaō appears as a three-eyed, ferocious guardian with
glaring eyes and fangs emerging from his mouth. In a
dynamic stride he stands on his left foot while raising
his right leg high and to the side. The right toes and the
left foot are missing. His slim upper body is covered
only with a scarf that goes over his left shoulder and
down toward his right waist. On the hip, above his
lower garment, is a tiger skin. As with some esoteric
guardians, his hair is tied in a knot at the top and
adorned with a simple diadem with a rosette in the
center; side locks of hair stand out like flames. On his
chest and wrist are inlaid pieces of glass, representing
his jewelry. A naillike metal projection under the tiger
skin could have held a damaged piece of the bottom
part of the skirt, which is now lost. The missing right
arm apparently was bent at the elbow and raised, bran-
dishing a thunderbolt (*vajra*), the emblem that distin-
guishes Zaō and other esoteric Buddhist guardians. The
left hand is held at the hip with the five fingers extended
and held close together. Gongen of later dates show the
sword gesture (*ken-in*), which is formed with thumb
and two fingers pointing stiffly out and the other fin-
gers curled. A superb bronze Zaō in The Metropolitan
Museum of Art, datable in the eleventh century, shows
the sword gesture (Fig. 10). The absence of this *ken-in*
gesture in the Packard Zaō is considered a sign of un-
even iconographical development in different regions.[1]

Although the surface is now worn, this figure was
originally gilded and brightly colored; Zaō's flesh was
coated with lacquer and gilded, and the skirt was coated
with white clay (*hakudo*) and painted in ink in a tiger-
skin pattern; the scarf, armbands, and anklets were
painted red.

Zaō Gongen, originally a minor local *kami,* acquired
extremely complex multiple identities in the tenth and
eleventh centuries. Zaō Gongen's name first appeared in
the late tenth to eleventh century and gained importance
in the Buddhist and Shinto pantheon.[2] In the interac-
tion of Shinto and Buddhism, Zaō came to be regarded
as a manifestation (*suijaku*) of three Buddhist deities
(*honji*), Miroku (Buddha of the Future), Shaka, and
Amida.[3]

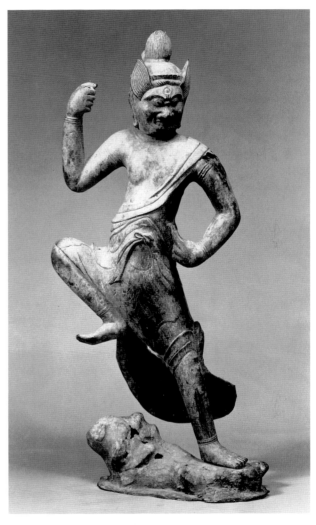

Fig. 10. *Zaō Gongen;* bronze; Heian period, 11th century;
The Metropolitan Museum of Art, New York; The Harry G. C.
Packard Collection of Asian Art, Gift of Harry G. C. Packard and
Purchase, Fletcher, Rogers, Harris Brisbane Dick and Louis V. Bell
Funds, Joseph Pulitzer Bequest and The Annenberg Fund, Inc.
Gift, 1975. (1975.268.155)

Furthermore Zaō Gongen came to be considered
as the guardian of ascetics who practiced religious dis-
cipline and prayer deep in the mountains, to acquire
magical power to cure the sick and expel evil spirits.
Their order, Shugendō, is another uniquely Japanese
religious synthesis combining pre-Buddhist mountain
worship and esoteric Buddhist doctrine, ritual, and
symbolism. Active by the twelfth century, the members
of the order were called *yamabushi* (those who sleep in

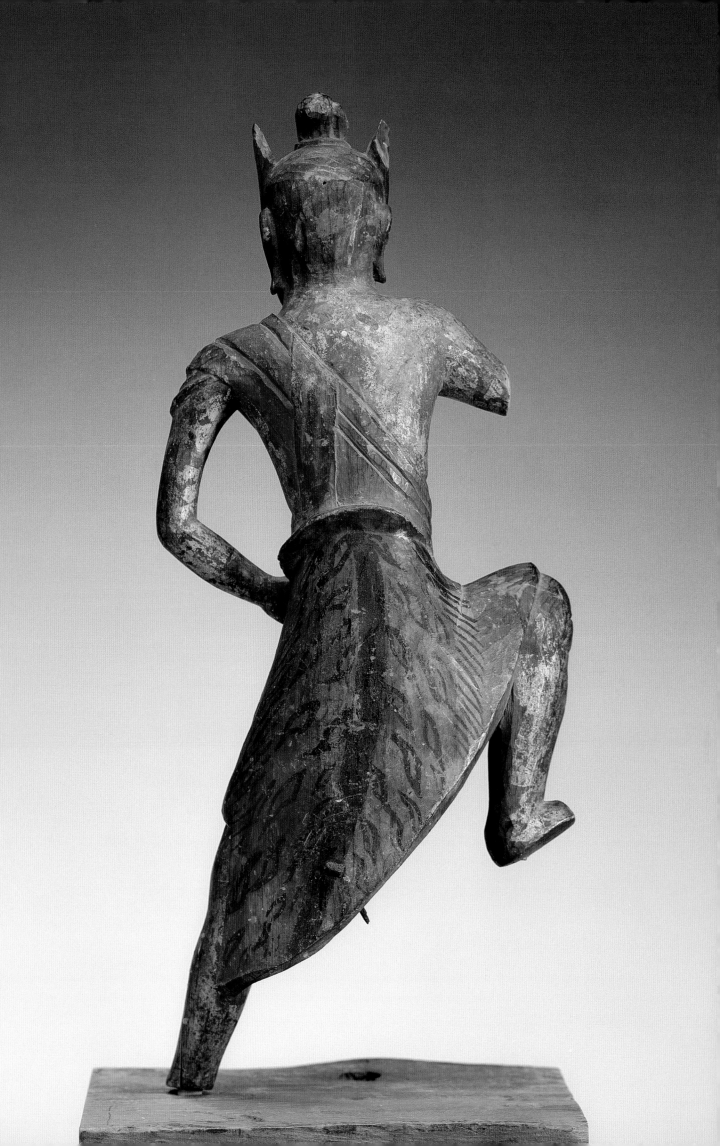

the mountain). Neither Buddhist monks nor Shinto priests, *yamabushi* trained by immersing themselves in cold water and reciting holy texts, such as the Lotus Sutra. Through these practices they acquired, it was believed, the power to heal sick people and to bring prosperity to a family. Individual ascetics organized in groups devoted to the Shugendō creed. The sect had no historical founder, but the *yamabushi* credit En no Gyōja (b. 634), a legendary ascetic, as Shugendō's originator. A Kamakura period tradition further ascribes to Zaō Gongen his manifestation as Shaka, in a fierce guardian form, En no Gyōja, during a period of severe religious austerity. Zaō came to be taken as the guardian of the *yamabushi*. By the twelfth century his unique appearance as it is known today had been established in the hybrid form of the esoteric Buddhist guardians. *Kimpu himitsu den* (Story of the Secrets of Mount Kimpu) describes Zaō's form: "Three-eyed Zaō holds the *sankosho* [three-horned *vajra*] in his right hand and makes the sword gesture with his left hand. He stands with his left foot on the rock, kicking his right foot high in the air."[4] A Heian-period *Zaō* in The Metropolitan Museum's Packard collection has all these features and attributes (Fig. 10).

The pessimistic religious atmosphere of the eleventh century further popularized Zaō Gongen. The fearful people believed that the End of the Law was coming, a bleak millennial event that would cause Buddhist doctrine to disappear before the advent of the savior Maitreya, the Buddha of the Future. In an effort to preserve the law of Buddhism until Maitreya's arrival, aristocrats in Kyoto buried vast numbers of sutras under mounds, especially on Mount Kimpu. With them they placed statues of Zaō Gongen to guard the mounds; there many Zaō figures, predominantly in bronze, have been found. Zaō figures are also widely distributed in other mountainous regions of Japan, attesting that Zaō came to be worshiped throughout the country.

Provenance unknown.

Unpublished.

Notes

1. Saburōsuke Tanabe, *Shinbutsu shūgō to shugen*, Zusetsu Nihon no bukkyō, v. 6 (Tokyo: Shinchōsha, 1989), 239.

2. Masashi Mitsumori, "Kue issho no Zaō Gongen-zō," *Kobijutsu* 81(1987): 129.

3. Haruki Kageyama, *Shinto Arts: Nature, Gods, and Men in Japan* (New York: Japan Society, 1976), 119.

4. Quoted in Naoya Oka and Shōichi Uehara, "Suijaku Chōkoku," in *Suijaku bijutsu* (Tokyo: Kadokawa Shoten/Nara National Museum, 1964), 86.

SECULAR ART

15. BUGAKU DANCERS SCROLL

Abe no Suehide (1361–1411)
Handscroll, ink and colors on paper
Muromachi period, dated 1408 (15th year of Oei)
H: 28.2 cm L: 473.4 cm
1991.60

On a long scroll, eleven dancing figures are depicted in their familiar poses. Beside each figure is an inscription in ink of the title of the piece and a note on how many men are involved in the dance. The dance sequence and number of performers, from right to left, are: Chikyū (four or six); Sanju (one); Kitoku (one); Batō (one); Soshimari (six); Genjōraku (one); Korobase (four); Saisōrō (one); Ayakiri (four); Ryōō (one); Rakuson (two).

An inscription at the end of the scroll reads "Copy based on the secret scrolls, painted on the 8th of November, 1408." It is signed by Yamashina Norikoto. This handscroll was known to exist until the nineteenth century, and was accessible to painters interested in *bugaku*. Early in the fifteenth century, apparently, Tosa Mitsunobu (1434–1525) copied it; a copy of Mitsunobu's copy exists in the Tokyo National Museum.[1] In the nineteenth century, Kano Seisen'in Yōshin made an almost identical copy except for the last four figures, which are missing; that copy is also in the Tokyo National Museum (Fig. 11). The scroll's whereabouts then became obscure until it reappeared in 1979, in an exhibition at the University Art Museum, University of California, Berkeley, on loan from "a private collection" (the Harry Packard collection).[2]

The Japanese are adept at assimilating foreign art forms, styles, and techniques, in both fine and theatrical arts, reorganizing and modifying them so they acquire a truly Japanese nature. Adopted arts flourish side by side with those of purely Japanese origin. *Bugaku* (lit. dance and music) is an ancient art that the Japanese adopted from countries spread over the Asian continent—India, Persia, China, Southeast Asia, Manchuria, Korea—and which developed into classical Japanese theatrical art. Today it is still performed at the imperial court and in some older temples and shrines, at a time when very few of these other Asian cultures retain their ancient dances and music in their original spectacular forms.

This *Bugaku Dancers* scroll is a fascinating and important work, interesting for its history of the pictorial and dramatic arts. The inscription by a court noble, Lord Yamashina Norikoto, at the scroll's end, reveals the specific nature of the work, the date, and the patron (Norikoto himself). The diary of this nobleman provides further insight into the process of the scroll's production from beginning to completion. It is the oldest extant *bugaku* dance scroll, executed in colorful *yamato-e* style at a time when ink painting inspired by Zen Buddhism was the dominant style.

Bugaku is a dance performed in masks and accompanied by instrumental music (*gagaku*). *Bugaku* most likely developed on the Asian continent from folk dances synthesized and stylized during the eighth century in the Tang court in China, when it was first brought to Japan. After *bugaku* declined in China with the fall of the Tang dynasty (906), it gained great and extended popularity in Japan during the Heian and Muromachi periods. Long ceremonial use in the imperial court and large shrines greatly refined *bugaku*, giving it a meditative quality on the one hand, but causing it to lose its original amusing nature on the other.

Bugaku was very popular among imperial family members and nobles, who often sponsored *bugaku* concerts. Not only did they appreciate the dances and music performed by members of the Imperial Household Ensemble, but they also played *gagaku* instruments and performed *bugaku* dances themselves. Its popularity is attested by the fact that *bugaku* dancing figures frequently appeared in paintings from the eleventh century on.[3] During the Muromachi period, *bugaku* dancers, along with the *Tale of Genji* theme, became a favorite subject of figurative paintings for fans, screens, and handscrolls. Beautifully colored fans and spectacular screens, both featuring dancers, were appreciated for their aesthetic quality and became popular gift items exchanged among the members of the ruling class.[4] *Bugaku* handscrolls, however, were meant to describe dance pieces in detail and to preserve the art for later generations. Against a plain background, single dancing figures are depicted at the height of their movement, with long trains flying in the air. While the primary function of handscrolls was descriptive, they are also aesthetically satisfying. These handscrolls were kept exclusively as "secret scrolls" (*hihon*) in private collections of specialists and admirers of *bugaku*.[5]

Two types of painters made *bugaku* dance paintings: professional painters employed at the Court Painting Academy (Edokoro), and amateur painters in imperial

a.

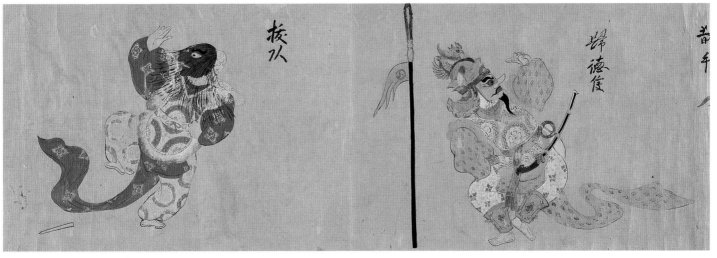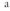

b.

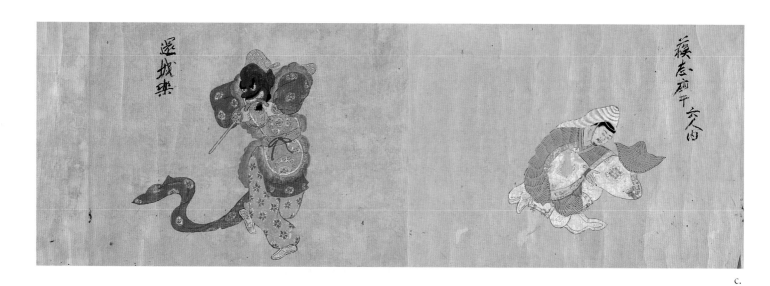

還城楽　　　　　　　　　　　　　　　　　　　　　　　　�志平六人内

c.

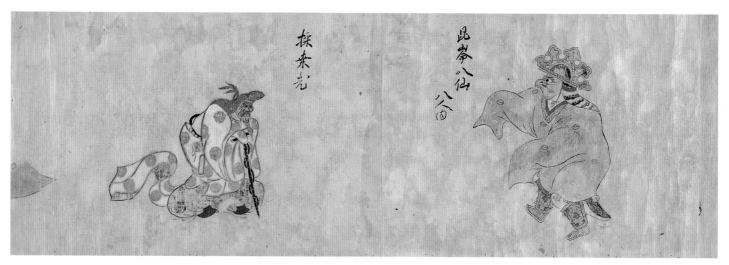

採桑老　　　　　　昆崙八仙八人内

d.

Detail: Inscription by Yamashina Norikoto, signed and dated 1408.

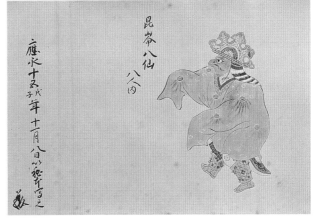

Fig. 11. *Bugaku Dancers Scroll,* detail; copy by Kano Seisen'in Yōshin (1796–1846); handscroll, ink and color on paper; Edo period, dated 1820; Tokyo National Museum.

society, often dancers and musicians in the guild of the Imperial Household Ensemble.[6] This handscroll is of the second type, painted by a musician in the *gagaku* ensemble of the Imperial Household. Since *gagaku* musicians daily observed the dance performances, they were thoroughly familiar with this performing art, and if they had talent in painting, they were well able to make paintings of this theme.

Yamashina Norikoto was born in 1328 to the Yamashina family. Several generations of the family worked as directors of the Naizōryō (the Imperial Household Storage). Their duties included registering the household implements and clothing of the emperor and his family, and purchasing new supplies for them. At the time the scroll was produced, Norikoto was eighty-one years old and still active, possessing an expert's knowledge of materials, colors, and styles of costumes of emperors, courtiers, and *bugaku* dancers. Norikoto was an excellent *shō* (pan pipe) player and shared a joint appointment as superintendent of the School of Music of the Imperial Court; he thus exercised great influence over the court musicians.[7]

The painter of the scroll, Abe no Suehide, was born to a family of *gagaku* musicians in the Imperial Household Ensemble, specialists in *hichiriki* (a double-reed, vertical bamboo flute with seven holes). Besides playing in formal concerts, he regularly attended private concerts held by Norikoto at his residence, which served as a salon of cultured courtiers.[8]

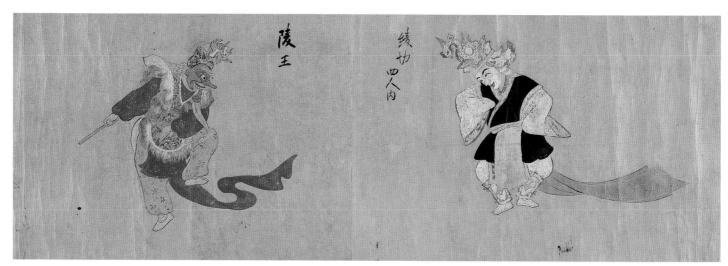

綾切
四人内

陵王

e.

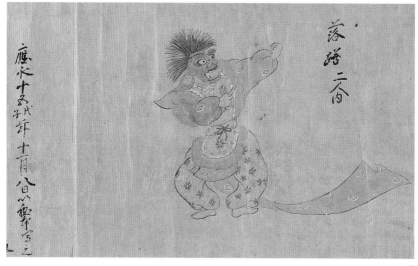

落蹲
二人内

應永十五戊子年
十一月八日以□
□□□寫之

f.

Norikoto's diary *Norikoto Kyō ki* (Record of Lord Norikoto) describes the circumstances of the scroll's production. Having seen a *bugaku* performance at the court, Norikoto was inspired to make a scroll based on the three scrolls in Prince Toganoo's collection. The entries in his diary from October 16 to November 8 record the progress of the copying project:

> *October 23, 1408:* Dancers paintings [three handscrolls in Prince Toganoo's collection] have been kindly lent to me. Suehide drew some figures to include in my scroll. *November 1:* Paints and other materials have been purchased, and Suehide examined them. *November 2:* Suehide came and drew the figures. *November 5:* Suehide came and drew the figures. *November 6:* Suehide came again and chose the colors. *November 7:* Suehide came and colored the figures. *November 8:* The copy of the dancers scroll was completed. Suehide did a splendid job. I gave him a gift of 50 *piki* [money as payment for the works].[9]

The payment of 50 *piki* to Suehide was more substantial than the 30 *piki* which Norikoto had paid to a professional Edokoro painter, Tosa Yukihiro (fl. 1406–34), for his painting of *Myōonten*.[10] The diary gives further insight into painting procedures and interaction among patrons and painters in the imperial society of this period. Obviously patrons initiated painting projects and sought out a painter. The painter, for his part, selected figures to depict and painted at the patron's house. The patrons purchased materials that the painter preferred to use.

Because of their function as "secret scrolls," handscrolls like this one were faithfully copied from time to time, to serve as valuable models to painters of later periods with interest in the dance. Many dance screens and fans of utilitarian nature have perished; however, several screens surviving from the seventeenth century demonstrate their close connection to the scrolls.[11] To fill the vast space of a screen, single figures taken from the scrolls were multiplied, sometimes extensively. The renowned *Bugaku-zu Screen* by Tawaraya Sōtatsu (d. ca. 1640) is the high point of the creative use of figures from the scrolls.[12] By arranging the dancers diagonally against the gold background, Sotatsu created a painting truly evocative of the drama and dynamism of the *bugaku* dances. This scroll is also the prototype for the versatile screen paintings of artists such as Sōtatsu.

Provenance unknown.

Published: Masahiko Aizawa, "Muromachi kyūtei shakai ni okeru mai-e seisaku to sono ichirei ni tsuite," *Kobijutsu* 58(1981).

Notes

1. Nobuo Tsuji, *Bugaku-zu byōbu ni tsuite,* Nihon byōbu-e shūsei, v. 12 (Tokyo: Kōdansha, 1980), 106.

2. Aizawa, "Muromachi kyūtei," 62.

3. Nobuo Tsuji, "Bugaku-zu no keifu to Sōtatsu hitsu Bugaku-zu byōbu," in *Rimpa kaiga zenshū, Sōtatsu,* v. 1 (Tokyo: Nihon Keizai Shinbunsha, 1977), 73.

4. Aizawa, "Muromachi kyūtei," 51.

5. Ibid., 60.

6. Ibid., 53, 55.

7. Ibid., 56–57.

8. Ibid., 59.

9. *Norikoto Kyō ki* is included in four volumes of *Shiryō Sanshū.* The entries from October 16 to November 8, 1408, are quoted in Tsuji, "Bugaku-zu no keifu," 79.

10. Aizawa, "Muromachi kyūtei," 60.

11. Tsuji, "Bugaku-zu no keifu," 71.

12. This famous painting is reproduced in many publications. For an easily accessible source, see William Watson, *Sōtatsu* (London: Faber and Faber Ltd., 1956), pl. 6.

16. SPLASHED-INK LANDSCAPE

Soga Sōjō (act. 1490–1512?)
Hanging scroll, ink on paper
Muromachi period
H: 82.8 cm W: 19.3 cm
1991.63

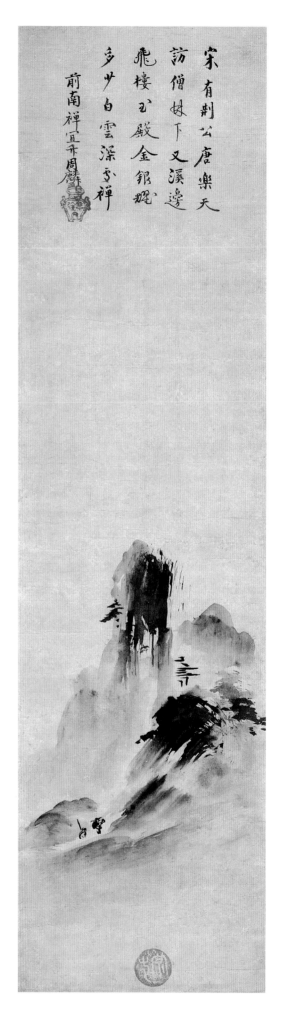

This small landscape painting is executed in *haboku* (splashed ink) manner, an ink-monochrome technique favored by Zen monks in China and Japan. Applied instantaneously, a few ink strokes and washes suggest the mountains, pavilion, path, and two human figures. The powerful expression is achieved by the contrast between the vigorous strokes and the broad, saturated washes, and of the intense black and the varying tones of gray. Although it looks simple and playful, splashed-ink technique is a most difficult idiom for a painter to rely on for serious works. Success is determined by the delicate balance between the artist's premeditated plan and the fortuitous effects of the execution.

Haboku technique originated in China and was perfected by Yujian, one of the Chinese Southern Song painters. In Japan this technique was also developed by Zen monk-painters, some of whom learned it in China. Although many tried splashed-ink landscapes, only a few were successful. Sōjō's *haboku* technique conveys a deliberate explosive motion that gives spiritual energy to the cold and forbidding landscape. It epitomizes the severe discipline of the Zen ideal, which conceived humans to be small in nature, yet significant because they have a potential of attaining Buddhahood by their spirituality.

Soga Sōjō belonged to the Soga school of ink painting, founded by Soga Bokkei (1410?–73). Soga school style and techniques were carried forward by generations of Sōjō's descendants throughout the late Muromachi period. By the sixteenth century, however, the identities of the painters and their works had become confused. Sōjō was identified as Soga Bokkei, and his masterworks, the paintings on sliding doors (*fusuma*) at the Shinjuan, a subsidiary temple of Daitokuji, were attributed to Bokkei, raising Bokkei's name to prominence, but leaving Sōjō in obscurity.

The confusion was caused, in part, by the pseudonym Jasoku (Dasoku), which was used by five successive generations of painters of the Soga school—Bokkei, Sōjō, Shōsen, Sōyo, and Shōjō. It seems also to have been the name for Soga's painting studio. Recent research on this school and its painters has revealed that Bokkei and Sōjō were two artists, most likely father and son.[1] Furthermore, documentary sources and circumstantial evidence clarified that Sōjō, not Bokkei, painted the *fusuma*

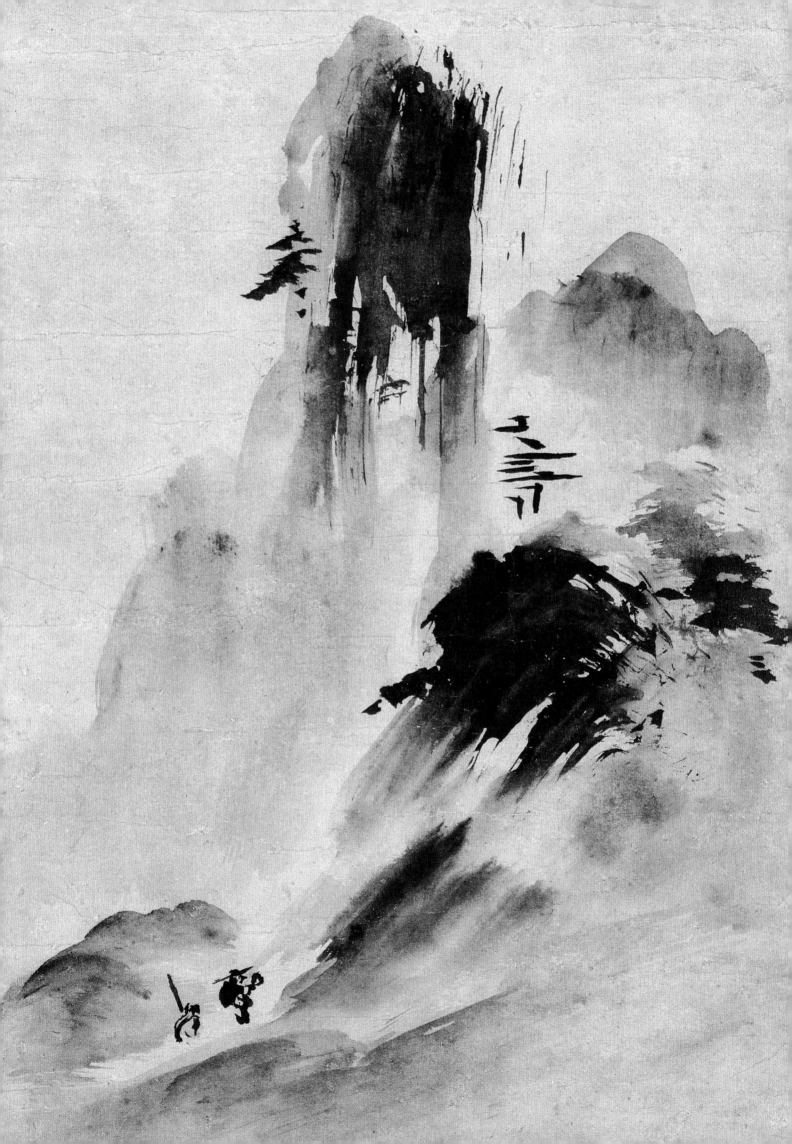

Poem and calligraphy by Gichiku Shūrin.

Seal, *Sōjō*.

at Shinjuan, which was built in 1491. Bokkei had died in 1473; thus Sōjō had to be the painter. This reattribution to Sōjō acknowledges him as the crucial figure who raised the school to fame in Muromachi ink painting.[2]

Soga Bokkei, originally called Hyōbu, was a samurai by birth who served the lord Asakura Norikage (d. 1463 at age eighty-four) of Echizen province.[3] Like other provincial lords of the time, Norikage maintained a residence in Kyoto, where he was active in cultural and religious affairs.[4] He was particularly influenced by the famous Zen priest Ikkyū Sōjun (1394–1481) of Daitokuji, with whom he studied Zen. Following Norikage, Bokkei came to Kyoto and also studied Zen under Ikkyū, from whom he later received the name Bokkei.[5] At the same time Bokkei studied painting under the renowned Zen-monk painter Shūbun (fl. 1414–63) of Shōkokuji, one of the five Zen temples. By 1455 he had become competent enough to paint Shūbun's portrait.[6] Bokkei particularly excelled in figure paintings executed in vigorous brushstrokes, which might indicate the stern aspect of the painter's personality. A few such examples are *Dharuma* and the *Portrait of Rinzai*, both in the collection of Shinjuan.[7] Depicted in wild and energy-charged brushwork, the paintings show little affinity with the more delicate paintings of his teacher Shūbun.

Bokkei's son Sōjō was active in the 1490s and seems to have died by 1512.[8] Like his father, he studied Zen under Ikkyū, whose portrait the painter later produced. Sōjō was a prolific, well-rounded painter who excelled equally in portraits, landscape, flowers and birds, and legendary figures. While Sōjō inherited and retained some of Bokkei's severe style, he developed his own gentle style, with the kind of refinement and lyricism seen in the *fusuma* paintings in Shinjuan. In those paintings the serious spiritualism of Shūbun was modified by intimacy and evocative lyricism. Sōjō mastered various brush techniques including descriptive and linear brushwork as well as the abstract *haboku* technique.

In addition to the Packard landscape, two more splashed-ink landscapes by Sōjō are extant: a landscape on *fusuma* panels in the *shoin* (abbot's quarters) of the main hall of Shinjuan, and a horizontal landscape inscribed by Bai'un Shōi (d. 1505). The Shinjuan *fusuma* landscape over four panels is extremely abbreviated,

with a few mountain peaks and two temple roofs only partially visible above the mist.[9] Tremendous skill was needed to paint the splashed-ink landscape flawlessly in the large space of the *fusuma*. The *shoin* painting is datable around 1491, a decade earlier than the Packard painting, which is datable to around 1503.

The *haboku* landscape with inscription by Bai'un Shōi is a little more descriptive, with mountains, forests near a beach, and two fishing boats at anchor near the bay.[10] The work combines strong, wet brushwork in jet-black ink and a contrasting, delicate, dry-brush technique. Bai'un was a Zen monk-poet at Tōjiji, and a good friend of Gichiku Shūrin, the eighty-third abbot of Shōkokuji, with whom he shared an interest in Chinese poetry. Bai'un died in 1505, providing the painting with its latest possible date.

In addition to its intrinsic artistic value, the Packard landscape has documentary merit: a round seal, *Sōjō*, impressed in the center bottom, and an inscription by Gichiku Shūrin. As curious as it may look, the seal is not unusual in Soga school practice. Sōjō's son Shōsen, for example, also impressed his seal in the center bottom. The round seal of Sōjō was already noted in *Bengyoku-shū*, and appeared in a few of Sōjō's paintings.

Gichiku Shūrin (fl. 16th century), also called Keijo, later became registrar-general at Rokuon'in. A talented composer of Chinese poems, he was sought to inscribe poems on ink paintings by monk-painters of the time. The poem below is included in the anthology of Shūrin's poems, *Kanrin koroshū*, and is datable between 1503 and 1505, further evidence that this painting is datable within a few years of 1503.

> In the Song period there was a painter Jing Haoran,[11]
> in the Tang period there was a poet Bai Juyi (Letian).
>
> A monk strolls in the forests and around streams,
> tall pavilion and mansion glitter in gold and silver.
>
> A few clouds float in the sky,
> a distant mountain silently awaits him.
>
> [Signed] Zen Nanzen Gichiku Shūrin
>
> [Seal] *Keijo*

Provenance: Kuhara Hisanosuke; see Ichimatsu Tanaka, "Soga Jasoku to Sōjō o meguru shomondai," *Bukkyō geijutsu* 79(April 1971): 34.

Published: Tanaka, "Soga Jasoku," pl. 7; Toyomune Minamoto, *Soga Jasoku,* Nihon bijutsu kaiga zenshū, v. 3 (Tokyo: Shūeisha, 1980), pl. 48.

Notes

1. Concerning Soga Bokkei and Sōjō and the confusion about them, see Toyomune Minamoto, "Soga-ha to Asakura bunka," *Kobijutsu* 38(Sept. 1972): 31–32.

2. Minamoto, *Soga Jasoku,* 108.

3. Minamoto, "Soga-ha," 31.

4. Ibid., 30.

5. Ikkyū Sōjun, *Kyō'unshū,* quoted by Minamoto; see "Soga-ha," 32.

6. Ibid., 33.

7. Minamoto, "Soga-ha" (unnumbered plate, 7th page).

8. Minamoto, *Soga Jasoku,* pl. 108.

9. Tanaka, "Soga Jasoku," pl. 6.

10. Ibid., pl. 6, 23.

11. Shūrin seems to have remembered Jing's date incorrectly; Jing Haoran's date is late Tang, not Song.

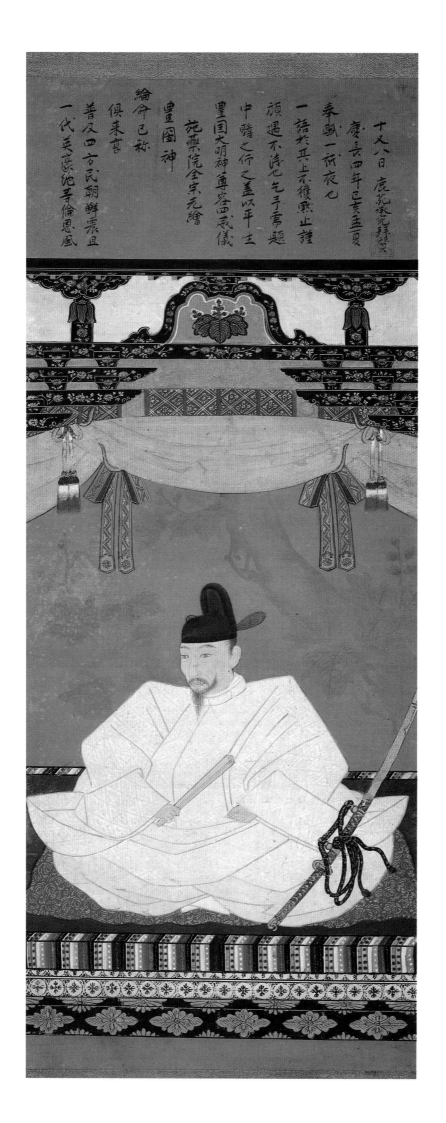

一代芙蓉綻等倫恩風
普及四方民朝鮮震且
倶来售
繪命已秋
豐國神
施藥院全宗元繪
豐國大明神尊容四歲儀
中壽之行之盖以平生
頑遇不得也气子高題
一語共其上亢獲黙止謹
奉飄一祈衣已
慶長四年己亥孟夏
十又八日鹿苑承兌拝誌

17. PORTRAIT OF TOYOTOMI HIDEYOSHI

Hanging scroll, ink and colors on silk
Inscription by Seishō Shōtai
Momoyama period, dated 1599
H: 90.7 cm W: 37.8 cm
1991.61

This portrait depicts the great warlord Toyotomi Hide-yoshi (1537–98) as a regent. He is seated on a raised mat (*agedatami*) in formal attire: headgear, a white robe (*nōshi*), loose, billowing trousers, and white silk socks (*tabi*). Behind him is a rolled curtain. He holds a cere-monial fan in his right hand and clenches his left hand near a long sword. The wide, staring eyes and pointed, bearded chin convey Hideyoshi's unattractive and often-noted "monkeylike" looks. On the back wall an ink land-scape dominated by a large paulownia tree is painted in a typical Momoyama composition. The space above the elaborate architectural structure over the figure is re-served for an inscription by Seishō Shōtai (1548–1607), director of the Zen seminary established by the shogun Ashikaga Yoshimitsu at Shōkokuji:

> The absolute hero of this generation exceeded all men of his time. His graciousness extended to all people. He performed diplomatic feats with Korea and China. At his death, by the emperor's order, he was venerated as the deity of the Hōkoku (Toyokuni) Shrine. The venerable Yakuin Zensō commissioned this painting. Here Hōkoku Myōjin (The Bright Deity of the Pros-perous Country) is dignified in appearance, causing us to look up to him with reverence. Perhaps because I received special favor from him during his lifetime, I was asked to write a line of inscription on this paint-ing. As I could not keep silent, I wrote this and re-spectfully dedicate it to him.

> April 18, 1599

> Reverently inscribed by Rokuon Shōtai

Emerging as a great warlord in the turbulent Momo-yama period, Toyotomi Hideyoshi completed the work of national hegemony in 1590. During the Warring States period from 1467 to 1568, a time of poor economy dur-ing the weak Ashikaga shogunate, Japan once again became a field for a succession of civil wars waged by ambitious provincial lords, who struggled for military supremacy. The turmoil continued into the Momoyama period.

Humble in origin but a brilliant military strategist, Hideyoshi succeeded in the campaign for national uni-fication begun by Oda Nobunaga (1534–82), another powerful lord, whom he had served from 1558 until

Nobunaga's assassination in 1582. In 1585 Hideyoshi was appointed *kampaku* (regent), and in 1586 was pro-moted by the new emperor, Go-Yōzei, to the office of Dajō Daijin (Grand Minister of State), the highest office that anyone except imperial court members could achieve. Hideyoshi's ambition to stabilize the country, and to secure the continuity of Toyotomi rule for his heir, looked promising at one time but was fragile, as it turned out. His imprudent attempts to invade Korea exhausted his resources and energy, and his son Hide-yori (1593–1615) was too young to succeed him when he fell ill. In 1598 Hideyoshi died in agony, worrying about his young son, whose future he entrusted to his closest lords, the so-called Five Great Elders. His earnest plea from his deathbed to these five, "Please, please take care of my son," is well known. But after Hideyoshi's death, severe competition for succession continued. Tokugawa Ieyasu (1542–1616), ten years Hideyoshi's junior and one of the Five Elders, emerged as the most powerful, and in 1603 finally succeeded in establishing national unity through the Tokugawa *bakufu* (military government). Earlier in 1599, a year after his death, Hideyoshi was venerated by the emperor as the Great Deity of the Hōkoku Shrine (Shrine of the Prosperous Country), where his tomb is located. The Toyotomi family was destroyed by the Tokugawa shogunate in 1615, inaugu-rating the Tokugawa period, which lasted until 1867.

This portrait is particularly important both as a work of art and as an invaluable document, as it con-tains the inscription, the date, and the names of those who commissioned and inscribed it. Another notable feature is the number 18, the day of Hideyoshi's death in August. Most good portraits of Hideyoshi include this number to memorialize this day. It was customary for people close to Hideyoshi to commission his portrait to commemorate his death anniversary. Yakuin Zensō, a Tendai sect priest and Hideyoshi's personal physician, had won Hideyoshi's confidence and was his constant companion during his military campaigns. A contem-porary source comments that "Zensō's opinions were always adopted, and that he got whatever he wanted."[1]

Seishō Shōtai was the ninety-second abbot of the Shōkokuji, and was the head administrator of all Zen priests in the hierarchy of the Five Zen Temples (*Gozan*) and Ten Additional Zen Temples (*Jissatsu*). He was also

Inscription by Seishō Shōtai, dated April 18, 1599.

one of Hideyoshi's political advisers and enjoyed special treatment. But he was politically minded, and after Hideyoshi's death, Shōtai did not delay in turning to serve Ieyasu, Hideyoshi's competitor.[2]

Relatively large numbers of portraits of Hideyoshi are known from records, and about eighteen are extant, of which ten are superior in quality.[3] Considering, however, that he was an important and successful political personage with legendary appeal, as well as inspiring because of his humble origin, this seems a rather small surviving number. Soon after the establishment of the Tokugawa regime, production of Hideyoshi portraits subsided, probably because he was a tragic transitional figure whose power diminished quickly when Ieyasu, in less than a decade, succeeded in finally consolidating the country.

There were two types of Hideyoshi portraits: a youthful-looking one best represented by the portrait at Hatakeyama Kinenkan, and an old-looking one, exemplified by that at the Itsuō Museum of Art (Fig. 12).[4] The Packard *Hideyoshi* is definitely related to the Hatakeyama type, where the figure has a mature but youthful look and the full vitality of middle age. The two types of portraits indicate that different *kamigata* (paper models) drawings existed showing Hideyoshi at different ages, on which portrait painters based their works.

Fig. 12. *Toyotomi Hideyoshi;* ink on paper; Momoyama period; Itsuō Museum of Art, Ikeda.

Provenance: The Mutaguchi family. The note on the photograph of this portrait at the Archive Room in the Tokyo National Museum indicates this family name as a provenance. See Masahiko Aizawa, "Kyū Mutaguchi-ke bon Toyokuni Myōjin zō o megutte," *Kobijutsu* 63(July 1982): 62.

Published: Aizawa, "Kyū Mutaguchi-ke," 49–62.

Notes

1. Aizawa, "Kyū Mutaguchi-ke," 52.

2. Ibid.

3. Shin'ichi Tani, "Hō Taikō gazō-ron," *Bijutsu kenkyū* 92(1939): 2.

4. Aizawa, "Kyū Mutaguchi-ke," 59.

18. MONKEYS PLAYING ON OAK BRANCHES

Pair of hanging scrolls, ink and colors on paper
Edo period
H: 177.5 cm W: 138.4 cm
1991.62.1–2

Now mounted in two hanging scrolls, these large paintings were formerly sliding-door panels (*fusuma*). The paintings are enlivened by four monkeys, three black and one white, playing on oak branches that extend horizontally at the top of both pictures. The larger monkey in the left scroll hangs from the branch in a position commonly known as "monkey trying to catch a reflection of the moon in water," a favorite Zen theme satirizing human folly. In the lower foreground, winding streams rush into pools. The rocks and streams are surrounded with sparse bamboo-grasses and blossoming flowers. Their green and white colors add a striking, lively effect to this otherwise monochromatic ink painting.

Energetic brushstrokes in wet ink in the tree trunks and boulders contrast with the fine, dry brushwork of the monkeys' fur. The broad oak leaves are masterfully rendered in the *tarashikomi* (lit. dripping into) technique, where wet ink, applied on the wet surface of the paper, takes the desired forms without contour lines. This technique became the trademark of the Rimpa school, especially of the artist Tawaraya Sōtatsu (d. ca. 1640) of the early Edo period.

Resembling humans in look and behavior, curious monkeys were closely observed and depicted in Chinese paintings as early as the thirteenth century, and in Japanese paintings in the fourteenth century, by Zen monk painters of the Muromachi period.

The most influential monkey painter is a late thirteenth-century Chinese Zen monk, Muxi (d. ca. 1269–74), whose works were brought back to Japan by Japanese Zen monks who had visited China. A number of Muxi's monkey paintings existed in Japan in the fourteenth century; for example, a 1365 inventory of works at Engakuji, a Zen temple in Kamakura, records one monkey painting by Muxi. His most famous monkey painting is extant in Daitokuji in Kyoto.[1] Today it is the right-hand scroll of a triptych of the White-robed Kannon and a crane. In it, a mother monkey sits on a branch high above the ground, cuddling her baby. The serene, contemplative monkey is thought to express either motherly love or a profound Zen thought. Imported to Japan in the late thirteenth or early fourteenth century, Zen Buddhism, with its faith in human ability to arrive at enlightenment and its emphasis on discipline, appealed especially to the military class.

The Japanese had a special fondness for monkeys, as they were native to Japan. During the fifteenth and sixteenth centuries, Japanese artists, inspired by Muxi's monkeys—long-armed, with round heads, white faces, and facial features gathered in the center—developed two types of monkeys. The idealized monkey with a pious expression is exemplified in paintings by Sesshū Tōyō (1420–1506) and other Zen monks, as well as painters in the Ami and Kano schools. The first type culminated in the late sixteenth century in the work of Hasegawa Tōhaku (1539–1610).[2] A native of Noto province, Tōhaku studied painting under Kano Shōei (1519–92) or Eitoku (1543–90). With his excellent command of ink and brush, he eventually founded his own school. The individualistic types were developed by painters like Shikibu Terutada (fl. early 16th century), Sesson Shūkei (1504–89?), and Tawaraya Sōtatsu, who adopted Muxi's type of monkey into their personal painting styles.

In addition to its Zen connotation, the monkey was connected to a popular belief, originating in China, that these animals were guardians of horses.[3] In Japan the belief appealed particularly to the samurai whose horses were a symbol of power and an important part of a warrior's armament. Monkeys appeared in paintings of samurai stables.[4] From the viewpoint of both Zen and their guardian role, monkeys became an appropriate painting theme to decorate samurai mansions and castles.

The renowned gibbon painting by Hasegawa Tōhaku, now mounted as a hanging scroll at Ryūsen'an, a subsidiary temple at Myōshinji, originally belonged to panels of a screen in the Maeda clan's Komatsu castle in Kaga.[5] The Packard pair is said to have been *fusuma* panels in the Toda clan's Matsumoto castle in Nagano. Although documentation of this provenance has yet to be pursued, both paintings' theme, their large scale, and evidence on each that a door-catch has been removed, attest that they were likely once *fusuma* panels in a grand castle or mansion of a high-ranking samurai.

The Packard paintings bear no inscription or painter's seal. Their style, however, suggests an Edo period date, inspired by the grand style of the preceding Momoyama period. The composition with powerful oak trees truncated at the top (commonly called a

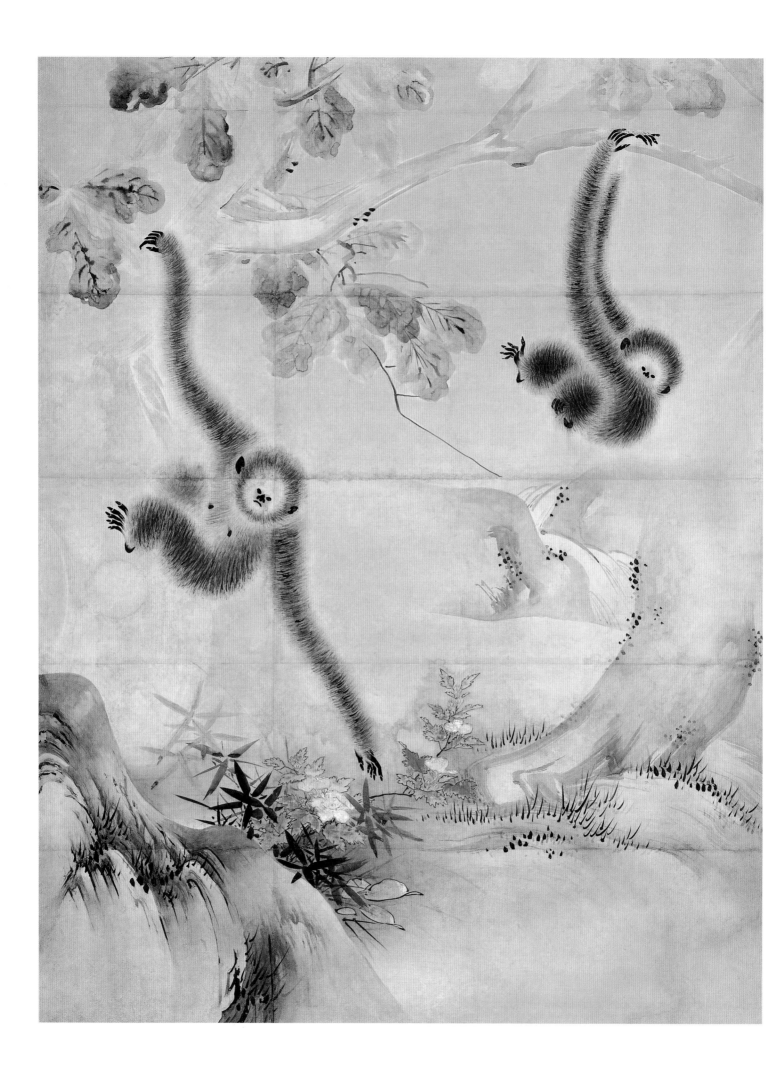

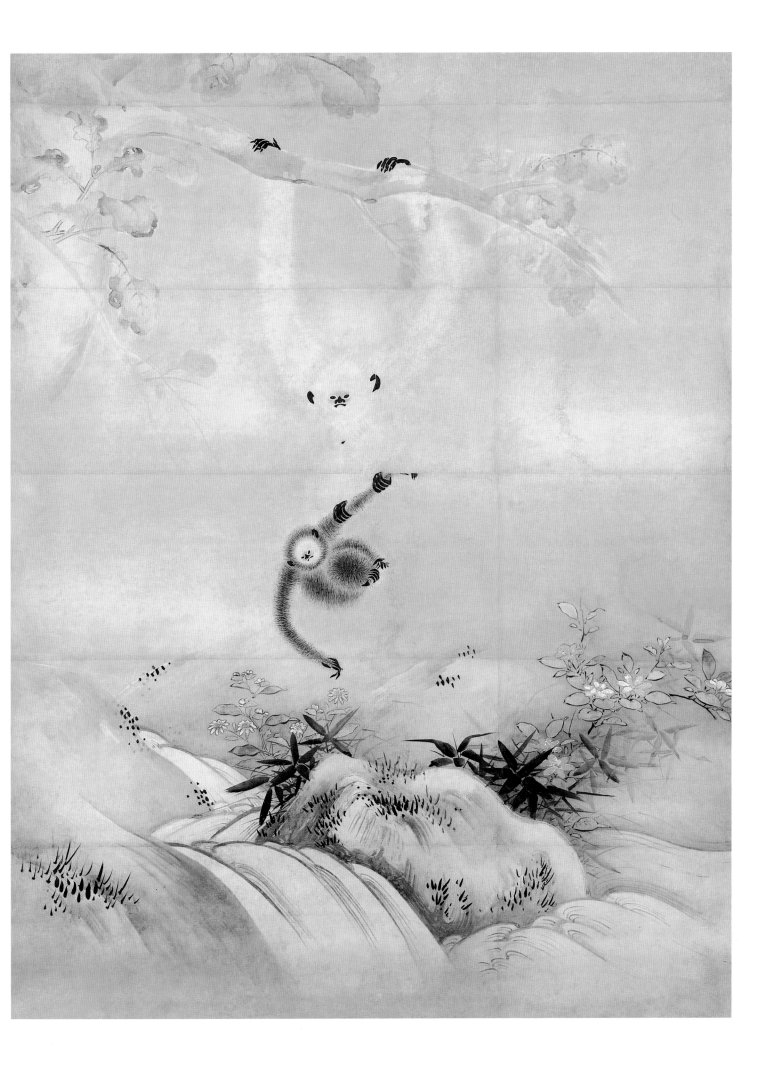

"heroic tree") is a typical compositional device in Momoyama screen paintings. The skillful use of ink, attested in the tree trunks and the leaves, suggests that the painter was highly trained in the ink-painting tradition of the Hasegawa and Kaihō schools. The monkeys have close affinities with those of Muxi-style prototypes of the sixteenth/seventeenth century, especially of Hasegawa Tōhaku.

In the Packard scroll, the larger monkey hanging by the right hand from a branch and with left arm reaching to the water is very close to a monkey in the screen at Konchiin at Nanzenji, which is attributed to Tōhaku.[6] The Packard monkey is reversed. The smaller monkey hanging from a branch with both hands is identical to one in another screen attributed to Tōhaku.[7] From their general postures-to the fine details, such as the rendering of fingers and feet, the two monkeys are virtually identical. This suggests the availability of instruction books (*funpon*), which showed painters how to render monkeys step by step. The faces, however, and the rendering of the fur, differ slightly, marking this anonymous painter's personal style.

The rocks and floral forms as well as the Packard composition's overall dynamism have very strong reflections of the style of Kaihō Yūshō (1533–1615). Seventeenth- and eighteenth-century painters borrowed old styles and techniques, making it a little difficult to attribute this painting to a single painter or place it in a school. But it is reasonable to assume that the painter had very good training in the Hasegawa and Kaihō school styles of the Momoyama period.

Provenance unknown.

Unpublished.

Notes

1. On Muxi's *Monkeys* as a part of the triptych in Daitokuji, see "Daitokuji Mokkei enkakuzu," *Kokka* 185(1905) and "Kannon-zu," *Kokka* 265(1912).

2. Yukihiko Fujishima, "Nihon ni okeru Mokkei-fū enkō-zu no tenkai," *Bijutsushi kenkyū* 21(1984), quoted by Kaoru Uchiyama, "Hasegawa Tōhaku hitsu Chikurin enkō-zu byōbu o megutte," *Kokka* 1164(1993): 38.

3. Yoshida Mitsukuni, "Sōjūga no genryū," *Sōjūga, Ryūko Enkō*, Nihon byōbu-e shūsei, v. 16 (Tokyo: Kōdansha, 1979), 146–47.

4. Ibid., pl. 60 and pl. 63, a work in the collection of the Cleveland Museum of Art.

5. Tsuneo Takeda, *Tōhaku, Yūshō*, Suiboku bijutsu taikei, v. 9 (Tokyo: Kōdansha, 1973), 57–58.

6. For the monkey *fusuma* painting at Konchiin at Nanzenji, see ibid., pl. 39. For the monkey screen in Shōkokuji, see *Sōjūga, Ryūko Enkō*, pl. 50; for *Monkeys* in Ryūsen'an at Myōshinji, see ibid., pls. 48, 49.

7. Ibid., pl. 54.

Pair of six-panel screens, ink, colors, and gold on paper
Edo period, early 17th century
Each: H: 93.0 cm W: 271.0 cm
1991.65.1–2

This pair of screens strikingly combines two entirely different themes. The right-hand screen illustrates nine narrative scenes from the *Tale of Genji,* each vignette depicted in bird's-eye view and isolated by gold clouds. The left-hand screen depicts a single theme, an aviary containing many lively birds in a unified composition. Despite the obvious and unusual differences in subjects and compositional schemes, the two screens' uniformity of size, shared techniques such as the embossed gold clouds, and materials confirm that they were intended as a pair.

The *Tale of Genji,* the world's oldest novel, written in the late eleventh century by Murasaki Shikibu, a lady-in-waiting to Empress Akiko, provided Japanese artists with endless sources of inspiration for narrative paintings. In fifty-four chapters, the novel unfolds stories of the life of the fictional Prince Genji, who possessed aristocratic birth, great charm, and a brilliant talent for poetry, but who lacked the opportunity to ascend the throne. Forty chapters are devoted to Genji's amorous life with numerous women. The remaining chapters narrate the lives of his son and grandson. From the tale's first appearance, the Japanese were captivated by Genji's spectacular yet unfulfilled life. From the twelfth to the twentieth century, famous episodes were illustrated in the colorful *yamato-e* style in every painting format—handscroll, album, hanging scroll, and screen. These paintings subtly expressed not only the stories, but also the customs, values, aesthetics, and pathos of the people who lived in the highly refined aristocratic society of the later Heian period.

The oldest extant painting of the *Tale of Genji,* dating to the twelfth century, was done by painters in a court workshop. Nineteen paintings survive from what was once a much larger set. Originally the paintings were mounted in a handscroll format alternating with passages from the text. These early paintings are now kept in two museums, the Tokugawa Reimeikai and the Gotō Museum in Japan.

In the seventeenth and eighteenth centuries, albums and folding screens were favorite formats for *Genji* paintings. Like a book, a *Genji* album contains small pages folded accordion-style, in which depictions of episodes are mounted alternately with calligraphic pages of the text. To satisfy the exacting observation of one viewer or a small group in a private situation, the paintings were executed carefully in minute detail. Folding screens, on the other hand, differ from albums in both size and purpose. Functioning as room dividers and interior decorations, paintings on wall-size screens required clarity in design and a limited color scheme. In some screens, a single scene in a unified composition fills the entire space; others present several narrative scenes in spaces isolated by surrounding gold clouds.

Here, in the left screen, nine episodes from nine chapters are spread for the most pleasing compositional effect (see schematic layout), but not in strict consecutive order of the chapters. The first episode is from Chapter 1, "The Paulownia Court" (*Kiritsubo*). It depicts Prince Genji's initiation ceremony at age twelve, an occasion on which he received the cap of an adult and had his hair ceremonially cut. The Kiritsubo emperor is present on the throne, before which the boyish Genji stands.

The second episode, from Chapter 3, "The Shell of the Locust" (*Utsusemi*), depicts Genji coming to the house of Utsusemi, a provincial governor's wife of whom he was enamored. Hoping to observe Utsusemi and her stepdaughter playing *go,* Genji peeks inside, leaning over the blind.

The third scene, from Chapter 10, illustrates "The Sacred Tree" (*Sakaki*), where Genji visits the Lady Rokujō at her temporary residence at a shrine. Genji pushes a branch of the sacred tree in under the blinds, apologizing for neglecting her in the past weeks.

The fourth episode, from Chapter 11, "Orange Blossoms" (*Hanachirusato*), illustrates Genji's visit to Reikeiden and her sister San-no-Kimi at their residence near Nakagawa, where the woman is playing a *koto.* Genji has his carriage turned so he can observe her.

The fifth episode, from Chapter 14, "Channel Buoys" (*Miotsukushi*), illustrates the story of Genji and the Lady Akashi. While in exile, Genji had an affair with this lady, who bore him a daughter. This child was later married to the emperor and received the title Akashi Empress. The scene shows Genji and his entourage resting on the shore of Naniwa Bay (near present-day Osaka). Just as the Lady Akashi's boat enters the bay, Genji's retainer brings him ink and a brush so that he can write a note to her.

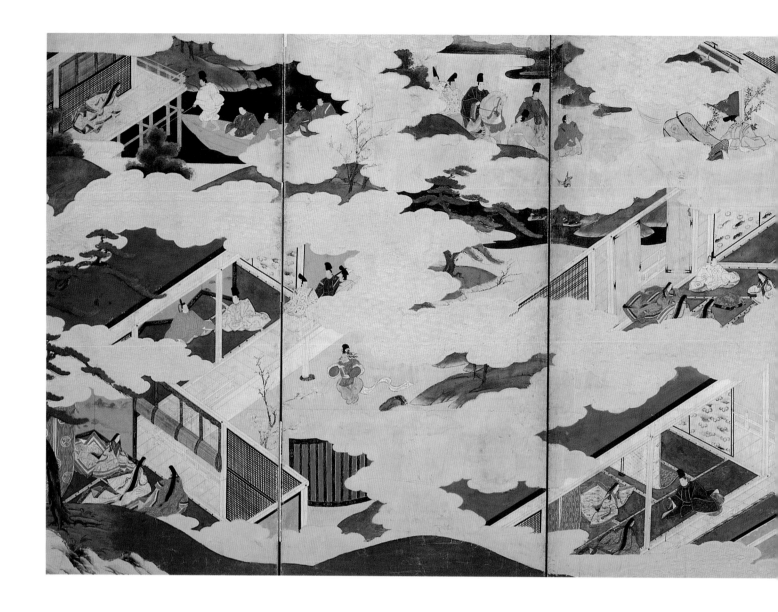

46	11	22		14	1
				3	
40		10			28

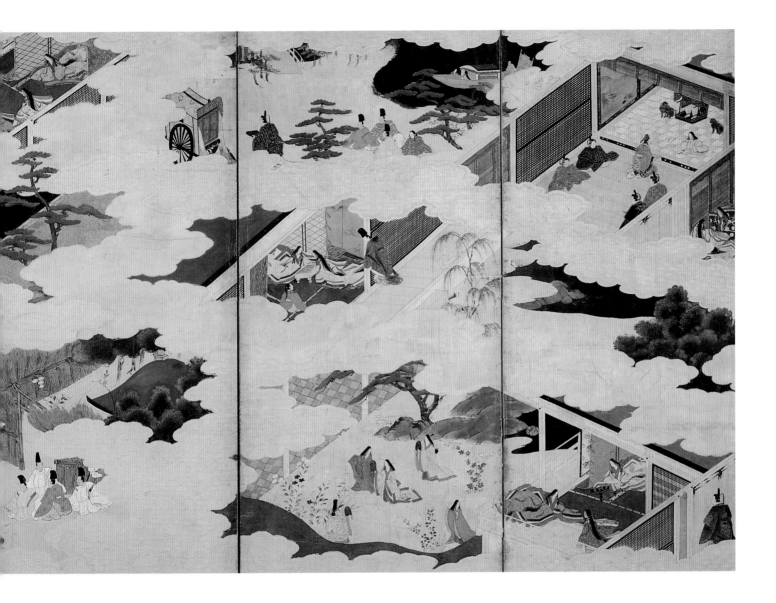

Fig. 19. *Tale of Genji* screen showing location of the episodes by chapter.

1. *Kiritsubo* (The Paulownia Court)
3. *Utsusemi* (The Shell of the Locust)
10. *Sakaki* (The Sacred Tree)
11. *Hanachirusato* (Orange Blossoms)
14. *Miotsukushi* (Channel Buoys)
22. *Tamakazura* (The Jeweled Chaplet)
28. *Nowaki* (The Typhoon)
40. *Minori* (The Rites)
46. *Shiigamoto* (Beneath the Oak)

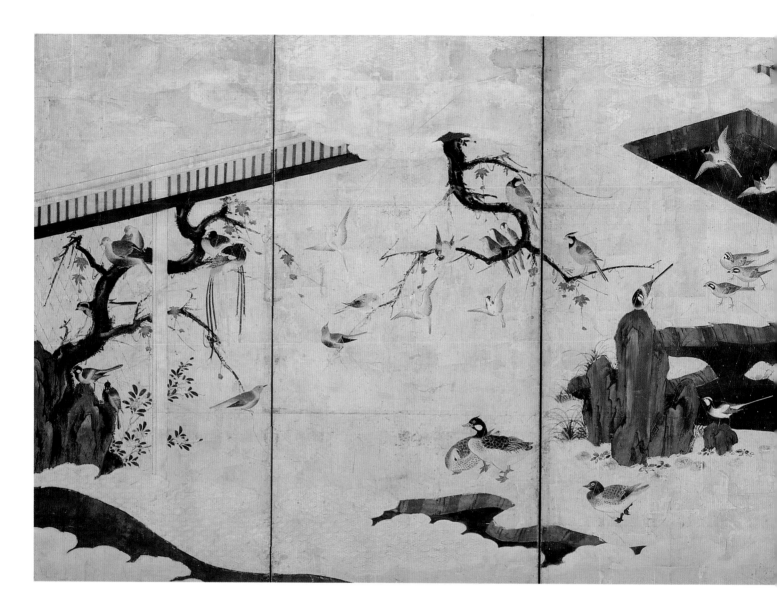

The sixth scene, from Chapter 22, "The Jeweled Chaplet" (*Tamakazura*), depicts Genji's gift for the winter season. Genji and his wife Murasaki put dresses in chests to distribute to people, some of whom are Genji's women.

The seventh scene, from Chapter 28, "The Typhoon" (*Nowaki*), depicts Yūgiri (son of Genji and Aoi) visiting Akikonomu's quarters as Genji's messenger. He sees many women in robes in deeper shades of autumn colors. Little girls are laying out insect cages in the garden. They pick wild carnations damaged by the typhoon.

The eighth episode, from Chapter 40, "The Rites" (*Minori*), illustrates the dedication ceremony of sutras at Nijō on the tenth day of the third month. The Lady Akashi and the Lady of the Orange Blossoms (Hana-chirusato) enjoy watching a *bugaku* dancer perform the role of Ryōō (General Ling).

The ninth scene, from Chapter 46, "Beneath the Oak" (*Shiigamoto*), depicts Prince Niou, Genji's grandson, and many princes and sons of ministers as they make an excursion to Uji, on the Uji River.

The same decorative cloud pattern continues from the right screen to the first panel of the left. Over the other five panels is a splendid scene of a large aviary constructed with bamboo nets. Vertical panels made of finely knit blinds of split bamboo are reminiscent of the fence over which purple morning glories spill, in the Tenkyū-in of Myōshinji, attributed to Kano Sanraku (1559–1635).[1] Inside the aviary is a pond with inlets and an island, tall rocks, and trees. A great variety of carefully observed birds—ducks, mandarin ducks, sparrows, quail, chickadees or titmice, magpies, and others—are depicted as they freely fly about and enjoy themselves on the trees, rocks, and in the pond of the spacious enclosure.

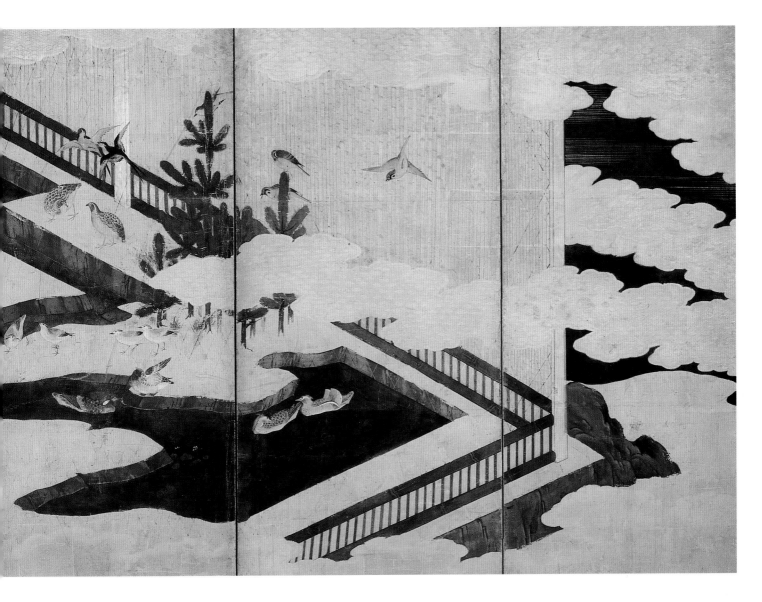

Representation of a variety of birds reflects a kind of encyclopedism typical of the early seventeenth century. The specificity of the aviary scene suggests that it was painted for someone, perhaps a court noble, who owned such a collection of birds. From the most ancient periods, the Japanese have loved beautiful birds; handscrolls and screens illustrate their appreciation of native as well as migratory birds. Sometimes unusual species were kept in aviaries. A section of a handscroll, *Kasuga Gongen genki-e,* dated 1309, depicting the life of a successful government official, Tachibana no Toshimori, shows an aviary built between two buildings of a *shinden*-style mansion (Fig. 13).[2] A stream springs under a pavilion and runs through the aviary, continuing into a pond with an island. The construction of the aviary is similar except for the pattern of the bamboo net, which is a chicken-net pattern. The aviary was obviously built beside the family quarters where children were casually playing.

The elimination of human figures from the architectural setting in the aviary screen is unusual but not unprecedented. A similar example may be seen in the screen of a *koto,* painted by a Momoyama period Tosa school painter. The *koto* screen, which occupies the entire screen space, is supposed to allude to *Hahakigi* ("The Broom Tree," Chapter 2 of *Tale of Genji*).[3] Here a *koto* is placed in the middle of a room, which is enclosed by *fusuma* and bamboo blinds, but neither a *koto* player or any other human figure is represented. Autumn-colored maple leaves are falling, and the damaged fence alludes to a lonely autumn night.

Traditionally the Tosa school painters had a close connection with the Court Painting Academy (Edo-koro) and expertise in the *yamato-e* style of narrative

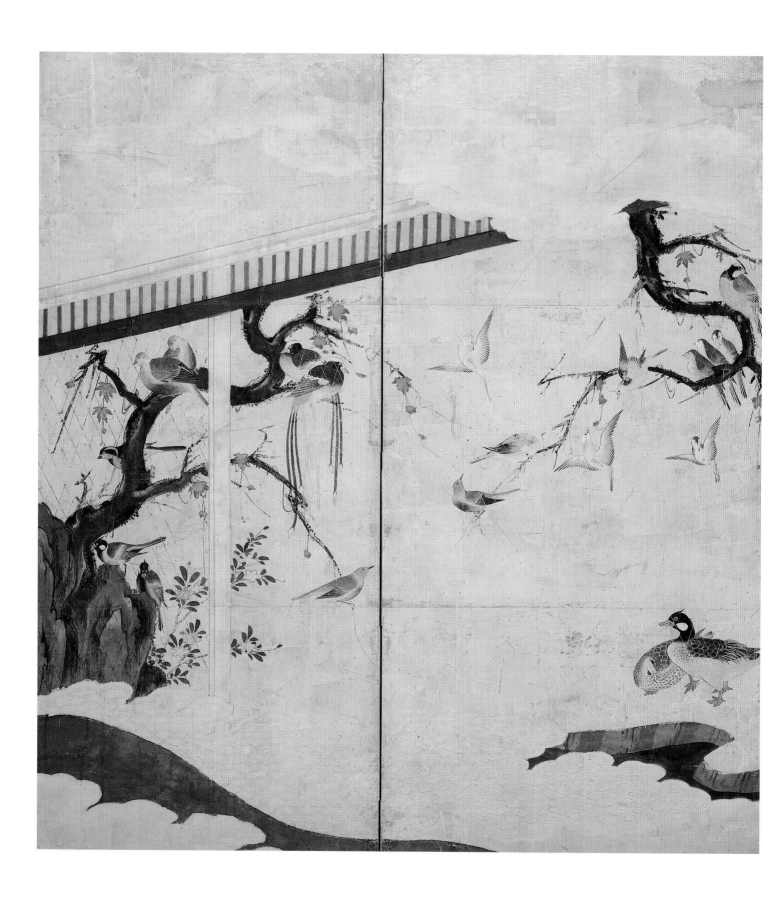

Fig. 13. *Kasuga Gongen genki-e*, aviary detail; handscroll, ink and color on paper; Kamakura period, dated 1309; Sannomaru Shōzōkan, Imperial Household Agency. Photo: Kadokawa Shoten, Tokyo.

paintings such as the *Tale of Genji;* they maintained their speciality for centuries. Toward the end of the sixteenth century, however, the Kano school painters, who had specialized in landscape styles of Chinese derivation with strong brushwork, expanded their repertoires to large, decorative screens of narrative subjects. Certain features in these Packard screens, such as the drawing of rocks in the aviary, suggest that they were the work of a Kano school artist who also had had good training in the Tosa school.[4]

Provenance: Joe Brotherton.

Published: *Kinsei kyūtei no bijutsu,* Nihon bijutsu zenshū, v. 19 (Tokyo: Gakushū Kenkyūsha, 1979), fig. 102; *Shōhekiga,* Zaigai Nihon no shihō, v. 4 (Tokyo: Mainichi Shinbunsha, 1979), 139, pl. 74; *Edo shoki no kachō: Shōsha na sōshokubi,* Kachōga no sekai, v. 5 (Tokyo: Gakushū Kenkyūsha, 1981), 146–47; Yoshiaki Shimizu, *Genji: The World of a Prince* (Bloomington: Indiana University Art Museum, 1982), 31–32.

Notes

1. *Edo shoki no kachō,* pls. 11–17.

2. *Kasuga Gongen genki-e,* section 2 of the 5th scroll, in Nihon emakimono zenshū, v. 15 (Tokyo: Kadokawa Shoten, 1963), pl. 2.

3. *Muromachi jidai no byōbu* (Tokyo: Tokyo National Museum, 1989), pl. 44.

4. Shimizu, *Genji: The World of a Prince,* 33.

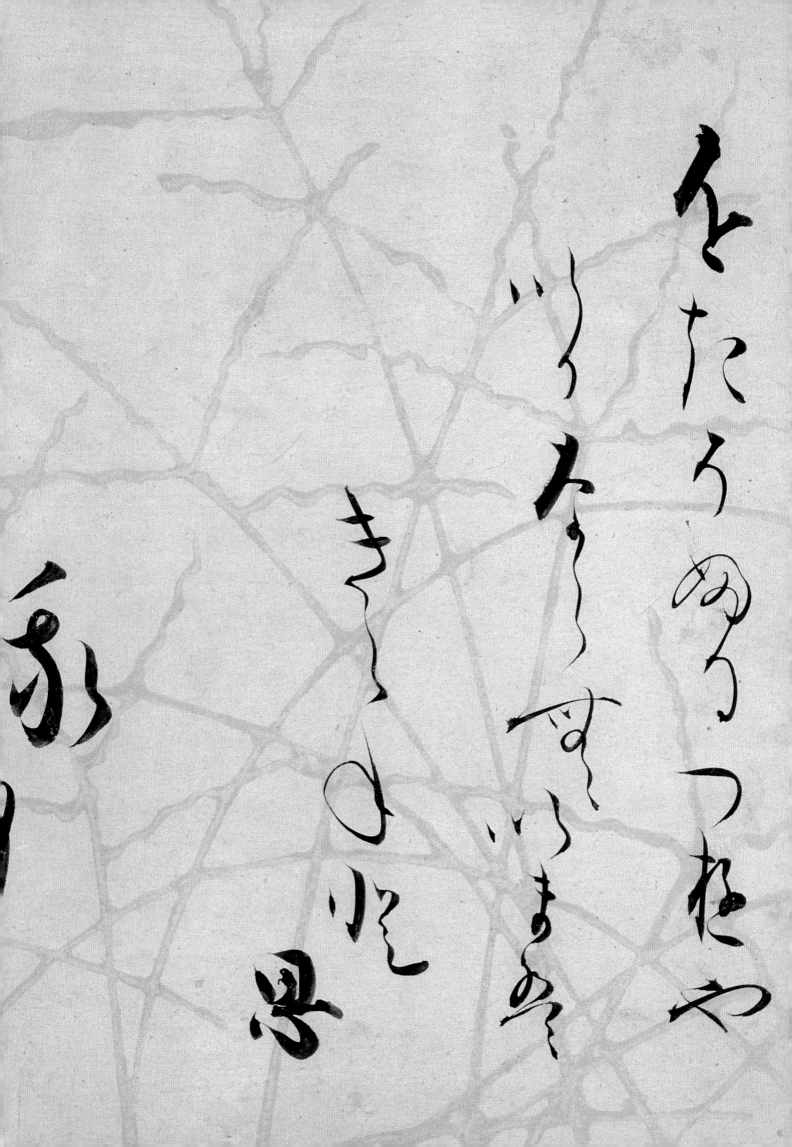

20. SIXTEEN POEMS FROM THE SHIN KOKIN WAKASHŪ

(New Collection of Ancient and Modern Poems)
Calligraphy by Hon'ami Kōetsu (1558–1637)
Paper designs by Tawaraya Sōtatsu (d. ca. 1640)
Seals: Kōetsu, Keikokuryō (*kanzō-in*)
Handscroll, ink and mica on paper
Edo period
H: 22.8 cm L: 570.0 cm
1991.64

This long handscroll consists of fifteen sheets of paper dyed in five colors: pale cream, green, yellow-green, orange-brown, and light orange. The papers are woodblock-printed with mica flecks, and include ten designs: maple tree, mountain near water, water plants, flying cranes, plum branches, bamboo, pampas grass, two of a full moon over pine-covered mountains, and *mehishiba*, a kind of grass. These colored sheets were originally produced as paper covers for luxury editions of the books that Kōetsu and his rich friend Suminokura Soan (1571–1632) published from 1605 to 1610. Named after the location of its press, Saga, the books were commonly called Saga-bon. These books included classical literature such as the *Tale of Genji, Tales of Ise,* and Noh play librettos.

Saga-bon books were bound in beautiful papers with designs by Sōtatsu printed by woodblock in inks flecked with either gold, silver, or mica, or a combination of them. Each standard-size paper measures approximately 22.8 cm high and 35 cm wide. When the blocks were coated a bit excessively with these metallic solutions, the impressions would leave puddles, creating accidental effects much like those of *tarashikomi* (lit. "dripping into"), a painting technique where ink is dropped on the paper to which ink has already been applied, so that the two ink solutions merge together to give a form without outlines. Texts by Kōetsu in *kana* script were also carved on blocks and printed.

Calligrapher Hon'ami Kōetsu and the painter and designer Tawaraya Sōtatsu frequently collaborated in artistic productions. These two artists, expressing the essence of Japanese taste and style, had a long-lasting influence on later artists. They are considered the arbiters of an artistic current of the late Momoyama to the Edo period. This handscroll is one of their collaborations. Over its expanse Kōetsu wrote sixteen love poems extracted from the *Shin Kokin Wakashū* (New Collection of Ancient and Modern Poems), compiled in 1205 at the direction of the retired Emperor Gotoba (1180–1239) by a committee headed by Fujiwara no Teika (1162–1241). The anthology contains 2008 poems in twenty volumes. The sixteen poems in this scroll, in chronological order from 1158 to 1173, are from the chapter on love.

In his fluid style, Kōetsu writes lines in rhythmic alternation of bold and delicate, dark and light strokes. Starting with thick, round letters, the brushstrokes often end in extremely thin lines, particularly in the case of the small characters.

The few years from the Momoyama to early Edo period were politically turbulent, but were a golden age of cultural and artistic development. A series of brutal civil wars continued among the ambitious warlords, but in the civilian sector the vital, free spirit of the time inspired talented artists to pursue new artistic ideas and technical innovations. For example, they made superb screens and sliding doors in bold designs, with abundant use of bright colors and gold, to decorate the mansions of warlords and temple interiors. As the period came to a close toward the seventeenth century, eventually ending in peace and stability, the aristocratic families and rich merchants in Kyoto became patrons who acquired luxurious articles in the classical style. The revival of ancient literature and art was part of this current. Rich townsmen practiced writing *waka* (a poem of thirty-one syllables) and studied the ancient calligraphic styles of the Heian and Kamakura periods. Poems and calligraphy by famous poets in the past, above all those of Fujiwara no Teika, were much admired and emulated. The leading figure of this revival was Hon'ami Kōetsu, who wrote ancient poems in his elegant style on handscrolls and poem cards (*shikishi*).

To establish his own style, Kōetsu assimilated various sources: he had trained with Prince Shōrenin Sonchō (1571–1632), whose style was popular at the time, and had studied original calligraphic works (*kohitsu*). Kōetsu's calligraphy was enhanced by the beautiful papers designed by Tawaraya Sōtatsu, whose inspiration also derived from the classical *yamato-e* tradition of the Heian and Kamakura periods.

Between 1607 and 1610, the woodblock-printed papers designed by Sōtatsu reached a peak in quality, design, and printing techniques. Those with mica designs, in particular, were most in demand, especially for Saga-bon. About 200 designs printed against dark background colors came to be available. It was a technical challenge to dye papers in deep, solid colors on which the designs in these metallic pigments would stand out.

a.

b.

c.

d.

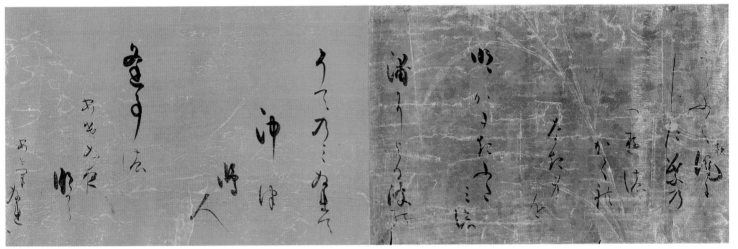

e.

f.

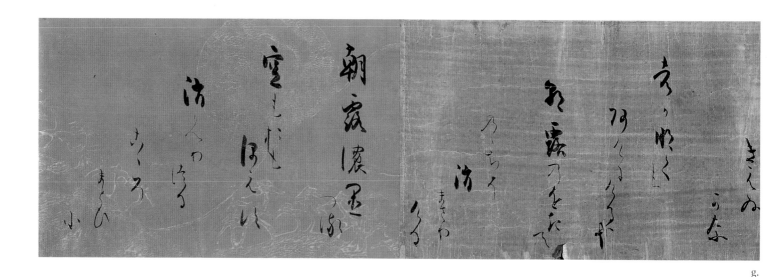

g.

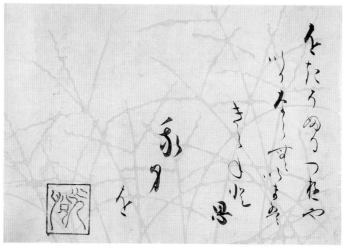

h.

By 1607, papers in orange, brown, green, and yellow-green were available. These mass-produced sheets were sometimes joined to make long scrolls.

The designs on two sheets in this handscroll are found in Saga-bon binding papers for a Noh playbook, *Taema*, written by the prominent Muromachi period Noh playwright Zeami (1363?–1443?). Against an orange-brown ground, a design with a full moon over a pine-covered mountain is printed in mica. The large moon has just risen above one mountain and illuminates the pines. Although the Packard scroll is not dated by Kōetsu, the 1609 publication date of *Taema* allows us to date it around this time—that is, several years before Kōetsu moved to Takagamine in 1615. The peak of technical development in woodblock printing occurred at the height of Kōetsu's and Sōtatsu's greatest virtuosity, when this scroll was made.

Kōetsu was a son of Katayama Kōji, who founded a branch of the Hon'ami family in Kyoto. The family business included cleaning, polishing, and appraising sword blades, which were very much in demand in the unsettled late Momoyama period. Their clients included famous warriors of the time: Oda Nobunaga (1534–82), Tokugawa Ieyasu (1542–1616), and Maeda Toshiie (1538–99). Kōetsu's father operated the same kind of business as the other branch of the family.[1] Although little is known of Kōetsu's life before his father's death in 1603, he was very likely trained in art and literature as well as in the family's sword business.

Sōtatsu, a brilliant designer and painter, and proprietor of an art shop, Tawaraya, was connected with Kōetsu through marriage to one of his cousins. It is not clear how the shop was operated, but speculation is that it was one of those painting shops (*eya*) in Kyoto which emerged at the end of the Muromachi period. *Eya* seem to have produced craft-type artifacts—screens, fans, and poem cards—and became increasingly prosperous by catering to affluent merchants. By 1615 Tawaraya had become famous.[2] In 1602 Sōtatsu began to collaborate with Kōetsu in a restoration project of the famous twelfth-century sutra *Heike Nōkyō*, in the collection of the Itsukushima Shrine.

In 1605 Sōtatsu began providing Kōetsu with writing papers decorated with his designs, either painted or woodblock-printed. Kōetsu and Sōtatsu continued to work together on Saga-bon publications as well as on many scrolls and *shikishi*, including the *Deer Scroll* (now divided among the Seattle Art Museum, MOA Museum of Art, and others). In 1615 Tokugawa Ieyasu, first shogun of the new Tokugawa *bakufu* (military government), granted Kōetsu a piece of land at Takagamine, northwest of Kyoto. Eventually fifty-five families settled there. All ardent believers of the Hokke sect, the settlers lived a disciplined religious life of chant and prayer and worked as artists and craftsmen.

For some reason Sōtatsu did not move to Takagamine with Kōetsu; his name does not appear on the map of the colony. He most likely remained in Kyoto and pursued an independent course as a painter. Toward the end of his life, Sōtatsu apparently ceased collaborating with Kōetsu.[3] The attribution of the paper decorations to Sōtatsu is based largely on their stylistic resemblance to his paintings.[4]

The paper backings in this scroll are composed of decorated sheets, like the front sheets. Each seam is stamped with gourd-shaped seals with illegible characters. Kōetsu's scrolls often bear on their versos the seal of Kamiya Sōji. He and his father were Chinese paper craftsmen (*karakami-shi*) who lived in Takagamine.[5] Since his seals appear only on the versos at the seams, it is speculated that he was a mounter. Kōetsu's scrolls made after 1626 do not bear Sōji's seal. The fact that the Packard scroll lacks Sōji's seal may indicate that it was remounted at some later time.[6]

Provenance: The handscroll was owned by Dō Shōan, a member of the circle of Kōetsu's friends. See Toyomune Minamoto, *Tawaraya Sōtatsu*, Nihon bijutsu kaiga zenshū, v. 14 (Tokyo: Shūeisha, 1976), 143.

Published: *Kōetsu sho Sōtatsu kingindei-e* (Tokyo: Asahi Shinbunsha, 1978), pl. 25: 1–8; Minamoto, *Tawaraya Sōtatsu*, pl. 94.

Notes

1. Toyomune Minamoto, "Hon'ami Kōetsu no geijutsu," in *Kōetsu no sho* (Osaka: Osaka Municipal Museum, 1990), 263.

2. Yasushi Murashige, "Rimpa no Kōbō," in *Rimpa Hyakuzu; Kōetsu, Sōtatsu, Kōrin, Kenzan, Bessatsu Taiyō* (Spring 1974): 163.

3. Hiroshi Mizuo, "Kōetsu sho Sōtatsu kingindei-e no suii," in *Kōetsu sho Sōtatsu kingindei-e*, text vol., 76.

4. Murashige, "Rimpa no Kōbō," 164 and 166. Unmistakably Sōtatsu, no one else could have done these works. See Yuzō Yamane, *Rimpa*, Zaigai Nihon no shihō, v. 5 (Tokyo: Mainichi Shinbunsha, 1979), 58.

5. Yuzō Yamane, "Sōtatsu kingindei-e no seiritsu to tenkai," in *Kōetsu sho Sōtatsu kingindei-e*, text vol., 110.

6. Toshiko Itō, "Kōetsu no shoseki," in *Kōetsu sho Sōtatsu kingindei-e*, text vol., 110.

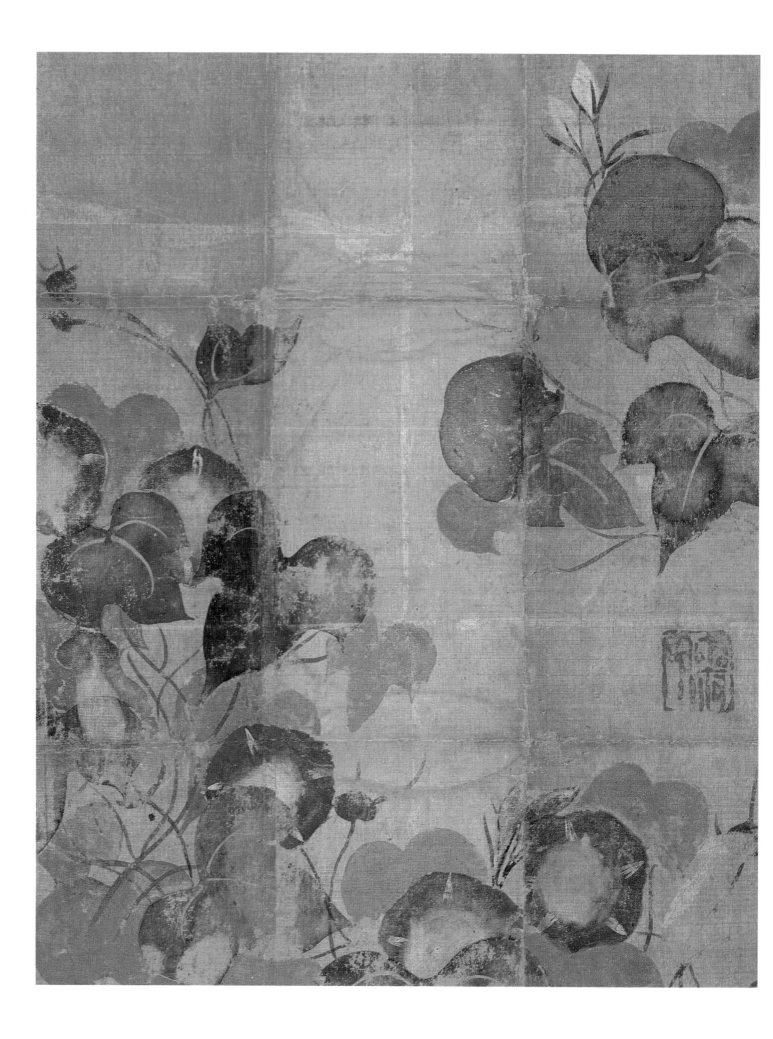

21. MORNING GLORIES

Ogata Kōrin (1658–1716)
Hanging scroll, ink, colors, and gold on silk
Edo period
H: 26.6 cm W: 21.1 cm
1991.79

Now mounted as a hanging scroll, this small painting is a wrapper (*kōzutsumi*) for incense used in the incense-appreciation ceremony (*kōdō*). The painting was done on gold foil affixed to silk. As the creases indicate, the wrapper was folded around a thin slice of aromatic wood (*kōboku*). The composition of morning-glory flowers and leaves is ingeniously adapted to this function; pictorial elements are concentrated in the right and left sides, reserving the center space so that when folded, the blank area of the painting is the bottom of the folded packet, and the most beautiful parts of the picture appear on its front.

Using his keen observation of nature and a fine design talent, Kōrin depicts, against the lustrous gold background, flowers just open in the fresh morning air. The purplish-blue flowers are rendered in a mixture of blue pigment and white *gofun* (ground shell); the clusters of broad leaves in green or black ink avoid the monotony of a single-color treatment. The ink and colors are applied in the *mokkotsu* (boneless) manner, without outlines. The subtle gradations of ink tones skillfully express the shining surface of the leaves. Gracefully arching stems link the clustered elements from one side of the composition to the other.

In the middle of the right side, a square seal reads *Jakumei*, a name Kōrin used in the last years of his life, from 1711 to 1716.[1] At least nine other extant wrappers are attributed to Kōrin but do not bear his seal; their attributions are based purely on style. This Packard wrapper with seal bears a documentary value, providing a more secure ground for attributing the others.

Incense was first used in the sixth century in Buddhist rituals. Burned in an incense burner before the altar of Buddhist temples, its rising smoke and faint scent were considered to purify people's spirits and to ward off evil. During the Heian period incense began to be used in secular life; it was etiquette for aristocratic ladies to use incense so that its fragrance lingered in their robes. Competition to identify names of incenses made of mixtures of pulverized scented wood, animal musks, honey, and other substances became a popular pastime of court nobles. Guests would burn incense they brought and decide which was the best.[2] From the latter half of the fifteenth century, wood from aromatic trees began to be used as well. As this aristocratic pas-

time eventually spread to commoners in the seventeenth century, the rules and manner of the competitions were codified. For example, participants had to make special preparations the day before to keep themselves odorless by not eating any strong-smelling food and not using incense in their hair or clothes; and they were required to wash hands and mouth in the host's home.[3]

Elaborate sets of ceremonial utensils, all splendidly decorated in lacquer and gold, were used in incense ceremonies. The incense wrapper, a part of the set, was also made in elegant designs and in luxurious materials. Made in a set of twelve, one for each month, the *kōzutsumi* designs derived from motifs that suggest seasons— cranes for winter, willow or flowering plum for spring, and morning glory for summer.

Ogata Kōrin was the second of three sons of Ogata Sōken (1621–87), owner of the prosperous textile store Kariganeya. Ogata Kenzan (1663–1743), a renowned ceramic artist and painter, was Kōrin's younger brother. The two were inseparable throughout their entire lives; Kenzan, more scholarly and studious, provided moral support to the unrestrained, flamboyant, and perhaps more talented Kōrin. Through marriage the Ogata family was connected to Hon'ami Kōetsu (1558–1637), the great calligrapher and artistic innovator of the early Edo period, Kōrin's great-grandfather Dōhaku had married Kōetsu's sister. The couple lived in a house just across the street from Kōetsu's house in Takagamine near Kyoto, a religious and artistic colony that Kōetsu had founded.[4]

Kariganeya supplied kimono and related articles to aristocratic families and rich merchants, above all to the official empress (*chūgū*), Tōfukumon-in Kazuko (1607–78), of Emperor Gomizunoo (1596–1680), and to their daughters. Living among beautiful textiles and in contact with designers and artisans, Kōrin and Kenzan benefited greatly, cultivating a refined taste and skill in design. The self-indulgent Kōrin, however, did not turn to art seriously or professionally until he had exhausted the fortune inherited from his father, who died in 1687.[5] Challenged by his financial straits, Kōrin strode rapidly toward great accomplishments, which were officially recognized by the honorary title of artist, Hokkyō, granted in 1701.

In 1704, in search of a more lucrative market, Kōrin moved to Edo (now Tokyo), where he produced works for powerful daimyo such as the lords of Tsugaru and Sakai, and rich merchants like the Fuyuki family, lumber dealers. In Edo he actively copied and studied ink paintings of Sesshū Tōyō (1420–1506) and Sesson Shūkei (1504–89), the renowned Zen monk painters of the Muromachi period.[6] His study of these paintings, which held profound spiritual meaning, succeeded in giving Kōrin personal depth and perhaps a measure of self-discipline. Kōrin, however, was not happy in Edo, a vital city but one lacking the long cultural tradition of Kyoto, and dominated by the samurai class. In a letter to a friend, Kōrin wrote how hard it was, on a hot summer day, to "walk to a samurai lord's house and paint several paintings, and then be criticized."[7]

In 1709 Kōrin retreated to Kyoto, where, seven years later, he died, again in strained circumstances, worrying about his son's future.[8] Despite these problems, in this period Kōrin produced most of the works now considered his masterpieces. The brilliant design, superb technique, and bright, yet refined color scheme in this small painting are unmistakably characteristic of Kōrin's last period.

Incense wrappers seem to have been an item in Kōrin's repertoire. His design notebook, *Kōrin oboega-kichō* (The Notes of Kōrin), now in the collection of the Konishi family, mentions that he was commissioned to produce wrappers in two different sizes for the Nijō family. Some scholars believe that Kōrin's extant *kōzut-sumi* were commissioned works for the Fuyuki family, because the *kōzutsumi* with flowering plum[9] has an inscription by Suzuki Shuitsu to that effect inside the box. There is no conclusive evidence, however, to determine that any of the extant wrappers, including this one, were produced for the Fuyuki family.

Kōrin's seal, *Jakumei.*

Provenance unknown.

Published: Hiroshi Mizuo, "Asagao-zu kōzutsumi," *Kokka* 892(July 1966): 32; Munashige Narazaki and Shūjirō Shimada, eds., *Shōhekiga, Rimpa, bunjinga, Zaigai hihō* (Tokyo: Gakushū Kenkyusha, 1969), 81; Yoshi Shirahata, *Rimpa kaiga senshū*, v. 2 (Kyoto: Kyoto Shoin, 1975), pl. 7; *Rimpa kaiga senshū: Kōrin-ha* (Tokyo: Nihon Keizai Shinbunsha, 1979), no. 189; *Kachō no bi: Kaiga to ishō* (Kyoto: Kyoto National Museum, 1982), pl. 250; *Rimpa no ishō* (Himeji: Himeji Shiritsu Bijutsukan, 1986), pl. 13.

Notes

1. Yūzō Yamane speculates that the seal was used after the late 1710s (Kōrin's later life in Edo); see *Shōhekiga, Rimpa, bunjinga, Zaigai hihō*, 81.

2. About the *kōdō*, see Gerd Lester, "Kōdō," *Arts of Asia* (Jan./Feb. 1993): 70–75.

3. *Kō to kōdō* (Kyoto: Kōdō Bunka Kenkyukai, 1992), 74.

4. Shin'ichi Tani, "Kōrin to sono jidai," in Ichimatsu Tanaka, ed., *Kōrin* (Tokyo: Nihon Keizai Shinbunsha, 1958), 9.

5. Kōrin's economic life was quite difficult around this time. He put a Kōetsu-designed *suzuribako* (inkstone box) and Shigaraki water jar in pawn; see Tani, "Kōrin to sono jidai," 5.

6. Keiko Nakamachi, "Ogata Kōrin no byōbu-e o meguru mondai," *Kobijutsu* 76(Oct. 1985): 10.

7. Ibid., 10–11.

8. Teiji Chizawa, "Kōrin no hito to geijutsu," in *Kōrin* (Tokyo: Nihon Keizai Shinbunsha, 1958), 8.

9. "Kōrin oboegakichō"; quoted by Shūko Nishimoto in plate entry, pl. 191, in *Rimpa kaiga zenshū: Kōrin-ha.*

Watanabe Shikō (1683–1755)
Pair of six-panel screens, ink, colors, and gold on paper
Edo period
H: 154.5 cm W: 352.0 cm
1991.54.1–2

This pair of screens, one of Shikō's monumental works, depicts a landscape with streams, waterfall, trees, and plants against a sumptuous gold background. In the right-hand screen, a stream winds diagonally from the upper right to lower left, in a manner similar to that known as "Kōrin's wave," a stylized pattern of flowing water. The diagonal movement provides a visual guide in the enormous space. At the right, two large trees (*maki*), their tops obscured by clouds, hang down graceful branches; their delicate leaves create shimmering surface effects on the smooth gold. A few angular rocks accentuate gently rolling boulders in the foreground. Flowering azaleas, bamboo grasses, a young bamboo, and a Japanese medlar with fruits in the lower part provide the picture with seasonal indications of the spring and summer.

In the left screen, from upper left to center, a gently flowing stream suddenly drops as a waterfall in the two middle panels, where it changes direction to the left, joining below it a river that runs in large, rolling waves. The waterfall is drawn in ink lines in the standard Kano school manner. On the left, pine and maple trees, again truncated at the top, spread down their branches. The round boulders are enlivened with autumn plants—a pomegranate with fully ripe fruits, grasses, and bellflowers. The elegantly shaped maple leaves, pine needles, and other plants provide delicate, rhythmic movements.

Watanabe Shikō was a famed painter of the Rimpa school in Kyoto, a school of painting known for its refined, decorative style, fine design sense, and often, the use of luxurious materials. Of noble background and with comfortable means, Shikō was not a professional painter, but produced paintings only for people close to him. Thus his paintings are quite rare.

Painters of the Rimpa school were most often natives of Kyoto born into artisans' families that produced some type of artistic and craft works, such as fans, screens, dyeing, and weaving. From early in life, young artists-to-be were exposed to the beautiful things that their families produced for members of the imperial court as well as for upper-class merchants. Their environment provided them an almost innate sensitivity to artistic refinement and indigenous design, more so than what might be learned from teachers in a school situation. An upbringing in such an environment seemed to be a prerequisite in the development of a Rimpa school artist.

Shikō, however, was one of a few exceptions; he was born to a prestigious family whose members successively served the house of Konoe, which had been established in the later Heian period.[1] The Konoe family served the emperors as regents and grand ministers of state. By 1708 Shikō himself had begun serving Lord Konoe Iehiro (1667–1736), who was to become regent in 1709.

Shikō studied painting under Ogata Kōrin (1658–1716) and was active for three decades after Kōrin's death. The name Rimpa (lit. Rin school) derived from the last syllable of Kōrin's name, but the school itself had originated earlier in the early seventeenth century. It was founded by Hon'ami Kōetsu (1558–1637), a celebrated calligrapher and influential leader of an artistic circle in Kyoto, which included Tawaraya Sōtatsu (d. ca. 1640), a superb painter and proprietor of the painting shop Tawaraya. Unlike other schools, which were structured in tightly knit teacher-student relationships (such as the Kano school), the Rimpa was a loosely formed school whose tradition was carried forward into the nineteenth century by artists who appeared sporadically. Shikō played an important role in transmitting the Rimpa tradition to the latter half of the eighteenth century.

The Kano school's strong brushwork and powerful expression particularly appealed to the ranks of the military (samurai) class. It is speculated that Shikō first studied under a pupil of Kano Tan'yū (1602–74) or Kano Naonobu (1607–50); most likely his teacher was Kano Tangei (1688–1769), one of Tan'yū's pupils.[2] Around 1708, however, Shikō shifted to the Rimpa school,[3] in which he stayed for the rest of his life. At court, Shikō was very likely to have had access to the best artistic collections, which had been accumulating since the Heian period. He must also have seen numerous works by the great Rimpa masters Hon'ami Kōetsu, Tawaraya Sōtatsu, and Ogata Kōrin.

Shikō typically produced simple but beautiful paintings in a style directly related to the Rimpa school, where flowers and grasses are scattered rhythmically all

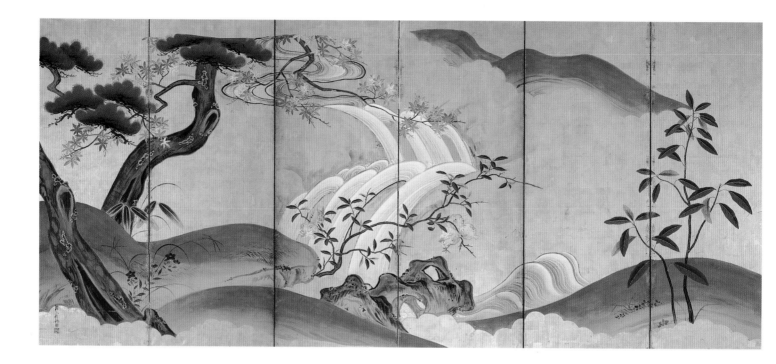

over the space. Lacking emphatic, monumental elements such as large trees and waterfalls, those flower paintings focus upon the sheer beauty of delicate flowers that are not overshadowed by large trees. But occasionally he reconciled both aspects of his training and managed to produce impressive paintings in an eclectic style. This pair of screens provides a very good example of that synthesis. The graceful plants are elements from Rimpa, while the monumental composition with large trees rendered in strong brushwork reflects the Kano school.

The signature reads "Watanabe Shikō." Two seals read *Shikō no in;* the other is indecipherable. From its powerful expression and energetic brushwork, the painting is datable between 1734 and 1736.[4]

Provenance unknown.

Published: Yoshi Shirahata, "Watanabe Shikō hitsu ryūsui taki ni kaki-zu," *Kobijutsu* 52(May 1977): 151–52.

Notes

1. Sakai Hōitsu (1761–1828) is another Rimpa school painter from a prestigious family. Hōitsu was born in Edo, the second son of Lord Sakai of Himeji Castle in Harima province. He had an eclectic painting training which included the Kano, *ukiyo-e*, Maruyama, literati, and Rimpa schools.

2. O. R. Impey, "Watanabe Shikō: A Reassessment," *Oriental Art* 17:4(Winter 1971): 329.

3. Tsugiyoshi Doi, *Watanabe Shikō shōhekiga* (Tokyo: Mitsumura Suikō Shoin, 1972), quoted by Shirahata, "Watanabe Shikō," 151.

4. Shirahata, "Watanabe Shikō," 152.

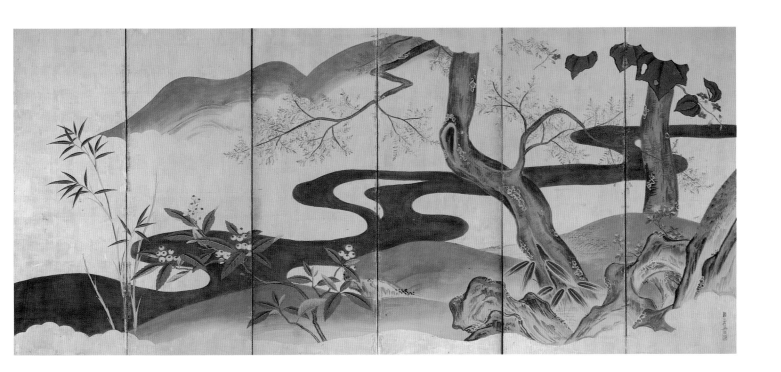

23. WEST LAKE IN SPRING

Yosa Buson (1716–83)
Hanging scroll, ink and colors on silk
Edo period
H: 133.2 cm W: 62.5 cm
1991.80

This large painting depicts a landscape with a waterway that winds around wooded hills, curved stone bridges, a boat full of passengers who appear to be gentry taking their ease, and willow trees with luxuriant foliage. All these elements and motifs immediately identify the subject of the painting as a spring scene of the West Lake in China.

Located near Hangzhou in Zhejiang province, the West Lake was well known for its magnificent scenic beauty and long-standing literary associations. It was a favorite subject of Chinese poems and paintings. In Japanese painting, the lake was depicted as early as the fourteenth century; later Sesshū Tōyō (1420–1506), a great Zen monk painter of the Muromachi period, visited the site and depicted it.[1] The subject became even more popular in the Edo period; painters of various schools depicted the lake in hanging scrolls and screens.[2]

A self-imposed isolation policy by the shogunal military government (*bakufu*), which, between 1639 and 1854, prohibited all Japanese from leaving the country, intensified the people's interest in the West Lake and other Chinese sites. The literati, most of whom were sinologists and poets in the Chinese style, especially yearned to visit famous sites in China, which they knew only through books. They found some consolation in painting these famous sites based on their descriptions in the books, on actual paintings, and on their imaginations. This practice eventually created simplified depictions of famous places in China, which combined the most obvious features of the sites.

Like others, Buson interpreted his West Lake simply, but he created a more personal version, expressing his love for nature by creating a dense, sumptuous surface with the soft foliage of the willows. The green and blue colors add liveliness without sacrificing the abstract quality of ink monochrome, the essential element in literati paintings with motifs of Chinese origin. It is an idealized, tranquil spring scene. On the upper right side are Buson's signature, Sha Shunsei, and two seals, *Chōkō* and *Shunsei*. Buson adopted the name Sha Shunsei in 1763.[3] His *Wild Horse* screen, dated 1763, bears this name, and he used it until 1778, when he adopted the name Shain. An artist who matured late, Buson entered a fifteen-year-long period of artistic accomplishment

beginning at age fifty. It was a crucial time, during which he steadily advanced, establishing his own style from his earlier numerous and undefinable painting styles, and eventually creating a grand manner with evocative lyricism in his last years.

Buson is acclaimed as a literati painter and a haiku poet. Called *haikai* in the Edo period, haiku was developed from *renga* (linked verse, a form involving a continuous chain of alternating twenty-one- and fourteen-syllable verses). A native of Kema village near Osaka (present-day Kema-machi, Toshima-ku, Osaka), Buson was the son of a wealthy farmer with substantial property holdings. But we know little more of his early life; Buson was reticent concerning the circumstances surrounding his birth and upbringing. In 1732, at age seventeen, he went to Edo to seek a career as a haiku poet.[4] In 1737 he began living with his haiku teacher Hayano Hajin (1677–1742), a member of the Bashō school. His life seems to have been quiet and fulfilling, as he studiously composed and published his poems.

In 1742, after the death of Hajin, Buson moved to the prosperous rural town of Yūki, Ibaraki, famed for its cotton products. Yūki had long been a cultural and literary center and attracted many amateur haiku poets, some of whom had been Buson's fellow pupils at Hajin's school. Living with one of them from time to time, and sometimes traveling to the rustic northern provinces, Buson led a wanderer's life for nearly ten more years. He supported himself by producing paintings in various styles for local temples and for his friends.

In 1751 he ended his wanderings and went back to the Kansai (Osaka-Kyoto) region, although he spent a short time in Tango, a town on the other side of Kyoto facing the Sea of Japan. By this time he had studied many painting styles of the Tosa, Kano, and Unkoku schools, as well as styles of Chinese literati painting (*bunjinga*, or Nanga). Only in the 1760s did Buson strive to establish his own style in the Chinese-oriented literati school. The crucial change occurred in Sanuki in northern Shikoku, where he sojourned from 1766 to 1768, and where he was probably exposed to the many Ming and Qing paintings in the collections of rich merchants in the area. Studying them, Buson finally grasped the manner of brushwork and the deliberate and highly calculated compositions of the literati school.

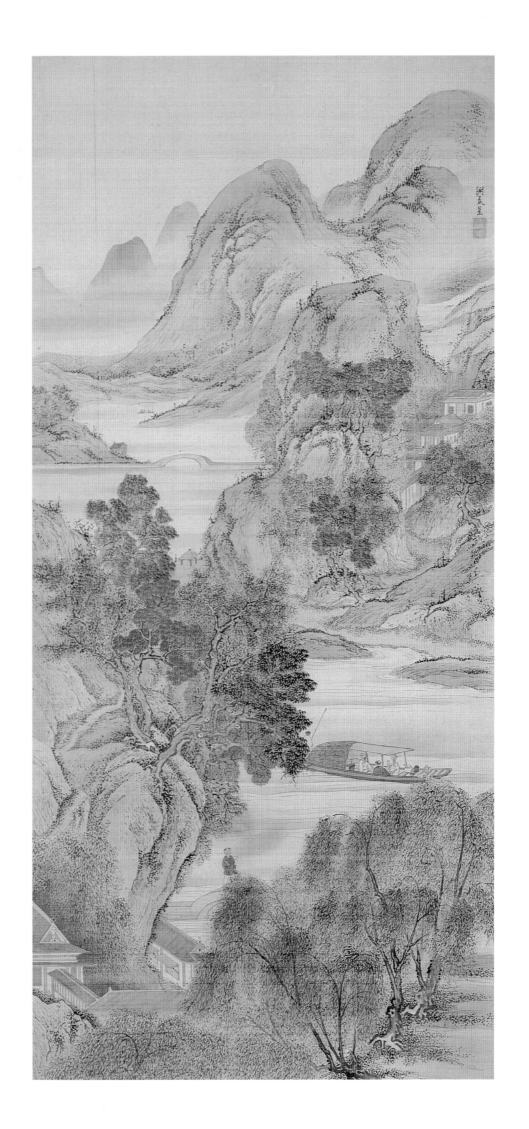

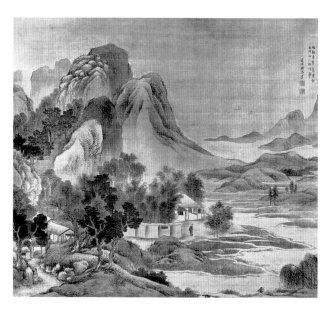

Fig. 14. *Zōzusan-zu;* Yosa Buson (1716–83); hanging scroll, ink and color on silk; Edo period. Photo: Shibundō, Tokyo.

Buson painted *Zōzusan-zu* (Picture of Mount Zōzu [Elephant Head]; Fig. 14) at Kompira in Sanuki. This work shows the culmination of his efforts in the literati style. Based on the style of the late Ming master Qian Gong (act. late 16th–early 17th century) from Suzhou, this large horizontal painting exhibits close affinities with the Packard *West Lake* in the rounded rocks, the sense of deep space achieved by systematically multiplying forms, thin contour lines, and many fine texture strokes. However, there are obvious differences. While *Zōzusan-zu* is more static and somewhat dry, the *West Lake* composition is softer, more fluid and evocative, warmly touched with human elements. The willow leaves flutter in the wind, conveying the feeling of a pleasant spring breeze; human figures on the bridge and in the boat are enjoying the warm weather. Considering that Buson's predilection was for fluidity of form and brushwork, and for a deeper feeling for his subjects, as seen in the works of his last years, the Packard *West Lake* must be datable to after *Zōzusan-zu,* which was produced between 1766 and 1768.

One of the ten pages of Buson's album *Jūgi* (Ten Pleasures), which he executed in collaboration with Ike no Taiga (1723–76), an equally brilliant literati painter who did the *Jūben* album (Ten Advantages; both are dated 1771), provides a clue to establishing the latest possible date for Buson's *West Lake* landscape.[5] *The Pleasure of Spring* in *Jūgi* depicts a subject similar to *West Lake*—several willow trees intermingled with blossoming peach trees. At the top of the painting is a poem by Li Li (act. late 17th century), which glorifies the pleasure of gazing at the willow trees in his garden, Yiyuan, in spring. The album painting is much simpler—only a few trees are depicted; there are no imposing hills and mountains; and the dense leaves in the *West Lake* have been minimized, giving more space for swaying branches. The brushwork, freer and swifter, is accentuated with dark and light ink, making the work decidedly more expressive. It is a bold departure from the artist's more descriptive styles in earlier works. Buson could only have painted this album leaf after practicing such works as the Packard *West Lake,* for which, therefore, a date between 1768 and 1771 seems warranted.

Yosa Buson is one of the most complex of Japanese painters. The question of how the two art forms he mastered affected each other has yet to be assessed. But in his artistic life, haiku and painting complemented each other. Even after Buson was established as an acclaimed professional haiku master (*sōshō*), he was unable to support himself and his family; his paintings eventually supported him. He sold them to his haiku-poet friends and students. The more famous he became as a poet, the more friends and students he made, and they eventually bought and commissioned his paintings. Buson was a forerunner of the literati painters of the nineteenth century, who united poetry and painting in their works and supported themselves by their paintings.

Provenance unknown.

Published: *Yosa Buson meisaku ten: Tokubetsu ten botsugo 200-nen kinen* (Nara: Yamato Bunkakan, 1983), pl. 17; Monta Hayakawa and Kenkichi Yamamoto, *Buson gafu* (Tokyo: Mainichi Shinbunsha, 1984), pl. 22.

Notes

1. Noriko Miyazaki, "Seiko o meguru kaiga," *Chūgoku kinsei no toshi to bunka* (Kyoto: Kyoto Daigaku Jinbun Kagaku Kenkyūsho, 1984), 230.

2. For example, Ike no Taiga's several versions of *West Lake;* see Ichimatsu Tanaka et al., *Ike Taiga sakuhinshū* (Tokyo: Chuō Kōron bijutsu shuppansha), pls. 150, 313-1, 316. For Maruyama Ōkyo's *West Lake,* see *Kaikan jūgoshūnen kinenten zuroku* (Tokyo: Idemitsu Museum of Arts, 1981), pl. 188.

3. Buson's *Wild Horse* screen, dated 1763, bears the name Sha Shunsei. See *Yosa Buson,* Nihon bijutsu kaiga zenshū, v. 19 (Tokyo: Shūeisha, 1980), pl. 9.

4. It is commonly believed that Buson was twenty years old in 1735 when he went to Edo, but recent evidence points to the year 1732, when he was seventeen years old. See Jōhei Sasaki, *Yosa Buson,* Nihon no bijutsu, v. 109 (Tokyo: Shibundō, 1975), 99.

5. Ibid., pl. 9.

24. GAKUYŌRŌ (YUEYANG) TOWER

Aoki Shukuya (d. 1802)
Two-panel screen, ink and colors on gold
Edo period, dated 1802
H: 167.3 cm W: 187.0 cm
1991.69

The screen painting represents the imposing Yueyang Tower fronted by a large pine tree and backed by a steep, wooded cliff. The tower overlooks the expansive waters of Lake Dongting, beyond which lie distant mountains and the Yangzi River. The lake's rolling waves are rendered in a neat, uniform pattern. On the tower's balcony, a group of scholars enjoys a party. Some stand at the railing and point to the boat crowded with people, which sails swiftly toward the tower, sending up a plume of spray in its wake. Close to the retaining wall are three boats at anchor. A scholar and his attendants slowly ascend the winding path leading to the tower.

At the lower left are an artist's inscription and two seals. The inscription reads "Painted at Taigadō [Taiga Hall] in the third month of 1802 by Yo Shukuya" followed by three square seals, two reading *Yo Shukuya* and one, *Kankoku Yo Shō-ō ei* (Descendant of the Korean King Yo Shō-ō). Produced in Shukuya's last year, *Yueyang Tower* is a rare example of a work in the screen format by this artist.

Aoki Shukuya was born in Kyoto into the Aoki family, which is said to be descended from the distinguished Ōuchi clan of the Sengoku period (1477–1573). They, in turn, claimed descent from a mythological Korean ruler, Yo Shō-ō.[1] Shukuya became the pupil of Ike no Taiga (1723–76), a celebrated literati painter of the time, through his cousin Kan Tenju (d. 1795), Taiga's best friend. After Taiga's death, his students established a memorial hall, the Taigado in Makuzugahara, Kyoto, where the master had spent his last years. Shukuya became its caretaker, and his life thereafter was that of a reclusive painter and connoisseur of his teacher's paintings.

Shukuya's *Yueyang Tower* is another example of the Japanese literati painters' imaginary depictions of Chinese sites famous for literary associations. The Yueyang Tower was built in the Tang dynasty (618–906) on the Western Gate of Yuezhou Cheng, in southern China, a site in fact overlooking Lake Dongting and, beyond the distant mountains, the Yangzi River. Its breathtaking beauty was celebrated by Song dynasty scholar Fan Zhongyan in his essays, *Record of Yueyang Tower*: "The magnificent view is enhanced by Lake Dongting, and the lake's rippling water seems to expand boundlessly."[2]

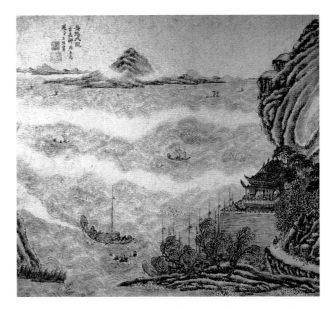

Fig. 15. *A Grand View of Yueyang Tower,* from the album *Zhang Huanzhen weng bashi zhushou huace;* Shao Zhenxian (act. 17th century); album leaf, ink and light color on paper; private collection, Tokyo.

Bookish Japanese literati yearned to see this ancient tower.

Shukuya found a model for his version of the tower, a Chinese Qing dynasty album leaf entitled *A Grand View of Yueyang Tower* by Shao Zhenxian (act. 17th century; Fig. 15). It is included, together with works by a group of painters from Suzhou, in *Zhang Huanzhen weng bashi zhushou huace* (Album in Honor of the Eightieth Birthday of Zhang Huanzhen). This album is said to have been in a collection in Sanuki by the second half of the eighteenth century. Taiga copied entire leaves from this album in 1757 for a kimono merchant in the area.[3] Later he adapted the leaf with the composition of the Yueyang Tower to his great screen painting of the same subject, which is paired with a screen based on *Zuiweng Ting (Suiōtei;* The Pavilion of the Drunken Old Man), a leaf by Gu Yucheng (act. 17th century) from the same album. The pair are now in the Tokyo National Museum.[4] To adjust to the format of the large screen, the landscape elements in Taiga's composition were spread horizontally, while the tower, the main focus, was enlarged considerably. The brushwork is thick and bold, in proportion to the screen's large scale.

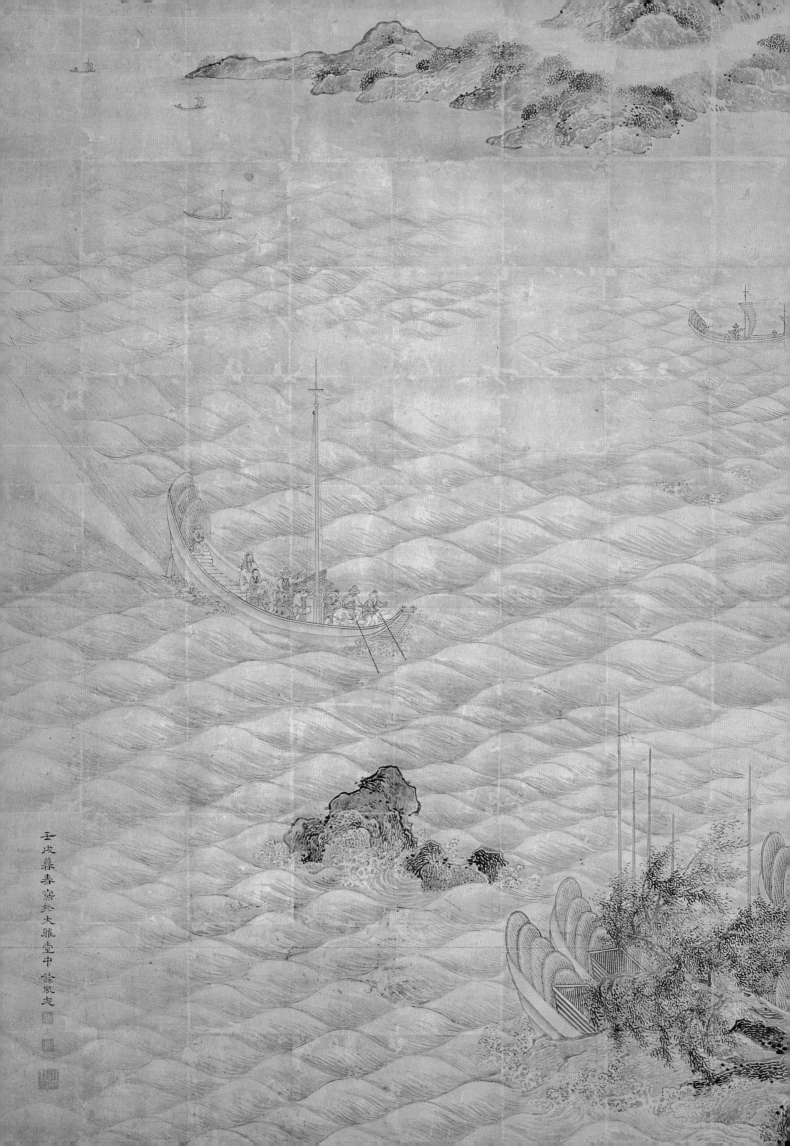

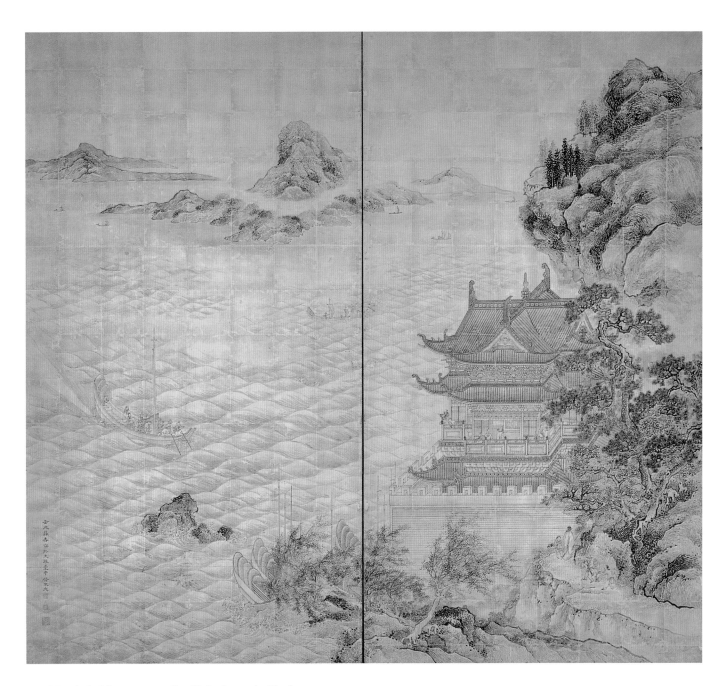

Nearly half a century after Taiga's work, Shukuya painted *Yueyang Tower* based on the same model. Reflecting Shukuya's restrained personality, the screen adheres closely to the original. Well articulated and precise, but somewhat conservative, the screen painting bears, in addition to its intrinsic value, a documentary value that illustrates how the Japanese artist adopted a Chinese original and transformed it into his own creation. Furthermore it demonstrates a relationship of pupil and master, where the teacher's resources were transmitted to the students in the Japanese literati school.

Provenance unknown.

Published: Chū Yoshizawa, *Nihon no Nanga*, Suiboku bijutsu taikei, Bekkan 1 (Tokyo: Kōdansha, 1976), pl. 10; *Bunjinga to shaseiga*, Nihon bijutsu zenshū, v. 24 (Tokyo: Gakushū Kenkyūsha, 1979), pl. 68; *Sansuiga: Nanga-sansui*, Nihon byobu-e shūsei, v. 3 (Tokyo: Kōdansha, 1979), pl. 86.

Notes

1. Comment by Jōhei Sasaki on "Rōkaku sanzui-zu byōbu," in Yoshizawa, *Nihon no Nanga*, pls. 10, 66.

2. Quoted in Tetsuji Morohashi, *Dai Kanwa jiten*, v. 4 (Tokyo: Taishūkan, 1955–60), 240.

3. Chōzō Yamanouchi, *Nihon Nangashi* (Tokyo: Ruri Shobō, 1981), 113.

4. *Sansuiga: Nanga-sansui*, pl. 4.

25. LANDSCAPE

Noro Kaiseki (1747–1828)
Pair of six-panel screens, ink on gold
Edo period, dated 1812
Each: H: 162.5 cm W: 360.0 cm
1991.66.1–2

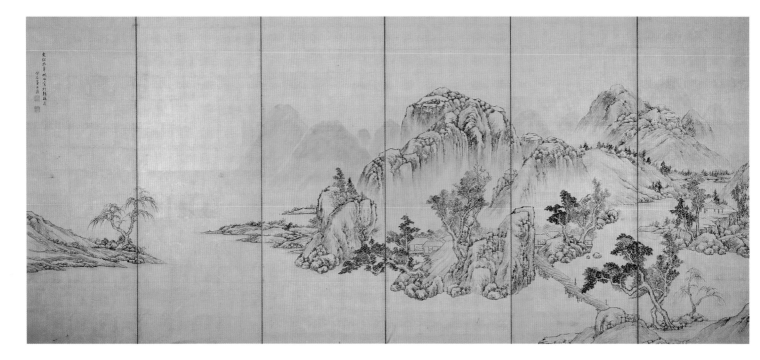

The pair of screens depicts a panorama of mountains unfolding around a wide, slow-flowing river. Beginning at the right of the right screen with the unobtrusive, distant mountains, the landscape quickly swells into impressive land masses that fill the space from top to bottom. The scene recedes in the left screen and ends quietly with a low point of land topped with a single tree. The landscape features—hills, rocks, and inlets—multiply to form large land masses, enhanced with numerous waterfalls, trees, bridges, pavilions, and houses as points of interest. The painter's inscription on the right screen reads, "Painted by Waibai Dōjin [Kaiseki's other name]," and on the left screen, "By Kaiseki Daigoryū, Autumn 1812, at Waibai's residence."

Kaiseki, fifth son of the merchant Noro Hōshō (1702–70), was born in Kii province (modern Wakayama prefecture). Around age ten, Kaiseki began studying Confucianism with Ito Rangū (1693–1778), a Confucian scholar in service to the Kii fief. Around this time he began to study painting under Kuwayama Gyokushū (1746–99), a native of Kii and a pupil and intimate friend of Ike no Taiga (1723–76), the most celebrated literati painter of the time. In 1760 Kaiseki went to Kyoto, where he studied painting under a minor teacher until 1767, when he became Taiga's pupil and pursued more

serious study. Kaiseki himself describes his studious life under the discipline of the artist's studio, Taigadō: "I spent about ten years studying landscape, each day painting ten landscapes, small or large."[1] Kaiseki's early works reflect his indebtedness to his teacher; pictorial elements in his work spread out in a flat, decorative pattern, but they lack Taiga's vigor and originality.

Eventually Kaiseki returned to Kii, and in 1790 he was employed by Lord Kii as a low-ranking official in charge of the fief's copper mines. In 1794, he was granted a house named Waibaikyo (House of the Old Plum Tree), after an old plum tree in its garden. Through his job, Kaiseki walked extensively in the deep mountains and was able to observe nature and geological formations of the land. These experiences greatly contributed to his landscape painting. He was a scholar and theorist whose art ideals are expressed in his book *Shihekisai gawa* (Talk on Painting by Shihekisai), issued in 1827.

This screen painting, executed in the artist's sixty-fifth year, is a culmination of Kaiseki's theoretical understanding and technical improvement, demonstrating his extraordinary ability to compose a large-scale painting consisting of countless elements and details. Unlike his teacher Taiga, who for his strikingly innovative works made free use of styles of both the Northern and

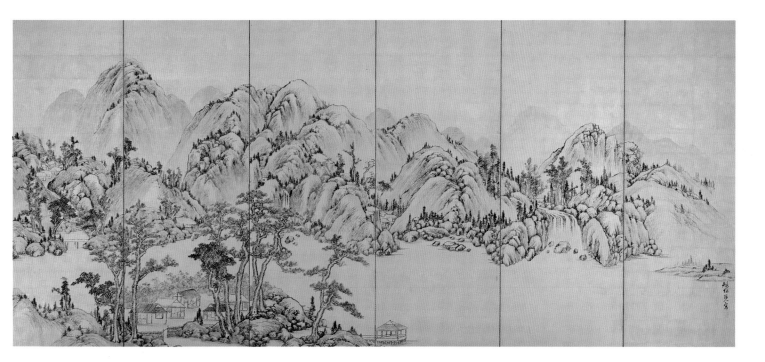

Southern schools as well as Japanese decorative traditions, Kaiseki adhered to the pure Southern school style practiced by Chinese literati painters. The scholarly and theoretical Kaiseki was the first Japanese literati painter who understood the theory of the Northern and Southern schools in China as formulated by Dong Qichang (1555–1636), the leading scholar and a master landscapist of the late Ming period. Observing two long currents from the Tang dynasty (618–906), Dong affirmed that the Southern school was the special tradition of the scholar-amateur painters, and that the Northern school was identified with professional and Academy painters. The Southern school included, for example, Wang Wei in the Tang dynasty, Mi Fu and Mi Yuren in the Song, the Four Great Masters, Huang Gongwang, Ni Zan, Wang Meng, and Wu Zhen in the Yuan, and Shen Zhou and Wen Zhengming in the Ming. Professional painters of the Northern school included Li Sixun and Li Zhaodao in the Tang dynasty, Li Tang, Liu Songnian, Ma Yuan, and Xia Gui in the Song period and their followers, and the Zhe school artists of the Ming. As a proud scholar holding a high-ranking office in the government, Dong advocated that scholars should practice the amateur style (or the literati school). Dong Qichang's lineage was carried forward in the early Qing period by the Four Wangs, who were identified as the Orthodox school. This final stage of the literati tradition was transmitted to Japan to influence later literati painters like Kaiseki and his friend Nagamachi Chikuseki (1747–1806).

Kaiseki particularly favored the style of Huang Gongwang (1296–1354) among the Four Great Masters. He seems to have learned it first through paintings of Yi Fujiu (Jpn. I Fukyū, 1698–after 1747), a Chinese merchant and painter who traded in Nagasaki. But the turning point for Kaiseki came when he copied for study, at Mount Tōnomine near Nara, a Ming version of Huang's famous work *Tiandi shibi* (Stone Cliff at the Pond of Heaven), painted in 1341 (Fig. 16). Stone Cliff is a real site in Suzhou. Through copying this famous painting, Kaiseki finally grasped the essence of Huang's style: the architectonic structure of the composition and restrained, repetitive brushwork. The fruit of his study is reflected immediately in *Spring Landscape,* a hanging scroll painted in 1811,[2] and in the Packard screens, in which Kaiseki expresses the essence of nature.

In addition to composition and brushwork, this pair of screens reflects another character of the Orthodox style, which distinguishes it from works by earlier painters such as Sakaki Hyakusen (1698–1753), Ike no

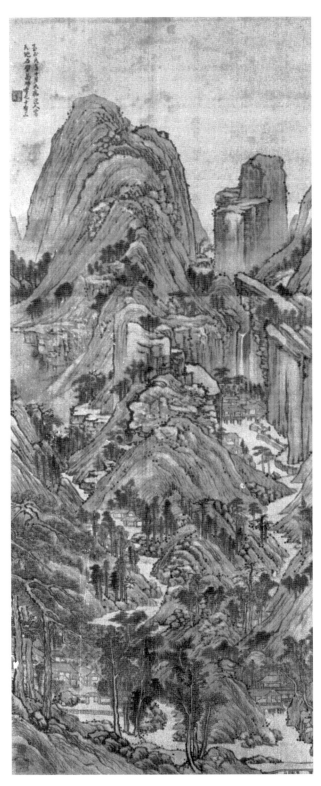

Taiga, and Yosa Buson. These painters had based their work on the earlier style of the Wu school, centered in Suzhou, which gave more prominence to human figures and allusions to literary associations with the sites or with nature. In his effort to be a "pure" Southern school artist, Kaiseki eliminated colors, except for pale blue, as well as the qualities of atmosphere and lyricism, at which the Japanese excelled. It is ironic that Kaiseki's technical improvements and theoretical understanding impaired his originality by making his painting somewhat dry. Kaiseki's conservatism, however, was an inevitable and necessary step toward accomplishing the goal of Japanese literati painters. Only after this stage was passed could the artists of later generations, such as Tanomura Chikuden (1777–1835) feel at ease to create their own styles.

Provenance unknown.

Published: *Noro Kaiseki tokubetsu-ten* (Wakayama: Wakayama Prefecture Museum, 1978), pl. 35.

Notes

1. Noro Kaiseki, "Shihekisai gawa," quoted by Hidetarō Wakita; see "Noro Kaiseki no kenkyū," *Kokka* 924(1970): ll.

2. James Cahill, "Sakaki Hyakusen and Early Nanga Painting" (Berkeley: Institute of East Asian Studies, University of California, Berkeley, 1983), 45–51.

Fig. 16. *Tiandi shibi* (Stone Cliff at the Pond of Heaven); Noro Kaiseki (1747–1828); copy after the Ming copy; hanging scroll, ink on paper; Edo period; Fujita Bijutsukan, Osaka.

26. SPRING AND AUTUMN LANDSCAPES

Okada Hankō (1782–1846)
Pair of six-panel screens, ink and colors on paper
Edo period, dated 1837
Each: H: 118.0 cm W: 284.4 cm
1991.67.1–2

This pair of screens depicts landscapes in spring and in autumn. In the right screen, fresh green and white flowering plums at the foot of the mountains announce the early spring. A farmer drives his ox toward a bridge. The stone tower and distant mountains seem to fade in the warm, misty air. In the left screen, the pale red-brown tone of the entire scene is a sign of autumn. Fishermen in a boat drift on the chilly river, and the buildings seem silent under the tall pine trees.

The two screens contrast further in their distinctive brush techniques; like the brushwork of Noro Kaiseki's painting, Hankō's brush manner follows the examples of Chinese masters. The dry, sparse, and delicate strokes over the angular mountains in the spring scene derive from a great Yuan master, Ni Zan (1301–74), who is said to have "used ink as though it were gold." The wet, broad, horizontal strokes in the fall scene were an innovation of the Song master Mi Fu (1051–1107). Although the two scenes are independent entities executed in different styles, they are thematically united by the water that expands from the right to the left screen. Hankō's spare, sensitive handling of detail and his light-hearted lyricism are distinctive features of his style. The right screen is inscribed by the artist: "Painting and poem by Hankō in the autumn of 1837 at Jiunzan."

A native of Osaka, Hankō was a popular literati painter active in the Kyoto/Osaka region. He studied painting under his father, Okada Beisanjin (1744–1820), a more powerful and individualistic painter. While Hankō continued the family business, a rice shop he inherited from his father, he also served Lord Tōdō, the clan master of Ise, probably in the position of caretaker of rice storage.

In 1822, Hankō resigned from government work and lived an independent life as a literati painter. This artist exemplifies a Japanese literati painter of the first half of the nineteenth century; he associated with a large group of educated men and painters who were beginning to establish their own professional lives outside the class system—samurai, farmer, artisan, and merchant—prescribed by the shogunate. His close friends were literati painters and poets Rai San'yō (1780–1832), Tanomura

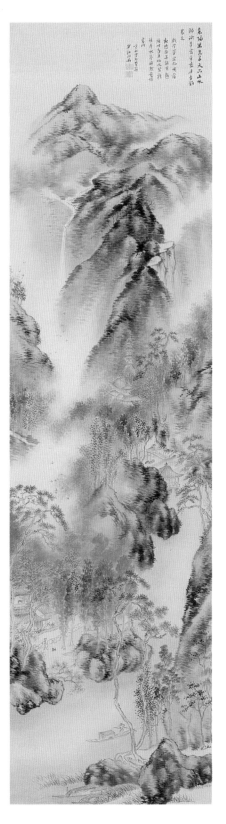

Fig. 17. *Crows Taking Flight through Spring Haze;* Okada Hankō (1782–1846); hanging scroll, ink and color on silk; Edo period, dated 1841; Tōyama Kinenkan, Saitama prefecture.

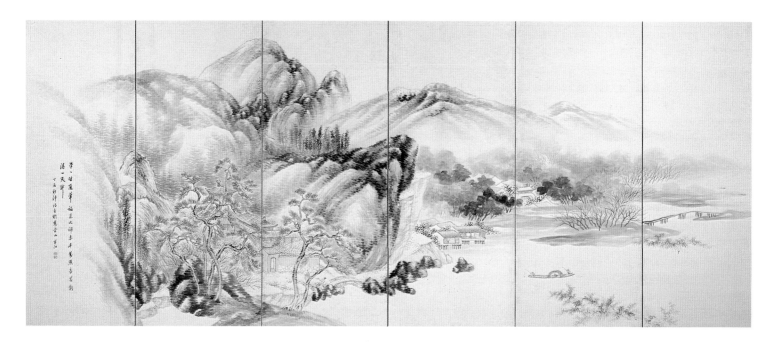

Chikuden (1777–1835), Uragami Shunkin (1779–1846), Nakabayashi Chikutō (1776–1853), and Yamamoto Baiitsu (1783–1856). Like the Chinese literati, these artists frequently congregated to discuss art and literature, and through them Hankō greatly refined his taste for painting and learned much of the theoretical background of Chinese painting techniques.

Hankō's particular strength in his later works is his brush technique in the Mi Fu manner. By 1841 he transformed Mi Fu's thin, delicate Mi dots, as seen in the Packard screen, to wetter and broader ones that submerge each other in pale washes, an excellent tech-

nique for depicting Japanese landscapes in the typically humid air of the islands. In addition, his use of restrained, sensitive color schemes made his landscapes attractive and commercially successful in the first half of the nineteenth century. The culmination of his technique is best represented in *Crows Taking Flight through Spring Haze*, dated 1841, in the collection of the Tōyama Kinenkan, Saitama prefecture (Fig. 17).

Provenance: Joe Brotherton.

Published: *Bunjinga shoha*, Zaigai Nihon no shihō, v. 6 (Tokyo: Mainichi Shinbunsha, 1980), pls. 37–39.

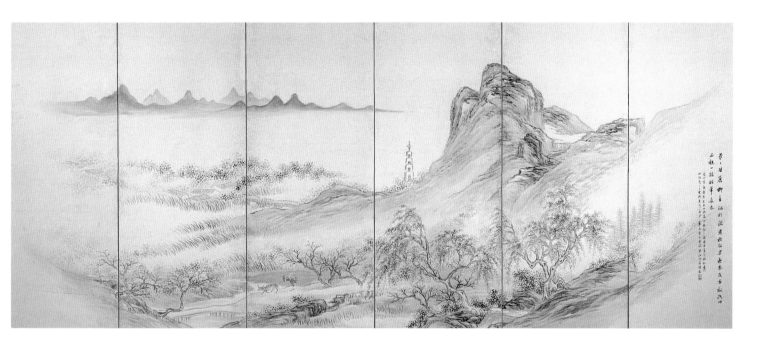

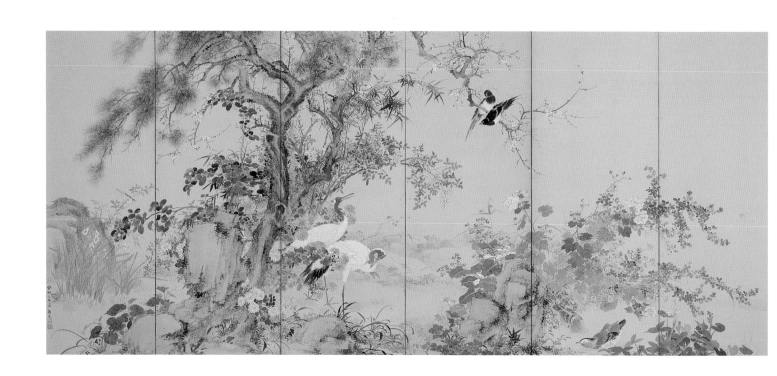

27. FLOWERS AND BIRDS

Yamamoto Baiitsu (1783–1856)
Six-panel screen, ink and colors on paper
Edo period, dated 1843
H: 156.3 cm W: 358.6 cm
1991.68

This screen painting depicts numerous birds and plants —pine, camellias, a plum tree, daffodils, chrysanthemums, bush clover, cranes, and small birds. The relatively open space on the right contrasts, on the left, with the imposing mass of the pine tree, rocks, flowering bushes, and two stately cranes. The well-preserved colors—various shades of greens, red, and yellow— give the painting a decorative splendor.

Yamamoto Baiitsu, a competent landscape artist, was an excellent painter of birds and flowers. His fine compositional sense is clearly revealed in the placement of groups of elements to create a rhythmic alternation of dense and open areas. His superb technique is evident in the rendition of the fine pine needles and bird feathers, and in the free use of *tarashikomi* (dripping ink) and the *mokkotsu* (boneless) manner of brushwork in the plants. Baiitsu inscribed the left panel: "Painted in winter of 1843 by Baiitsu."

Baiitsu, a colorful figure with a strong personality, stands out among the literati painters of the first half of the nineteenth century. He was born in Nagoya to a woodcarver's family and from childhood was acquainted with his father's craft. As a child Baiitsu stud-ied Chinese painting under the guidance of Kamiya Ten'yū (1710–93), a rich merchant and collector of Chinese paintings. In 1802 he went to Kyoto with his life-long friend Nakabayashi Chikutō (1776–1853), where he blossomed as a painter. Subsequently he went to Edo, where he became acquainted with Tani Bunchō (1763–1840), the leading figure among literati artists there. Baiitsu's strong use of the brush, distinctively different from the brushwork of other literati painters in Kyoto, may be related to the works of Bunchō and other Edo painters. Baiitsu spent most of his life in Kyoto until 1856, when at age seventy-three he returned to Nagoya, where he served the Owari clan as an official painter.[1]

This screen was originally the left-hand screen of a pair. When it was auctioned in 1933 at the Kyoto Arts Club, it was paired with the right-hand screen.[2] The illustration in the auction catalogue shows that it depicts a pheasantlike bird under a large willow tree and half hidden in profusely growing thickets (Fig. 18). The combination of exotic birds—a pheasant or a peacock in the right screen, and cranes in the left—seems the standard thematic scheme in Baiitsu's screen paintings

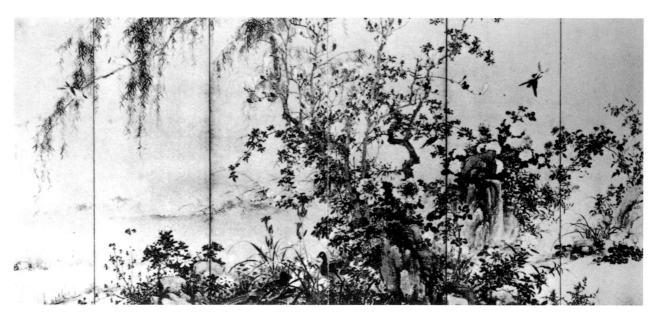

Fig. 18. *Pheasant under a Willow Tree;* Yamamoto Baiitsu (1783–1856); six-panel screen, ink and colors on paper; formerly in the Naiki family collection. Photo: Idemitsu Museum of Arts, Tokyo.

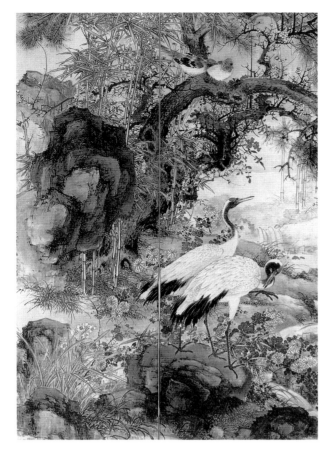

Fig. 19. *Flowers and Birds,* detail; Yamamoto Baiitsu (1783–1856); six-panel screen, ink and color on paper; Idemitsu Museum of Arts, Tokyo.

in the 1840s. Apparently the two screens were separated at the time of the sale. The present location of the pheasant screen is unknown.

From his youth Baiitsu was renowned for his birds and flowers, but only in the 1840s and early 1850s did he produce screens with combinations of exotic birds. At least six screens are extant from this period, the earliest dated 1841, and they are characterized by the similarity of their composition. The Packard screen has the closest affinities with a left-hand screen dated 1845, now in the collection of the Idemitsu Museum of Art, Tokyo.[3] The general scheme of a large pine tree, rocks, chrysanthemums, and other flowers in front of a pool fed by a small creek, and a smaller group of plants and birds toward the right is similar to the Packard screen's composition. Moreover the two cranes are identical, one gazing into the distance and the other with bent neck. In the Idemitsu screen, however, busy brushstrokes fill the space (Fig. 19). This closeness in composition in general, and the birds' gestures in particular, suggest that Baiitsu had a *funpon* (design book), a sketchbook in which the artist preserved his favorite compositional types and recorded detailed motifs. From such design books he could freely adapt motifs for new compositions. It is likely that a popular bird and flower painter like Baiitsu received substantial commissions for screens with this theme.

Provenance: The Naiki family.

Published: Taizō Kuroda, "Yamamoto Baiitsu hitsu kachō-zu byōbu," *Kokka* 1092(1986): fig. 4.

Notes

1. Toshihide Yoshida, "Yamamoto Baiitsu Kenkyū josetsu" *Nagoya-shi Hakubutsukan kenkyū kiyō* 2(1978): 15.

2. Kuroda, "Yamamoto Baiitsu," fig. 4.

3. Ibid., pls. 6, 7, 8.

Detail: Baiitsu's inscription and two seals.

CHECKLIST IN JAPANESE

サンフランシスコ市立アジア美術館蔵ハリーG. C. パッカードコレクション

THE HARRY G. C. PACKARD COLLECTION IN THE ASIAN ART MUSEUM OF SAN FRANCISCO

1
五髻文殊菩薩図像
掛幅一幅　紙本墨画
平安時代（12世紀後半）

Monju
Iconographic sketch
Hanging scroll, ink on paper
Heian period, late 12th century
H: 58.5 cm W: 40.5 cm
1991.55

2
十一面観音菩薩画像
掛幅一幅　絹本着色
鎌倉時代後期（14世紀）

Eleven-headed Kannon
Hanging scroll, ink and colors on silk
Late Kamakura period, 14th century
H: 153.5 cm W: 45.0 cm
1991.56

3
降三世明王画像
掛幅一幅　絹本着色
鎌倉時代（13世紀）

Gōzanze Myōō
Hanging scroll, ink and colors on silk
Kamakura period, 13th century
H: 107.3 cm W: 57.0 cm
1991.57

4
鳳凰
木造彩色
平安時代（12世紀初期）

Phoenix
Wood, painted with pigments
Heian period, early 12th century
H (figure): 40.5 cm W: 8.0 cm
1991.71

5
阿弥陀如来立像
銅造鍍金
鎌倉時代（14世紀初期）

Standing Amida
Bronze with traces of gilt
Kamakura period, early 14th century
H: 49.0 cm W: 16.5 cm
1991.74

6
阿弥陀如来立像
鉄造
鎌倉時代後期（13世紀）

Standing Amida
Cast iron
Kamakura period, 13th century
H: 30.5 cm W: 11.3 cm
1991.76

7
聖観音菩薩座像
銅造
鎌倉時代（13世紀後半）

Seated Shō-Kannon
Bronze
Kamakura period, late 13th century
H: 50.8 cm W: 38.0 cm
1991.77

8
王舞面
木造
室町時代（15 - 16世紀）

Ōmai Mask (Religious Mask)
Wood
Muromachi period, 15th–16th century
H: 22.2 cm W: 18.0 cm
1991.72

9
閻魔座像
銅造
鎌倉時代（14世紀）

King of Hell (Enma)
Bronze
Kamakura period, 14th century
H: 22.1 cm W: 21.7 cm
1991.75

10
経筒
銅造
平安時代（12世紀）

Sutra Container
Bronze
Heian period, 12th century
H: 33.3 cm Diam: 17.2 cm
1991.78

11
鹿島立御影図
掛幅一幅　絹本着色
鎌倉時代後期 - 室町時代（14世紀）

Appearance of Kasuga Myōjin
(Departure from Kashima)
Hanging scroll, ink and colors on silk
Late Kamakura–Muromachi period,
14th century
H: 92.8 cm W: 39.3 cm
1991.58

12
春日本地仏曼荼羅
掛幅一幅　絹本着色
室町時代（15世紀）

Kasuga Honjibutsu Mandala (Five Buddhist
Avatars of the Kasuga Gods Descending over
the Kasuga Shrine)
Hanging scroll, ink and colors on silk
Muromachi period, 15th century
H: 85.2 cm W: 37.3 cm
1991.59

13
聖観音座像懸仏
木造彩色
平安時代（11 - 12世紀）

Votive Plaque with Figure of Shō-Kannon
(*kakebotoke*)
Wood with colors
Heian period, late 11th–early 12th century
Diam: 24.0 cm
1991.70

14
蔵王権現像
木造彩色
平安時代（12世紀）

Zaō Gongen
Wood, colors, and inlaid glass
Heian period, 12th century
H: 31.5 cm
1991.73

15
応永舞楽図
阿部季英
巻子一巻　紙本着色
室町時代（1408年）

Bugaku Dancers Scroll
Abe no Suehide, 1361–1411
Handscroll, ink and colors on paper
Muromachi period, dated 1408
H: 28.2 cm L: 473.4 cm
1991.60

16
破墨山水画
曾我宗丈
印章：宗丈　賛詩：宜竹周麟
掛幅一幅　紙本墨画
室町時代（15世紀後半 - 16世紀前半）

Splashed-ink Landscape
Soga Sōjō, act. 1490–1512?
Hanging scroll, ink on paper
Muromachi period, late 15th–early
16th century
H: 71.6 cm W: 9.3 cm
1991.63

17
旧牟田口家蔵豊臣秀吉像
掛幅一幅　絹本着色
桃山時代（1599年）

Portrait of Toyotomi Hideyoshi
Hanging scroll, ink and colors on silk
Inscription by Seishō Shōtai
Momoyama period, dated 1599
H: 90.7 cm W: 37.8 cm
1991.61

18
柏猿猴図
掛幅双幅　紙本着色
江戸時代

Monkeys Playing on Oak Branches
Pair of hanging scrolls, ink and colors on paper
Edo period
H: 177.5 cm W: 138.4 cm
1991.62.1–2

19
源氏物語　鳥小屋図屏風
屏風六曲一双　紙本金地着色
江戸時代（17世紀前半）

The Tale of Genji and an Aviary Screen
Pair of six-panel screens, ink, colors, and gold
on paper
Edo period, early 17th century
Each: H: 93.0 cm W: 271.0 cm
1991.65.1–2

20
月に花鳥木版摺下絵新古今和歌集歌巻
本阿弥光悦書
俵屋宗達下絵
巻子一巻　紙本雲母
江戸時代（17世紀初期）

Sixteen Poems from the Shin Kokin Wakashū
Calligraphy by Hon'ami Kōetsu, 1558–1637
Paper designs by Tawaraya Sōtatsu, d. ca. 1640
Handscroll, ink and mica on paper
Edo period, early 17th century
H: 22.8 cm L: 570.0 cm
1991.64

21
朝顔図香包
尾形光琳
印章：寂明
掛幅一幅　紙本金着色
江戸時代（18世紀）

Morning Glories (incense wrapper)
Ogata Kōrin, 1658–1716
Hanging scroll, ink, colors, and gold on silk
Edo period, 18th century
H: 26.6 cm W: 21.1 cm
1991.79

22
流水瀧に花卉図屏風
渡辺始興
屏風六曲一双　紙本金地着色
江戸時代（18世紀）

Flowering Plants and Fruits of the Four Seasons
Watanabe Shikō, 1683–1755
Pair of six-panel screens, ink, colors, and gold
on paper
Edo period, 18th century
Each: H: 154.5 cm W: 352.0 cm
1991.54.1–2

23
西湖春景図
与謝蕪村
掛幅一幅　絹本淡彩
江戸時代（18世紀）

West Lake in Spring
Yosa Buson, 1716–83
Hanging scroll, ink and colors on silk
Edo period, 18th century
H: 133.2 cm W: 62.5 cm
1991.80

24
岳陽楼図屏風
青木夙夜
屏風二曲一隻　紙本金地墨画
江戸時代（1802年）

Gakuyōrō (Yueyang) Tower
Aoki Shukuya, d. 1802
Two-panel screen, ink and colors on gold
Edo period, dated 1802
H: 167.3 cm W: 187.0 cm
1991.69

25
山水図屏風
野呂介石
屏風六曲一双　紙本金地墨画
江戸時代（1812年）

Landscape
Noro Kaiseki, 1747–1828
Pair of six-panel screens, ink on gold
Edo period, dated 1812
Each: H: 162.5 cm W: 360.0 cm
1991.66.1–2

26
春秋山水図屏風
岡田半江
屏風六曲一双　紙本淡彩墨画
江戸時代（1837年）

Spring and Autumn Landscapes
Okada Hankō, 1782–1846
Pair of six-panel screens, ink and colors on
paper
Edo period, dated 1837
Each: H: 118.0 cm W: 284.4 cm
1991.67.1–2

27
花鳥図屏風
山本梅逸
屏風六曲一隻　紙本淡彩墨画
江戸時代（1843年）

Flowers and Birds
Yamamoto Baiitsu, 1783–1856
Six-panel screen, ink and colors on paper
Edo period, dated 1843
H: 156.3 cm W: 358.6 cm
1991.68

APPENDIX

OBJECTS ACQUIRED BY AVERY BRUNDAGE FROM HARRY PACKARD

This group contains some very important pieces. The six Chinese Imperial porcelains acquired in 1962 from Packard, including a *famille rose* enamel-decorated plate (B60P1707), are among the best in our collection. But the Japanese objects are the most numerous at twenty-nine: three porcelains, five stonewares, two earthenwares, nine hanging scrolls, four handscrolls, three screens, and three mirrors. Perhaps the most important of this group are the Sōami painting (B62D11); the handscroll *Angry Deities* (*Zuzōshō*) (B65D9); a ceramic tall-necked jar from the Sanage kilns (B65P39); and a painting by Sōtatsu (d. ca. 1640), of one of the Immortal Poets (B67D18). In addition, Packard provided one Vietnamese blue-and-white plate, and three Korean objects.

CHINA

B60P2101 Bowl
 Porcelain with underglaze blue decoration
 Ming dynasty, Xuande period (1426–35)
 (matching bowl returned to H. P.)
B60P1186 Plate
 Porcelain with underglaze blue decoration
 Ming dynasty, early 15th century
B60P1425 Bowl
 Porcelain with *famille verte* enamel decoration
 Qing dynasty, Yungzheng period (1723–35)
 (matching bowl returned to H. P.)
B60P1707 Plate
 Porcelain with *famille rose* enamel decoration
 Qing dynasty, Qianlong period (1736–95)
 (matching bowl returned to H. P.)
B60P1 Mei Ping vase
 Porcelain with underglaze red decoration
 Qing dynasty, Qianlong period (1736–95)
B62P167 Bowl
 Porcelain with yellow glaze
 Qing dynasty, Kangxi period (1662–1722)
B67D15 Buddhist Scene (fragment)
 Painting, ink and colors on silk
 (?)Song dynasty (960–1280)

JAPAN

Ceramics

B60P1206 Jar with lid
 Porcelain with overglaze enamels; Kakiemon ware
 Edo period, 17th century
B65P38 Fresh water jar
 Stoneware; Tamba ware
 Edo period, 17th century
B65P39 Tall-necked jar
 Stoneware; Sanage kilns
 Heian period, 9th century
B67P5 Spouted vessel
 Earthenware
 Late Jōmon period, 10th–3rd century B.C.
B67P4 Censor-shaped vessel
 Earthenware
 Late Jōmon period, 10th–3rd century B.C.
B67P9 Jar
 Stoneware; Sue ware
 Nara period, 7th century
B67P8 Square dish
 Stoneware with underglaze iron and copper decoration; Oribe ware; Mino kilns
 Momoyama period, late 16th century
B67P10 Jar with four handles
 Stoneware; Bizen kilns
 Momoyama period, early 17th century
B67P7 Jar
 Porcelain with underglaze blue decoration; Kakiemon ware.
 Edo period, late 17th century
B67P6 Dish
 Porcelain with purple and dark green enamel decoration; Matsugatani ware
 Edo period, early 18th century

Paintings

B62D11 *Li Taibo Looking at a Waterfall*
 Hanging scroll, ink on paper
 Attributed to Sōami (?–1525)
 Muromachi period

B65D9 *Angry Deities (Zuzōshō)*
Handscroll, ink on paper
Kamakura period, 13th–14th century

B65D11 *Portrait of Jittoku*
Hanging scroll, ink on paper
Seal of Tan'yū (1602–74)
Edo period

B65D50 & D51 *Landscapes*
Pair of six-panel screens, ink on paper
Ike no Taiga (1723–76)
Edo period

B65D10 *Three Household Gods Visiting Yoshiwara*
Handscroll, ink and colors on paper
Painting by Hosoda Eishi (1756–1815); calligraphy
by Shokusanjin (1768–1829)
Edo period

B65D14 *Two Herons under Lotus*
Hanging scroll, ink and colors on silk
Yamamoto Baiitsu (1783–1856)
Edo period

B65D12 *Landscape with Man in a Boat*
Hanging scroll, ink and colors on silk
Okada Hankō (1782–1846), dated 1805
Edo period

B65D13 *Landscape*
Hanging scroll, ink and colors on silk
Nakabayashi Chikutō (1776–1853), dated 1826
Edo period

B67D10 *Orchids and Grasses*
Handscroll, ink and colors on paper
Unge (1783–1850), dated 1832, with inscription by
Tanomura Chikuden (1777–1835)
Edo period

B67D19 *Landscape*
Eight-panel screen, ink on paper
Maruyama Ōkyo (1733–95), dated 1787
Edo period

B67D16 *Landscape*
Hanging scroll, ink on paper
Nakabayashi Chikutō (1776–1853)
Edo period

B67D18 *Kasen-e* (One of the Immortal Poets)
Hanging scroll, ink and color on paper
Tawaraya Sōtatsu (d. ca. 1640)
Edo period

B67D13 *Waterfall*
Hanging scroll, ink and colors on silk
Nagasawa Rosetsu (1755–99)
Edo period

B67D17 *Life of Priest Kōbō Daishi*
Handscroll, ink and colors on paper
Anonymous
Kamakura period, 14th century

B67D11 *Peach Blossoms in Landscape*
Hanging scroll, ink and colors on silk
Totoki Baigai (1733–1804), dated 1803
Edo period

Mirrors

B65B54 Mirror with six bosses
Bronze
Kofun period, ca. 4th century

B65B56 Mirror with eight-petaled lobes
Bronze
Heian period, ca. 11th century

B65B55 Mirror with landscape
Bronze
Muromachi period, ca. 15th century

KOREA

B67P11 Gourd-shaped ewer with lid
Stoneware
Koryŏ period, late 12th century

B67D14 *Deer in a Fantastic Mountain Scene*
Hanging scroll, ink on linen
Anonymous
Chosŏn period, ca. 18th–19th century

B67D12 *Monkeys*
Hanging scroll, ink on silk
Anonymous
(?)Chosŏn period

VIETNAM

B65P69 Large plate
Porcelain with blue underglaze decoration
15th–16th century

BIBLIOGRAPHY

Aizawa, Masahiko. "Muromachi kyūtei shakai ni okeru mai-e seisaku to sono ichirei ni tsuite" (A Case Study of Dance Painting Production in the Muromachi Imperial Court). *Kobijutsu* 58(1981).

———. "Kyū Mutaguchi-ke bon Toyokuni Myōjin zō o megutte" (On the Portrait of Toyotomi Hideyoshi formerly in the Mutaguchi Family Collection). *Kobijutsu* 63(July 1982).

Amidabutsu chōzō (Amida Sculpture). Nara: Nara National Museum, 1974.

Bunjinga shoha (Trends in Literati Painting). Zaigai Nihon no shihō, v. 6. Tokyo: Mainichi Shinbunsha, 1980.

Bunjinga to shaseiga (Literati and Realistic Painting). Nihon bijutsu zenshū, v. 24. Tokyo: Gakushū Kenkyūsha, 1979.

Cahill, James. *Sakaki Hyakusen and Early Nanga Painting.* Berkeley: Institute of East Asian Studies, University of California, 1983.

Chizawa, Teiji. "Kōrin no hito to geijutsu" (Kōrin: His Life and Art). In *Kōrin.* Tokyo: Nihon Keizai Shinbunsha, 1958.

"Daitokuji Mokkei enkaku-zu" (Monkey and Crane Painting by Muxi in Daitokuji). *Kokka* 185(1905).

Doi, Tsugiyoshi. *Watanabe Shikō shōhekiga* (Shikō's Screen and Wall Paintings). Tokyo: Mitsumura Suiko Shoin, 1972.

Edo shoki no kachō, Shōsha na sōshokubi (Flower and Bird Painting in the Early Edo Period). Kachōga no sekai, v. 5. Tokyo: Gakushū Kenkyūsha, 1981.

Enma tōjō (Emergence of the King of Hell). Kawasaki: Kawasaki Shimin Museum, 1989.

Fujishima, Yukihiko. "Nihon ni okeru Mokkei-fū enkō-zu no tenkai" (Development of Muxi-style Monkey Painting in Japan). *Bijutsushi kenkyū* 21(1984).

Hamada, Takashi. *Zuzō* (Iconographical Drawings). Nihon no bijutsu, no. 55. Tokyo: Shibundō, 1970.

Hamada, Takashi, and Ryūken Sawa, eds. *Mikkyō Kannonzō seiritsu to tenkai* (Development of Avalokitesvara Images in Esoteric Buddhism). Mikkyō bijutsu taikan, v. 2. Tokyo: Asahi Shinbunsha, 1984.

Hayakawa, Monta, and Kenkichi Yamamoto. *Buson gafu* (Collection of Buson's Paintings). Tokyo: Mainichi Shinbunsha, 1984.

Heian Butsuga (Buddhist Paintings in the Heian Period). Nara: Nara National Museum, 1986.

Heian Kamakura no kondōbutsu (Bronze Buddhist Sculptures of the Heian and Kamakura Period). Nara: Nara National Museum, 1976.

Hirata, Yutaka. "Tōdaiji no Fudarakusan Jūichimen Kannon raigō-zu" (Painting of the Eleven-headed Kannon Descending from Potalaka in the Tōdaiji Collection). *Kokka* 919(1968).

Impey, O. R. "Watanabe Shikō: A Reassessment." *Oriental Art* 17:4(Winter 1971).

Itō, Toshiko. "Kōetsu no shoseki" (Kōetsu's Calligraphy). In *Kōetsu sho Sōtatsu kingindei-e,* text vol. Tokyo: Asahi Shinbunsha, 1978.

Kachō no bi: Kaiga to ishō (Flower and Bird in Painting and the Applied Arts). Kyoto: Kyoto National Museum, 1982.

Kageyama, Haruki. *Shinto Arts: Nature, Gods, and Men in Japan.* New York: Japan Society, 1976.

Kaiga (Painting), 1. *Jūyō bunkazai* (Important Cultural Properties), v. 7. Tokyo: Mainichi Shinbunsha, 1973.

Kaikan jūgoshūnen kinenten zuroku (Fifteenth Anniversary Catalogue). Tokyo: Idemitsu Museum of Arts, 1981.

Kamigami no bijutsu (The Arts of Japanese Gods). Kyoto: Kyoto National Museum, 1974.

Kannon Bosatsu (Avalokitesvara Bodhisattva). Nara: Nara National Museum, 1977.

Kannon Bosatsu (Avalokitesvara Bodhisattva). Nara: Nara National Museum, 1981.

"Kannon-zu." *Kokka* 265(1912).

Kasuga Gongen genki-e (Kasuga Gongen Handscroll). Nihon emakimono zenshū, v. 15. Tokyo: Kadokawa Shoten, 1963.

Kawaguchi, Yoko. "Jūichimen kannon raigō zuyō; Nanto ni okeru tenkai to sono haikei" (Painting Style of the Descent of the Eleven-headed Kannon: Development and Background in Nara). *Bijutsushi kenkyū* 20(1983).

Kō to kōdō (Incense and the Incense Ceremony). Kyoto: Kōdō Bunka Kenkyūkai, 1992.

Kōdansha Encyclopedia of Japan. 9 vols. Tokyo: Kōdansha, 1983.

Kōetsu sho Sōtatsu kingindei-e. Tokyo: Asahi Shinbunsha, 1978.

"Koga Jūichimen Kannon-zu" (Ancient Painting of the Eleven-headed Kannon). *Kokka* 253(1911).

Kuno, Takeshi. "Mokuzō koinu zō" (Wooden Sculpture of a Puppy). *Kobijutsu* 97(1991).

Kuroda, Taizō. "Yamamoto Baiitsu hitsu kachō-zu byōbu" (A Flower and Bird Screen by Baiitsu). *Kokka* 1092(1986).

Lester, Gerd. "Kōdō." *Arts of Asia* (Jan./Feb. 1993).

Minamoto, Toyomune. "Soga-ha to Asakura bunka" (The Soga School and Culture in Lord Asakura's Domain). *Kobijutsu* 38(Sept. 1972).

———. *Tawaraya Sōtatsu*. Nihon bijutsu kaiga zenshū, v. 14. Tokyo: Shūeisha, 1976.

———. *Soga Jasoku*. Nihon bijutsu kaiga zenshū, v. 3. Tokyo: Shūeisha, 1980.

———. "Hon'ami Kōetsu no geijutsu" (The Arts of Hon'ami Kōetsu). In *Kōetsu no sho*. Osaka: Osaka Municipal Museum, 1990.

Mitsumori, Masashi. "Kue issho no Zaō Gongen-zō" (Two Statues of Zaō Gongen). *Kobijutsu* 81(1987).

Miyazaki, Noriko. "Seiko o meguru kaiga" (Paintings Depicting the West Lake). In *Chūgoku kinsei no toshi to bunka*. Kyoto: Kyoto Daigaku Jinbun Kagaku Kenkyūsho, 1984.

Mizuo, Hiroshi. "Asagao-zu kōzutsumi" (Incense Wrapper with a Morning-glory Design). *Kokka* 892(1966).

———. "Kōetsu sho Sōtatsu kingindei-e no suii" (Development of Calligraphic Works by Kōetsu on Sōtatsu-decorated Gold and Silver Papers). In *Kōetsu sho Sōtatsu kingindei-e*, text vol. Tokyo: Asahi Shinbunsha, 1978.

———. *Nihon bijutsushi: Yō to bi no zōkei* (History of Japanese Art: Beauty in Form and Function). Tokyo: Chikuma Shobō, 1982.

Mochizuki, Shinjō. *Nihon Bukkyō bijutsu hihō* (Treasures of Japanese Buddhist Art). Tokyo: Sansaisha, 1973.

———. "Jūichimen Kannon gazō" (A Painting of the Eleven-headed Kannon). *Kobijutsu* 46(1974).

Mochizuki, Shinkyō, ed. *Bukkyō daijiten* (Great Dictionary of Buddhism). Tokyo: Sekai Seiten Kankō Kyōkai, 1961–67.

Morohashi, Tetsuji, ed. *Dai Kanwa jiten* (Dictionary of Chinese/Japanese Literature), v. 4. Tokyo: Taishūkan, 1955–60.

Murashige, Yasushi. "Rimpa no kōbō" (Art Studios of the Rimpa School). *Rimpa Hyakuzu: Kōetsu, Sōtatsu, Kōrin, Kenzan, Bessatsu Taiyō* (Spring 1974).

Muromachi jidai no byōbu-e (Screen Painting in the Muromachi Period). Tokyo: Tokyo National Museum, 1989.

Nagashima, Fukutarō. "Kasuga mandara no hassei to sono rufu" (Emergence and Popularization of the Kasuga Mandala). *Bijutsu kenkyū* 133(1944).

Nakamachi, Keiko. "Ogata Kōrin no byōbu-e o meguru mondai" (Folding Screen Paintings of Ogata Kōrin). *Kobijutsu* 76(Oct. 1985).

Nakano, Genzō. *Bosatsu, Myōō* (Bodhisattva and Vidyaraja). Mikkyō bijutsu taikan, v. 3. Tokyo: Asahi Shinbunsha, 1984.

Naniwada, Tōru. *Kyōzō to kakebotoke* (Bronze Mirrors Inscribed with Shinto Images and Hanging Buddhist Images). Nihon no bijutsu, no. 284. Tokyo: Shibundō, 1990.

Nara rokudaiji taikan (Treasures of the Six Great Temples of Nara), v. 2. Tokyo: Iwanami Shoten, 1968.

Narazaki, Munashige, and Shūjirō Shimada, eds. *Shōhekiga, Rimpa, Bunjinga. Zaigai hihō*, 3 vols. (Tokyo: Gakushū Kenkyūsha, 1969).

Nishikawa, Kyōtarō. "Kōzanji no dōbutsu chōkoku" (Animal Sculpture in the Kōzanji). *Kokka* 1089(1985).

Nishikawa, Kyōtarō, and Emily Sano. *The Great Age of Japanese Buddhist Sculpture*, A.D. 600–1300. Fort Worth, Texas: Kimbell Art Museum, 1982.

Nishimoto, Shūko. "Kōrin oboegakichō" (Notes by Kōrin). *Rimpa kaiga zenshū; Kōrin-ha*. Tokyo: Nihon Keizai Shinbunsha, 1979.

Noma, Seiroku. *The Arts of Japan*, v. 1. Tokyo: Kōdansha, 1966.

Noro Kaiseki tokubetsu-ten (Special Exhibition of Noro Kaiseki). Wakayama: Wakayama Prefecture Museum, 1978.

Ōhigashi, Nobukazu. "History of the Kasuga Shrine." In *Bugaku: Treasures from the Kasuga Shrine*. Boston: Museum of Fine Arts, 1984.

Oka, Naoya, and Shōichi Uehara. "Suijaku chōkoku" (Sculpture in Suijaku Theory). In *Suijaku bijutsu*. Tokyo: Kadokawa Shoten and Nara National Museum, 1964.

Okumura, Hideo. "Kyōzuka ihō" (Treasures from Sutra Mounds). In *Shinto no bijutsu*. Nihon bijutsu zenshū, v. 11. Tokyo: Gakushū Kenkyūsha, 1979.

Rimpa kaiga zenshū: Kōrin-ha (Collection of Rimpa School Paintings: Kōrin). Tokyo: Nihon Keizai Shinbunsha, 1979.

Rimpa no ishō. Himeji: Himeji Shiritsu Bijutsukan, 1986.

Rosenfield, John. *Journey of the Three Jewels: Japanese Buddhist Paintings from Western Collections*. New York: Asia House Gallery and John Weatherhill, 1979.

Rosenfield, John, and Shūjirō Shimada. *Traditions of Japanese Art: Selections from the Kimiko and John Powers Collection*. Cambridge: Fogg Art Museum, Harvard University, 1970.

Saitō, Akio. *Tetsubutsu* (Buddhist Sculpture in Iron). Nihon no bijutsu, no. 252. Tokyo: Shibundō, 1987.

Sansuiga: Nanga-sansui (Nanga School Landscape Paintings). Nihon byōbu-e shūsei, v. 3. Tokyo: Kōdansha, 1979.

Sasaki, Gōzō, and Hideo Okamura, *Shintō no bijutsu* (Shinto Arts). Nihon bijutsu zenshū, v. 11. Tokyo: Gakushū Kenkyūsha, 1979.

Sasaki, Jōhei. *Yosa Buson*. Nihon no bijutsu, no. 109. Tokyo: Shibundō, 1975.

———. "Rōkaku sansui-zu byōbu" (Landscape with Pavilion). In *Nihon no Nanga*. Suiboku bijutsu taikei, Bekkan 1. Tokyo: Kōdansha, 1976.

Sawa, Ryūken. *Mikkyō bijutsu ron* (Theory of Esoteric Buddhist Art). Tokyo: Benridō, 1969.

Seattle Art Museum. *A Thousand Cranes*. Seattle: Seattle Art Museum, 1987.

Shimizu, Yoshiaki. *Genji: The World of a Prince*. Indiana: Indiana University Art Museum, 1982.

Shirahata, Yoshi. "Chigo Monju Bosatsu zuzō" (An Iconographic Drawing of Monju). *Kobijutsu* 44(April 1974).

———. *Rimpa kaiga senshū* (Selected Rimpa School Paintings), v. 2. Kyoto: Kyoto Shoin, 1975.

———. "Watanabe Shikō hitsu ryūsui taki ni kaki-zu" (Stream and Flower Screens by Watanabe Shikō). *Kobijutsu* 52(May 1977).

Suijaku bijutsu (Arts of the Shinto-Buddhist Integration). Nara: Nara National Museum, and Tokyo: Kadokawa, 1964.

Takeda, Tsuneo. *Tōhaku, Yūsho* (Tōhaku and Yūsho). Suiboku bijutsu taikei, v. 9. Tokyo: Kōdansha, 1973.

Tanabe, Saburōsuke. *Gyōdōmen to shishigashira* (Procession Masks and Lion Masks). Nihon no bijutsu, no. 185. Tokyo: Shibundō, 1981.

———. *Shinbutsu shūgō to shugen* (Buddhist and Shinto Unification and Mountain Ascetics). Zusetsu Nihon no bukkyō, v. 10. Tokyo: Shinchosha, 1989.

Tanaka, Ichimatsu. "Soga Jasoku to Sōjō o meguru shomondai" (Soga Jasoku and Soga Sōjō). *Bukkyō geijutsu* 79(April 1971).

Tanaka, Ichimatsu, ed. *Kōrin*. Tokyo: Nihon Keizai Shinbunsha, 1958.

Tanaka, Ichimatsu, et al. *Ike Taiga sakuhinshū* (Collection of Taiga's Works). Tokyo: Chuō Kōron Bijutsu Shuppansha, 1960.

Tani, Shin'ichi. "Hō Taikō gazō-ron" (Theory on a Portrait of the Seated Toyotomi Hideyoshi). *Bijutsu kenkyū* 92(1939).

———. "Kōrin to sono jidai" (Kōrin and His Time). In Tanaka, Ichimatsu, ed., *Kōrin*. Tokyo: Nihon Keizai Shinbunsha, 1958.

Tsuji, Nobuo. "Bugaku-zu no keifu to Sōtatsu hitsu Bugaku-zu byōbu" (Lineage of Bugaku Dance: Paintings and Screens by Sōtatsu). In *Rimpa kaiga senshū, Sōtatsu*, v. 1. Tokyo: Nihon Keizai Shinbunsha, 1977.

———. *Bugaku-zu byōbu ni tsuite* (On a Bugaku Dance Screen). Nihon byōbu-e shūsei, v. 12. Tokyo: Kōdansha, 1980.

Uchiyama, Kaoru. "Hasegawa Tōhaku hitsu chikurin enkō-zu byōbu o megutte" (Hasegawa Tōhaku's Bamboo Grove and Monkey Screens). *Kokka* 1164(1993).

Wakita, Hidetarō. "Noro Kaiseki no kenkyū" (Research on Noro Kaiseki). *Kokka* 924(1970).

Watson, William. *Sōtatsu*. London: Faber and Faber, Ltd., 1956.

Yamane, Yūzō. "Sōtatsu kingindei-e no seiritsu to tenkai" (Sōtatsu's Paintings in Gold and Silver). In *Kōetsu sho Sōtatsu kingindei-e*, text vol. Tokyo: Asahi Shinbunsha, 1978.

———. *Rimpa*. Zaigai Nihon no shihō, v. 5. Tokyo: Mainichi Shinbunsha, 1979.

Yamane, Yūzō, et al., eds. *Sōjūga, Ryūko Enkō* (Animal Painting: Tiger, Dragon, Monkey). Nihon byōbu-e shūsei, v. 16. Tokyo: Kōdansha, 1979.

Yamanouchi, Chōzō. *Nihon Nangashi* (History of Nanga in Japan). Tokyo: Ruri Shobō, 1981.

Yosa Buson. Nihon bijutsu kaiga zenshū, v. 19. Tokyo: Shūeisha, 1980.

Yosa Buson meisaku ten: Tokubetsu ten botsugo 200-nen kinen (Exhibition of Buson's Masterworks: 200th Anniversary). Nara: Yamato Bunkakan, 1983.

Yosano, Hiroshi, ed. *Nihon koten zenshū* (Japanese Classical Literature), v. 22. Tokyo: Nihon Koten Zenshū Kankōkai, 1926.

Yoshida, Mitsukuni. *Sōjūga no genryū* (Origin of Animal Paintings). Nihon byōbu-e shūsei, v. 16. Tokyo: Kōdansha, 1978.

Yoshida, Toshihide. "Yamamoto Baiitsu kenkyū josetsu" (Introductory Study of Yamamoto Baiitsu). In *Nagoya-shi Hakubutsukan kenkyū kiyō*, v. 2. Nagoya: Nagoya-shi Hakubutsukan kenkyū kiyō, 1978.

Yoshizawa, Chū. "Nanga no senkusha" (Pioneers of Nanga). In *Nihon no Nanga* (Japanese Nanga Painting). Suiboku bijutsu taikei, Bekkan 1. Tokyo: Kōdansha, 1976.

INDEX